Praise for

the *Trip*

"In *The Trip* . . . author Deborah Davis revivifies the era that made the man, and the man who helped define the era. . . . A bang-up job!"

—*The Boston Globe*

"An accessible and original book . . . with a joie de vivre that might have delighted the man himself. As a jaunty romp through American pop-art history, the book is a light and entertaining read."

—*The Washington Post*

"Davis's prose mirrors the zeitgeist Warhol brought to his art: bright, breezy, and easy to understand . . . an entertaining and accessible introduction to his work and a beginner's guide to the social scene of the pop art world."

—*Publishers Weekly*

"Deborah Davis' *The Trip: Andy Warhol's Plastic Fantastic Cross-Country Adventure* is both the story of Warhol's life at the moment just before stardom and a clever history of America during that period."

—*Chicago Tribune*

"Deborah Davis' chronicle of Warhol's travels on the hipster highway, Route 66, captures the moment the artist met Hollywood and became a superstar . . . quite convincingly makes the case that 1963 was the year when 'everything changed' not only for the famed American pop artist, but for the United States as well."

—*Toronto Star*

"Fast-moving. Totally engrossing. Filled with fascinating details about Andy that even I didn't know."

—Pat Hackett, Andy Warhol's diarist and coauthor

"Deborah Davis calls shotgun on Andy Warhol's era-defining 1963 cross-country road trip and thankfully takes us along for the ride. With electric storytelling and riveting prose, *The Trip* puts us right in the middle of the action as Andy crashed his way through Hollywood, Manhattan high society, and the heights of the art world."

—Kevin Kwan, bestselling author of *Crazy Rich Asians*

"Thanks to Deborah Davis I've just been on a cross-country road trip to Hollywood with Andy Warhol: 1963, the year America lost its innocence. Sure, there's high gossip, lots of gossip—Andy wouldn't leave home without it—but also something much more. A way of seeing things that has made Andy Warhol not just one of the most coveted artists of our age but also one of the greatest philosophers of the twentieth century."

—William Norwich, fashion editor,
author of *Learning to Drive*

"AAA+ to Deborah Davis for her brilliant travelogue detailing Andy Warhol's 1963 cross-country adventure. Thanks to Andy's time capsules and Davis's meticulous research, *The Trip* transports you, 'shotgun,' into this legendary road trip."

—Timothy Greenfield-Sanders,
photographer and filmmaker

ALSO BY DEBORAH DAVIS

Strapless: John Singer Sargent and the Fall of Madame X

*Party of the Century: The Fabulous Story of Truman
Capote and His Black and White Ball*

Gilded: How Newport Became America's Richest Resort

The Secret Lives of Frames: A Hundred Years of Art and Artistry

The Oprah Winfrey Show: Reflections on an American Legacy

*Guest of Honor: Booker T. Washington, Theodore Roosevelt,
and the White House Dinner That Shocked a Nation*

*Fabritius and the Goldfinch: A True Story of
Art, Tragedy, and Immortality*

the Trip

Andy Warhol's Plastic Fantastic Cross-Country Adventure

DEBORAH DAVIS

ATRIA PAPERBACK

NEW YORK TORONTO LONDON SYDNEY NEW DELHI

ATRIA PAPERBACK

An Imprint of Simon & Schuster, Inc.
1230 Avenue of the Americas
New York, NY 10020

Copyright © 2015 by Deborah Davis

All rights reserved, including the right to reproduce this book
or portions thereof in any form whatsoever. For information, address
Atria Books Subsidiary Rights Department,
1230 Avenue of the Americas, New York, NY 10020.

First Atria Paperback edition August 2016

ATRIA PAPERBACK and colophon are trademarks of Simon & Schuster, Inc.

For information about special discounts for bulk purchases, please contact
Simon & Schuster Special Sales at 1-866-506-1949
or business@simonandschuster.com.

The Simon & Schuster Speakers Bureau can bring authors to your
live event. For more information, or to book an event, contact the
Simon & Schuster Speakers Bureau at 1-866-248-3049
or visit our website at www.simonspeakers.com.

Interior design by Paul Dippolito

Manufactured in the United States of America

10 9 8 7 6 5 4 3 2 1

The Library of Congress has cataloged the hardcover edition as follows:

Davis, Deborah, date.
 The trip : Andy Warhol's plastic fantastic cross-country adventure / Deborah Davis.
 pages cm
1. Warhol, Andy, 1928–1987—Travel—United States. 2. Warhol, Andy,
1928–1987—Friends and associates. 3. Automobile travel—United States—
History—20th century. I. Title.
 N6537.W28D38 2015
 700.92--dc23 2015016732

ISBN 978-1-4767-0351-0
ISBN 978-1-4767-0352-7 (pbk)
ISBN 978-1-4767-0353-4 (ebook)

For my family

Sometimes the little times you don't think are anything while they're happening turn out to be what marks a whole period of your life.

—Andy Warhol

the *Trip*

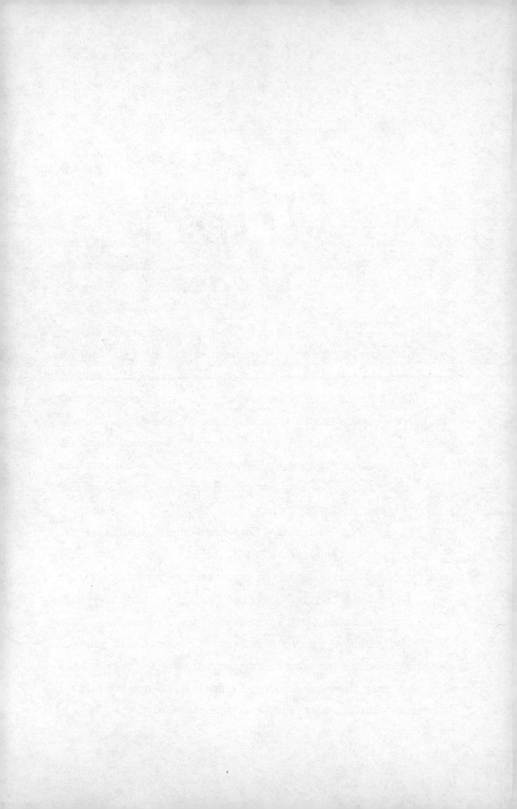

Introduction

I have always been fascinated by Andy Warhol, the artist, film-maker, writer, aphorist, media mogul, trendsetter, and visionary who remains one of the most enduring talents of the twentieth century and, somehow, one of the hottest of the twenty-first. Andy would be amused—although probably not at all surprised—to see that the paintings critics considered a joke in 1963, including his controversial Campbell's Soup cans, command hundreds of millions of dollars today; that an entire museum is dedicated to preserving his life and works; that Warhol exhibitions are in constant circulation; that his counterculture movies laid the groundwork for the mainstream, billion-dollar industry known today as independent film; that he is credited with having invented the "selfie"; and that fans, including artists and writers, view "Saint Andy" as their muse.

I was one of those adoring fans when I found myself sitting in front of Andy at a film event at the Museum of Modern Art in the early eighties. I was thrilled to be in his presence but too shy to turn around and speak to him. Later that evening, my husband made some comment about Andy's wig, and I asked, "What wig?" I was so young and naive that I thought his outrageous silver hair was *real*. Subsequently, I became better informed about everything Warhol, and when I became a writer, I contemplated making him the subject of a book. I just needed to find the right story.

Introduction

In *POPism,* Andy's intimate chronicle of his experiences in the 1960s, I came across a passing mention of a road trip he took in 1963, when he and some cronies drove cross-country from New York to Los Angeles. I soon became convinced that this adventure—a mere footnote in most Warhol biographies—was actually a defining moment in his life, as well as a window through which one could see the seismic shifts underway in America at the time. It is a road trip that becomes, in that sixties way, a head trip; a celebratory tour of heartland highways, California beaches, old Hollywood, new Hollywood, Las Vegas, and other quintessentially American places, and a Pop-infused exploration of American culture—art, literature, movies, television, advertising, music, sports, drugs, and the new sexuality—all filtered through Andy Warhol's experiences.

Andy was thirty-five the first time he set out for the West Coast, but in a larger sense, his journey began at birth. His evolution from a poor, sickly child, born in depressed Pittsburgh in 1928, to the nascent artist and filmmaker speeding along Route 66 in 1963 was an eventful trip in itself. As I researched his life and times, it occurred to me that if I *really* wanted to understand Andy at this critical moment, I would have to get into a car and take the trip myself.

I started planning the sort of road trip that most people take when they are eighteen and unencumbered or, conversely, retired and in an RV. I would drive from New York to New Jersey, across Pennsylvania, Ohio, and Indiana, and then pick up historic Route 66—the hipster's highway—straight across Missouri, Kansas, Oklahoma, Texas, New Mexico, and Arizona, all the way to the Santa Monica Pier, on the westernmost edge of California. My husband, a confirmed New Yorker, does not drive, so he would be strictly a passenger. Under the circumstances, I estimated it would

take us about seven days to get to Los Angeles. Andy did it in four and a half, but he and his companions had some quintessentially sixties drugs to help them along. I would leave on September 24, the very day that he had left.

The notion of re-creating Andy's journey was an abstract one until I came across a page of reproduced receipts in a book of Warhol memorabilia. Andy was a notorious pack rat who saved absolutely everything in cardboard boxes he called "time capsules." All sorts of odd things have turned up in them, including party invitations, food, nail clippings, and prescription drugs. In time capsule 55, Andy had stored what I considered absolute treasure—an assortment of receipts from his cross-country road trip.

Each one told a story. A stamped card from the Port of New York Authority recorded the exact minute he left New York City. A bill from the Beverly Hills Hotel listed room service charges and columns of long-distance phone calls. There were receipts from gas stations, motels, restaurants, camera stores, and other places he stopped along the way. Like a trail of crumbs, these details led me to the very places Andy went and also told me how he spent his time once he got there. This trove of information brought Andy to life and would allow me to actually see what *he* saw. Now I was truly excited about hitting the road.

What to pack for such a long trip, with so many hours to spend in the car? Music, books on tape, and magazines. To create the appropriate atmosphere and authentically retro mind-set, I decided that all my entertainment had to be from 1963. The best songs of the year were catchy pop classics—"Sugar Shack," "Sukiyaki," "Sally Go Round the Roses," "Surf City," to name a few. The most promising book on tape was Nabokov's *Lolita* – the film came out in 1963

and featured a road trip of its own. For vintage magazines, I selected the ones I knew Andy read all the time, everything from *Photoplay* and *Confidential* to *Vogue* and *Ladies' Home Journal*.

On departure day, the eagerly anticipated morning of Monday, September 24, 2012, the car rental company called with bad news. Apparently, the vehicle I had booked two months earlier was not available due to some inexplicable glitch. Fortunately, the mom-and-pop gas station down the street had an available rental car, and it was gassed up and ready to go within the hour. For better or worse, so were we.

A thoughtful friend dropped off a Warhol survival kit, complete with snacks, Andy T-shirts, and two platinum wigs. We immediately put them on for a commemorative photograph, and the first thing we noticed was how uncomfortable they were. Did Andy feel the same way about *his* wigs, I wondered. Were they hot and itchy? We said good-bye to family, friends, and dogs, and drove thirteen miles east to New York City so we could start exactly where Andy started—from his townhouse at 1342 Lexington Avenue.

Miraculously, I found a parking space directly in front of the building. I pulled in, fully aware of the significance of the moment, when I suddenly noticed that the door to number 1342 was slightly ajar and that construction workers were going in and out with buckets. Curious, I walked to the door and boldly pushed it open. "Bold" is not a word I would normally use to describe myself, but the urge to enter Andy's house was so compelling that it superseded my fear of trespassing.

Inside, I walked up the stairs to the parlor floor. There were drop cloths everywhere. The house was being renovated and it looked very different from the dark, old-fashioned place Andy called home

in 1963. Before long, the contractor spotted me amid the crowd of workers and I quickly explained that I was writing a book about Andy Warhol. I asked if it would be possible to look around, and he glanced at a coworker as if to say, "Not *another* one." Apparently I wasn't the first Warholic to trespass in the name of research. He left the room to call the current owner about authorizing my "visit," and the second he disappeared I gingerly started peeking through doorways.

It was thrilling to realize I was standing where Andy first painted his Campbell's Soup cans and Coca-Cola bottles. I recalled photographs I'd seen of him in this house. In one, he sat on the hall stairs sifting through his mail. In another, he ate breakfast in the downstairs kitchen with his mother, with whom he lived. I remembered yet another photograph in which every spare inch of space seemed filled with his collectibles, everything from a pair of Carmen Miranda's platform shoes, to a twisted sculpture by the artist John Chamberlain made of scrapped auto parts.

The contractor returned with the not-unexpected news that the owner refused to let an outsider wander through the work site. I thanked him, turned to exit the townhouse, and realized that even though I was denied a tour, I had been given an amazing opportunity. Thanks to divine intervention in the form of a parking space and a renovation, I could begin my trip *exactly* the way Andy had begun his own, forty-nine years earlier. I paused on the landing, walked down the stairs, pushed open the front door, and headed to the waiting car, just like Andy.

Prologue

September 24, 1963

Andy Warhol watched from the window of his Lexington Avenue townhouse as a black Ford Falcon station wagon pulled up to the curb. Grabbing what he considered "essentials"—dozens of magazines, a newly purchased Bolex movie camera (which he wasn't entirely sure how to use), and his tuxedo—Andy kissed his mother good-bye, raced down the steps, climbed into the car, and set out on his first all-American road trip. Destination: Los Angeles, where Irving Blum's Ferus Gallery was mounting an exhibition of Andy's paintings of Elvis Presley and Elizabeth Taylor.

Who was Andy Warhol on that sunny September day? Certainly not the cool, silver-haired sphinx and ubiquitous man about town he would later become. He was a successful illustrator in the 1950s, best known for his whimsical drawings of shoes, cherubs, and flowers. But the sixties unveiled a brand-new Andy, an avant-gardist who was painting seriously and thinking about making experimental films. In 1962, his controversial "portrait" of a Campbell's Soup can catapulted him to the forefront of a sensational new art movement called Pop. Yet in his torn chinos and dirty sneakers, he was still "Raggedy Andy," who struck most people as "charming and gracious," "generous," "easy, outgoing, pleasant, and high-spirited"—a perpetual teenager, even though he was thirty-five at the time, with an ever-enthusiastic and ebullient approach to life.

Prologue

Andy had been fantasizing about Hollywood since childhood, but he had not yet seen it with his own eyes. He loved painting celebrities—Liz, Elvis, Marilyn, Marlon, Troy—faces so iconic that they only needed one name. Now he was headed west on a pilgrimage. Even more thrilling than the Ferus exhibition was the fact that his new friend, Dennis Hopper, the actor and budding art collector, and his wife, Brooke Hayward, the beautiful daughter of Hollywood royalty (the producer Leland Hayward and the actress Margaret Sullavan), had promised to throw him a real "movie star party" when he arrived in LA. Cocktails with the Hoppers and their famous friends were set for Sunday, September 29, leaving Andy only four and a half days to travel all the way across the country.

With such a tight schedule, why a road trip in this age of jet-setting? "It was a beautiful time to be driving across America," Andy explained. "I wanted to see the United States." True, he was curious about the landscape between New York and Los Angeles, but he was also nervous about flying. After the highly publicized 1961 plane crash of Mike Todd, Elizabeth Taylor's then-husband and a Hollywood impresario, Andy's mother warned (in her heavy Eastern European accent), "Many a big-shot guy up in the sky might die." Staying on the ground seemed like the safe alternative, except for one small problem. Though he was fascinated by cars and loved to draw them, Andy Warhol did not know how to drive.

Ever resourceful, he recruited three of his friends, two of them with driver's licenses, to accompany him on his cross-country excursion: Wynn Chamberlain, an amiable artist whose chief qualification was that he owned the all-important Ford station wagon; Taylor Mead, a puckish actor who was making a name for himself in

the exciting world of underground film; and Gerard Malanga, Andy's handsome new studio assistant, an aspiring poet still in college.

Armed with a Carte Blanche credit card, Andy and his motley crew set out for Hollywood. Wynn and Taylor, the designated drivers, sat in front so they could take turns at the wheel, while Gerard joined Andy in the back. "This will be *fun*," Andy thought as he lounged in the car's roomy seat, listening to the radio blaring. With the Manhattan skyline in the rearview mirror and the open road ahead, he optimistically set out on a trip that would take him through twenty-one states—and who knows how many states of mind.

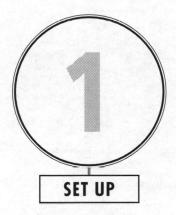

SET UP

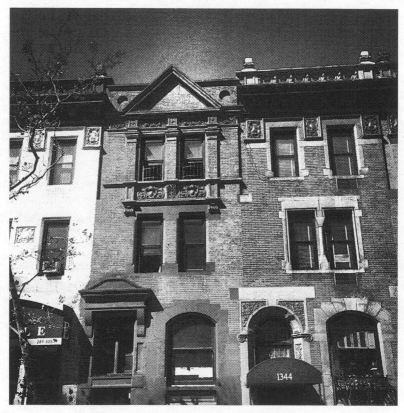

Andy's Lexington Avenue townhouse (*center*),
located in Manhattan's Carnegie Hill.

Chapter 1

It's not what you are that counts,
it's what they think you are.

—Andy Warhol

I n 1960, Andy Warhol was the opposite of a starving artist. In fact, he was a prosperous illustrator, living in a private townhouse on Lexington Avenue and Eighty-Ninth Street. The block was developed in 1888 by New York's aristocratic Rhinelander family, wealthy landowners who commissioned the architect Henry Hardenbergh to build six attached Northern Renaissance Revival houses on one of their properties in uptown Manhattan. Hardenbergh had designed the legendary Dakota apartment building on the Upper West Side, and he would go on to build some of the city's greatest hotels, including the Waldorf and the Plaza, among other landmarks. Decorated with brightly colored stone facades, arches, and balustrades, the buildings he erected for the Rhinelanders looked like dwellings in a fairy-tale village.

Sadly, these storybook houses deteriorated over the years. In 1931, Lexington Avenue was widened, narrowing the sidewalk and forcing the buildings to be stripped of the stairs that led to their parlor-floor entrances. Most of the residences in the row turned into rooming houses and offices, but Andy saw the potential in these

quaint old buildings and claimed one as his home. He moved in and filled four floors with his unusual possessions. One of his favorite pastimes was scouring antique stores and art galleries for new acquisitions. His collection included a variety of penny arcade machines that sprayed perfume, tested strength, and dispensed gumballs; carousel horses; stuffed peacocks; a phrenological head; a giant, somewhat sinister-looking Punch figure; a cigar-store Indian; Tiffany lamps; neoclassical furniture; and the beginnings of an art collection, including a distinctive double portrait of Andy and his friend Ted Carey that had been painted by the artist Fairfield Porter. The friends thought that they could cut the painting in half and have two portraits for the price of one, but Porter, anticipating their plan, placed them so close together that it was impossible to separate them.

The parlor floor, the house's public space, had two rooms—a small one overlooking Lexington Avenue, and a larger, paneled living room in the back. Andy described the rooms as "kind of schizo" because he designated the smaller space for his commercial work, his freelance illustration assignments, while he claimed the bigger room as his art studio and salon, the place where he did his *real* painting. His mother, Julia, and their ever-growing population of cats named Sam were installed in rooms on the street-level floor of the pale blue building, which contained a homey kitchen and an adjacent bedroom. His bedroom, outfitted with a brand-new four-poster bed, was on the third floor, and the other upstairs rooms were used for additional studio space and storage.

Andy's Upper East Side address, shopping sprees, and expanding art collection were proof of his success, but he wasn't satisfied. He still considered himself a work in progress, a man who was going

places but had not yet arrived. When one considers where Andy had started in life, the extent to which he had already transformed himself was nothing short of miraculous.

———

Andy was the youngest son of Julia and her husband, Ondrej Warhola, Eastern European immigrants (specifically, Ruthenians), who came from Miková, a tiny village in the mountains of Slovakia. At the turn of the twentieth century, young Mikovians realized that the only way to move up was to move out. Nineteen-year-old Ondrej did just that in 1906 when, like many of his countrymen, he traveled to America in search of fortune. He worked in Pittsburgh for three years before returning to Miková with his hard-earned bankroll.

Strong, blond, handsome, and prosperous by his village's standards, he attracted the attentions of every mother with a marriageable daughter. But it was seventeen-year-old Julia Zavacky, a golden-haired spitfire, who immediately caught his eye. Smitten, Ondrej proposed, only to be rejected. Unlike many of her contemporaries, Julia was a free spirit who loved to sing and tell stories, and she was not yet ready to become a wife. Knowing that suitable suitors were hard to come by in Slovakian villages, her practical parents pressured Julia into accepting Ondrej's proposal.

The couple soon settled into the grinding routine of village life—work, work, and more work. Three years later, Ondrej came to the sobering realization that there was *still* no future in Miková. In 1912, he returned to America, promising to send for his wife and their infant daughter as soon as he had saved enough money. Nine years passed—years of war, deprivation, and heartbreak for Julia, who lost both her parents and her daughter to illness—before

Deborah Davis

she took matters into her own hands and borrowed the money she needed to join her absent husband.

The Warholas reunited in 1921 and settled in Pittsburgh, a grim, gray, industrial city covered with so much smoke and fog that its inhabitants lived under a cloud of perpetual darkness. They moved into cheap tenement housing with primitive outdoor plumbing, and they struggled to get by on Ondrej's wages. The couple welcomed a son, Paul, in 1922, followed by John in 1925. Paul and John resembled their stalwart father, but Andrej, the Warholas' third son, was like a changeling—one of those enchanted infants from gypsy folklore whom the fairies substituted for a human child when the mother wasn't looking. Baby Andy, who was born on August 6, 1928, was so fair and fragile that he seemed to come from another world. Julia was charmed by her cherubic infant and instantly started spoiling him. Her older boys were born knowing how to take care of themselves and were constantly hatching schemes to make money, whether selling newspapers or delivering ice. Andy, on the other hand, was a delicate, introspective child who needed all the special attention that Julia gladly gave him.

Despite his mother's coddling, Andy learned early that hard work and thrift were the key to survival in Depression-era Pittsburgh. When Ondrej lost his job, forcing him to tighten his already taut belt, the hard times only made him work harder at whatever job he could find, and to save even more of what little he earned. By 1934 he had put aside enough money to buy half of a two-family house on Dawson Street, in the working-class section of Oakland. The Warholas rented their second floor to generate income, but the rest of the small house and yard, including a garden in the

back for Julia, was their palace, an immigrant family's American dream come true.

Although Andy was bright, he was also shy and fearful, and he preferred quiet games with the neighborhood girls to the rough-and-tumble activities his brothers enjoyed with other boys. The children's school, Holmes Elementary, was down the street from their house, so the brothers came home for lunch every day. Julia usually served Campbell's Soup, and tomato was Andy's favorite variety. When not in school, he spent his time drawing, coloring, and cutting out paper dolls. His mother rewarded his best pictures with praise and Hershey bars, promoting an insatiable sweet tooth that would stay with him the rest of his life. Julia thought of herself as an artist, too, and she made colorful floral bouquets out of paper and tin cans that she sold to housewives looking for decorative touches for their modest homes.

The Warholas acknowledged that Andy was spoiled, but no one in the family seemed to mind his favored status. When, at the age of seven, he asked for a movie projector, his brothers were taken aback by the unusual request, but were not at all surprised when their resourceful mother found the money to buy one secondhand. Andy projected cartoons on the wall, turning the modest Dawson Street living room into his own private picture palace.

Watching cartoons at home was no substitute for seeing stars on the big screen, and Saturdays brought happy outings to the local movie theater. It was there that Shirley Temple flashed her dimples and dazzled devoted fans like Andy with her adorable song-and-dance routines. The fabled child star had a lot to sing about in 1936: her movies, including *Bright Eyes, The Little Colonel, Captain January,* and her most recent hit, *The Poor Little Rich Girl,* were so

popular that Twentieth Century Fox was paying her an astonishing $50,000 per film.

As much as Andy enjoyed the star's fanciful movies, he always dreaded the inevitable moment when a father, or some other parental stand-in, would rush in at the end of the film to claim the curly-topped little girl. "It ruined everything," he complained. "I don't want to know who the father is." Even at an early age, Andy preferred fantasy to reality.

Shirley Temple had poise, charm, beauty, talent, celebrity, wealth, and an unlimited variety of happy endings. Of course Andy wanted to be just like her. "Morningstar," "Andy Morningstar"— *that's* what he called himself in his fantasies. He picked the name because it suggested bright beginnings, brilliance, fame. Alas, Andy was stuck with the less glamorous "Warhola," and the decidedly prosaic life that went with it. "Being born is like being kidnapped . . . and sold into slavery," he lamented when he was older.

Andy escaped to the movies most Saturdays, but he spent every Sunday in church. Located in a neighborhood called Ruska Dolina, or the Rusyn Valley, Saint John Chrysostom Byzantine Catholic Church was founded in 1910 by Carpatho-Rusyn immigrants who longed for the religious traditions they practiced in the old country. On Sundays, Julia and Andy rose early and walked a vigorous mile to make the first Mass at 7:00 a.m. They stayed at church the entire day, praying, socializing, and attending two more masses. Andy dutifully sat with his mother, staring at the magnificent iconostasis—a wall of hand-painted icons that had been commissioned for the church's interior.

Painted in vivid gold, blue, red, and other rich colors, the icons were beautiful to look at, but they were meant to be much more than pretty pictures. Icons were "scripture to the illiterate," according to

Saint Gregory the Dialogist, one of the early Roman popes. "What writing presents to readers, this a picture presents to the unlearned," he explained. The images of saints and religious scenes had a visual language all their own—an oversized forehead symbolized wisdom, full lips suggested eloquence, and large ears were the mark of a compassionate listener. The bright gold backgrounds haloing oversized heads indicated divine light, or heaven. Every aspect of an icon, including its color and scale, was infused with meaning and story.

The Warhola routine was interrupted in 1936, when eight-year-old Andy contracted rheumatic fever. It was a common illness in Pittsburgh, especially in the poorer neighborhoods, where children sometimes played near open sewage. But Andy's recovery was unusually slow, and there were complications. His hands shook, his legs were weak, his speech was slurred, and he had difficulty concentrating. Worse still, he couldn't stop fidgeting, and his limbs and torso constantly twitched in every direction. Eventually, the Warholas realized that something was terribly wrong. Only then did their doctor confirm that Andy's rheumatic fever had developed into Sydenham's chorea, a neurological disorder more commonly known as Saint Vitus' Dance, a cruel name for an illness that causes its victims to move in an awkward parody of dancing.

Thomas Sydenham, a famous seventeenth-century physician, first described the disorder in 1686, calling it "a kind of convulsion . . . a constellation of involuntary, purposeless, rapid movements of the limbs; muscular weakness; and emotional lability." Two hundred and fifty years later, the treatment for Saint Vitus' Dance was no more sophisticated than it was in Sydenham's time: patients had to endure a slow recuperation in a quiet environment, more commonly known as "bed rest."

Staying in bed for ten weeks would have been a challenging experience for most eight-year-old boys, but not for Andy. To him, the term "bed rest" sounded luxurious, something that would be prescribed for movie stars, not an ordinary child like Andy Warhola. Julia moved her son's bed into the first-floor dining room, where she and Ondrej normally slept, and showered him with attention, supplying comic books (Popeye and Dick Tracy were his favorites), movie magazines, candy, whatever he wanted. With his brothers' help, Andy wrote to movie stars—Bob Hope, Abbott and Costello, Alice Faye, Carmen Miranda—requesting publicity stills and autographed pictures, which, when received, he carefully pasted into a special scrapbook. Julia also encouraged Andy to do art projects, hoping such activities would help improve his motor skills.

Eventually Andy recovered, but he had been transformed by his illness. He seemed even paler and more fragile than before, and the rashes that accompanied Sydenham's chorea affected his fair skin, which became so blotchy and irregular as he matured that the neighborhood children called him "Andy the Red-Nosed Warhola." There were other changes, too. Andy had gone Hollywood during his "intermission." He was starstruck by the celebrity stories he had read in all those movie magazines, and the photographs he collected, including a signed, tinted headshot of Shirley Temple (dedicated sweetly, if incorrectly, to "Andrew Worhola"), were his prized possessions.

Post bed rest, Andy enjoyed drawing more than ever. Eventually, one of his teachers recognized that the odd little boy had real talent and arranged for him to attend free art classes at the Carnegie Museum on Saturday mornings. Although the museum was only a mile or so from Andy's house, it stood at the center of a completely different world from the working-class one he occupied. That part

of Oakland, nicknamed "the city beautiful," was Pittsburgh's show-place and cultural center, as well as a playground for its privileged millionaires.

Every Saturday, Andy went to the museum to study art with his fellow Tam O'Shanters, the name given to the group to honor its late Scottish American benefactor, the millionaire philanthro-pist Andrew Carnegie. He was envious of the pampered rich students who arrived at school in limousines—fancy Packards and Pierce-Arrows. Yet when class started, talent was the great equalizer, and Andy quickly proved that he was "more equal" than the other students. The instructor, Joseph Fitzpatrick, called his work "individual and unique," and he frequently held it up for the other students to admire. Even Ondrej recognized that his youngest son was a promising artist who was not destined to remain on Dawson Street. He planned accordingly, secretly putting aside money to fulfill another immigrant dream: Andy would be the first member of the Warhola family to go to college.

Ondrej did not live long enough to see that dream come true. He became ill, possibly from a liver infection, and when he knew he was dying, he told Paul and John about Andy's college fund. It was understood that the older boys would take care of their gifted younger brother. Ondrej passed away in 1942, and two years later, the family faced another crisis when Julia was diagnosed with colon cancer. She underwent a colostomy, recovered, and continued to look after her three industrious sons. Paul and John went to work so they could support the family, while Andy raced through high school and finished in three years. Upon graduation, he announced that he would use his father's savings to study commercial art at the Carnegie Institute of Technology.

———

Commercial art is what got Andy his townhouse on New York's Carnegie Hill, just blocks from where Pittsburgh's own Andrew Carnegie once had a Manhattan mansion and estate. Andy was proud of his accomplishments, observing, "Uptown is for people who have already done something." But, he added wistfully, "Downtown is where they're doing something now." In 1960, that downtown New York art scene was exploding with daring new talent. The Abstract Expressionists had stirred the pot by shunning traditional painting and turning their canvases into emotionally charged nonrepresentational performance pieces. But the next generation of revolutionary artists now declared their independence by embracing the concept of the "concept." Like modern Columbuses, they set out to chart a new course, to prove that art didn't have to be flat, or serious, or even important. While Andy was safely tucked away in his private house in Carnegie Hill, these upstarts were downtown, scattered throughout New York's fringe neighborhoods such as Coenties Slip in Lower Manhattan, the Lower East Side, the East Village, and SoHo. Rents were cheap, spaces were large, and if an area was dangerous at night, it was a small (and unavoidable) price to pay for producing exciting art in stimulating surroundings.

Thirty-one-year-old Claes Oldenburg was downtown doing something very "now" in his apartment-studio on East Fourth Street. Born in Stockholm, raised in Chicago, and educated at Yale and the School of the Art Institute of Chicago, Oldenburg aspired to be a painter, but when he moved to New York in 1956 he grew "just a little tired of four sides and a flat face." He wanted to liberate his work from the constraints of the past. "I am for art that does

something other than sit on its ass in a museum," he said. "I am for art that grows up not knowing it is art at all." To this end, Oldenburg started using cast-off materials from the city streets—pieces of wood, burlap garbage bags, newspapers, and anything else he could find—to create experimental constructions that expressed the essence and energy of the urban landscape.

He did acknowledge that there was also a less conceptual reason for foraging. Oldenburg was the classic starving artist; he worked part-time at the Cooper Union Museum for the Arts of Decoration and, consequently, was unable to afford materials. When times were good, he and his soon to be wife, the beautiful and high-spirited artist Patty Muschinski celebrated with pork chops and beer. On other occasions, they went to bed with growling stomachs.

In January 1960, Oldenburg and Jim Dine, a fellow downtown artist, created a double installation called *The Ray Gun Show* at the Judson Gallery, which was located in the Judson Memorial Church on Washington Square South, a classically beautiful house of worship designed by the architect Stanford White in 1893. But as New York's aristocracy moved uptown, the venerable old church became less social and more socially conscious, offering medical assistance and shelter to its low-income congregation, veterans, and the homeless. In the 1950s, while promoting civil rights and freedom of expression, the Judson invited local artists, including Oldenburg and Dine, to display their work in its galleries without fear of censorship. The artists were encouraged to do *anything*, and they generally did.

The *Ray Gun Show* featured two experimental environments: Oldenburg's *The Street*, which consisted of oversized burlap figures and cardboard constructions, and Dine's companion piece, *The*

Deborah Davis

House, a chaotic assemblage of paint cloths, bedsprings, signs with quotidian messages such as "Breakfast is ready," and floating body parts—a new take on domestic bliss.

If these disjointed images weren't shocking enough, visitors were welcome to come to the Judson to attend the artists' performance pieces, known as "Happenings." The new artists saw a fluid line between art and reality, and wanted the viewer to step into the art. Furthermore, they questioned why an artist had to work in one particular medium. According to Allan Kaprow, who staged the first Happening, "the young artist of today need no longer say 'I am a painter,' or a 'poet,' or a 'dancer.' He is simply an 'artist.'"

Happenings set out to prove that the new aesthetic landscape had no boundaries. Artist and audience were liberated from their defined roles. These events were spontaneous, to an extent. But Oldenburg actually wrote scripts, recruited a cast, rehearsed, and provided lighting notes (although "lighting" could mean a friend flipping a switch on and off) for his *Ray Gun* performances. Patty made the costumes. The stage directions were casual, such as "man looks in hand mirror," or "woman salutes," and characters performed in disjointed set pieces that resembled scenes from silent movies. The old-fashioned concept of story was replaced by a "spirit of exploration and experiment," which meant that everything happened all at once. There were real ideas behind the action, even if they were not always apparent. From the audience's point of view, attending a Happening was like being at the center of a bizarre *tableau vivant* where anything could happen.

Inspired by these experimental mavericks and the recent success of the up-and-coming artists Jasper Johns and Robert Rauschenberg, Andy wanted to return to his fine art roots and spend more

time painting. His friend Emile de Antonio, an oversized and out-spoken man who knew *everybody* in the art world, gave him the push he needed. "De," as he was called, often stopped by Andy's place at the end of the day for a generous serving of Scotch and conversation. He was a great raconteur, conversant in all the arts, including filmmaking (he would, in fact, become an acclaimed doc-umentarian), a great womanizer (much married and divorced), and überintellectual. He also loved to gossip. On one occasion when De was holding forth about his friends "Jap" and "Bob"—offering the kind of insider information Andy loved to hear about Johns and Rauschenberg—he stopped to say, "I don't know why you don't become a painter, Andy—you've got more ideas than any-body around." This is exactly what Andy was thinking: *I should be painting.* The question was, *what* should he be painting?

Andy had faced the same challenge several years earlier, when he was starting out as an art student at Carnegie Tech. Pittsburgh was considered an important city for art because of the Interna-tional, an exhibition founded and funded by steel magnate Andrew Carnegie, who, unlike his fellow robber barons, had no interest in acquiring an elitist personal art collection. Instead, he endowed his namesake institution with one million dollars to mount an annual salon dedicated to the works of living artists from around the globe. Over the years, painters as illustrious as Henri Matisse were de-lighted to participate because Carnegie had thoughtfully included a sizable cash prize for the winner of the annual competition.

In 1940, when World War II made it difficult to import submis-sions from overseas, the show was renamed "Painting in the United States" and featured the works of such American artists as Ben Shahn, Paul Cadmus, and Edward Hopper. This annual, encyclo-

pedic who's who of contemporary art provided Carnegie Tech students with privileged access to an extraordinary array of talent, and it was just one of the reasons why top-notch art teachers such as Balcomb Greene, Robert Lepper, and Sam Rosenberg, among others, were attracted to the city.

These gentlemen may not have been household names, but they were all distinguished working artists, as well as demanding professors of aesthetics, art history, and philosophy. The Art Department at Carnegie Tech had very high standards. At seventeen, Andy was imaginative, but he was not a consistent student, and art school presented him with a number of challenging firsts. A classmate, Bennard Pearlman, recalled the look on Andy's face the first time he laid eyes on a nude female model. "Poor Andy," he said. "He appeared to grow pale and a coed whose easel was adjacent to his thought he was about to faint." The coursework was difficult and the textbooks advanced, and Andy found himself struggling to keep up with classes like Thought and Expression that involved extensive reading and writing. According to Gretchen Schmertz, a fellow student, Andy "could barely write a sentence." Nor could he speak in public—Pearlman said it was actually painful to watch Andy try to answer a question because he strained for every word.

Then there was the problem of settling on a style. Art students were expected to express themselves in a distinct and personal way, but Andy was confused. Which way was *his* way? Should he be a realist? Should he turn to the past for inspiration, or try to create something new? The art world was such a free-for-all that even established artists—Balcomb Greene, for example, who started out painting abstract works, but later turned to landscapes and figures—switched styles midcareer.

The Trip

By the end of Andy's freshman year, several of his professors were not convinced he had the talent—or the dedication—to make it through the program. "If anyone had asked me at the time who was the least likely to succeed, I would have said Andy Warhola," observed Robert Lepper, one of his teachers. And Lepper had actually *liked* Andy's work. Russell "Papa" Hyde, who was sympathetic to Andy's situation, sensed that he needed time to mature and decided to give him another chance. Professor Samuel Rosenberg agreed, and advised Andy to attend summer school to offset the Cs and Ds on his report card. Barring a miraculous makeover, his future at Carnegie was in serious jeopardy, Andy tearfully admitted to his brothers. He immediately followed Rosenberg's advice and signed up to repeat the class he had failed.

Andy also had a job that summer. His enterprising brother Paul was working as a huckster, selling vegetables from the back of a flatbed truck, and Andy reluctantly served as his helper. They drove through Pittsburgh in the sweltering heat, catering to finicky housewives who bargained for produce. Andy hated the job so much that he passed the time by sketching. Papa Hyde, who ended up being one of his professors at summer school, urged him to carry a sketchbook everywhere and to stop trying so hard to please his teachers. "You do it the way you see it . . . to please yourself," he insisted, "and if you don't do it, you'll never amount to a damn."

Determined to take more chances, Andy looked closely at Paul's customers and captured what he saw in a series of hyper-realistic, quickly executed, *premier coup* (at first touch), drawings. His penetrating eye saw through his subjects right to their very souls, and he suggested with a few deft strokes of his pen that they were as worn and as colorless as their shapeless clothes. Andy was so pleased with

his work that he entered his drawings in a local contest at the end of the summer. He won a coveted forty-dollar prize *and* the admiration of the very teachers who had previously doubted his ability.

"Artist Huckster Sketches Customers and Wins Prize," the *Pittsburgh Press* reported in an interview with the young artist, praising his "series of pen-and-ink sketches that show the vagaries of everything from the idle rich to the scrambling poor." Andy wittily compared the harried mothers who congregated around his truck to the old woman who lived in a shoe, women who, like their nursery rhyme counterpart, had "so many children they didn't know what to do." And, while he disdained the "new rich," the pompous ladies who treated him like a servant to impress their friends, he assured the reporter that he was very impressed by the graciousness of the *real* rich. "Silver-apron families asked less in the way of service than even the poor," he pointed out knowingly, as if he had vast experience with Pittsburgh high society. The article—and the accompanying photo of a proud Andy—was his first taste of fame.

When school resumed, there was no longer any question that Andrew Warhola had talent. No one had to tell him to take chances: being edgy and a little "off" came naturally to him now. In fact, he had an expression for his skewed, very "Andy" way of doing things. He called it being "exactly wrong." "I like to be the right thing in the wrong place, or the wrong thing in the right place," he would say. Professors and classmates alike were impressed by his unique way of handling assignments. "He had a stylistic integrity about his work . . . Andy always drew in a way that you knew was his," praised a fellow student, George Klauber. Andy was perfecting a technique that would come to be known as "blotted line," whereby he created an ink drawing, blotted it, and used the mirror image.

The Carnegie campus was transformed in 1946 by an influx of veterans enjoying the benefits of the Servicemen's Readjustment Act, commonly known as the GI Bill. That fall, Andy befriended a talented veteran and fellow Pittsburgh native named Philip Pearlstein. Their paths had almost crossed in the 1930s when Pearlstein studied with the Tam O'Shanters at Carnegie's Saturday-morning art program. He had started at Carnegie Tech in 1942 and left when he was drafted, but he was nonetheless a bit of a local celebrity because his work had been featured in *Life* magazine.

Andy still lived at home, but the house on Dawson Street was crowded with his brothers, their wives, and their growing families, so he preferred to spend most of his time on campus. Carnegie Tech was both an escape and a rich cultural environment. In addition to studying great art at the museum, Andy was able to see avant-garde films imported from New York's Museum of Modern Art and attend performances and lectures by such contemporary artists as Martha Graham, John Cage, Marcel Duchamp, and Joseph Cornell.

Andy was still unusually pale and a little awkward, but he was also fresh, fun, and offbeat enough to be considered "interesting" instead of odd. He and his circle enjoyed such a strong sense of camaraderie that one idyllic summer they pooled their money and rented a nearby carriage house to use as a studio. They painted, argued about art, and created a vital creative community for themselves. It was Andy's first, intoxicating taste of *la vie de bohème*, and he loved it.

School was exciting and enlightening, but Andy found *true* inspiration in—of all places—Pittsburgh's leading department store. It was time for postwar America to start shopping again, and Larry Vollmer, the talented head of display at downtown's prestigious

Joseph Horne, was just the man to convince the city's fashionable matrons to go on a spending spree. To lure customers into the store, Vollmer wisely hired a Carnegie Tech art student—namely, Andy—to help him come up with eye-catching windows. "When you think of it, department stores are kind of like museums," Andy once said.

In addition to dazzling Andy with stories about his adventures in the big city (including working with the great Surrealist artist Salvador Dalí on a controversial window display), Vollmer introduced him to fashion magazines. One of Andy's assignments was to read *Vogue* and *Harper's Bazaar,* as well as international fashion periodicals, to find design concepts for Horne's windows. As he worked his way through stacks of gorgeous high-end glossies, Andy discovered that every issue was full of treasure, offering fascinating information about fashion, celebrity, high society, art, literature, and popular culture. Whether he was reading about upcoming exhibitions by the artists Paul Klee, Joan Miró, and Alexander Calder, or learning how to pack for a summer weekend in Newport, Southampton, or Maine, Andy was becoming more sophisticated—*so* sophisticated that he spent a weekend in New York City, sightseeing and visiting museums with Philip Pearlstein.

As Andy became more confident, he developed a high opinion of his own "oeuvre." At the end of the year, when art students cleaned out their desks and portfolios, they generally gave their work to other students who expressed interest. Not Andy. He wanted top dollar for his creations and refused to part with anything if the price wasn't right. "He *was* a kind of genius," Pearlstein said. "Like an angel in the sky at the beginning of his college times." Jack Smith, another veteran attending Carnegie on the GI Bill, described Andy

as "the damndest mixture of the six-year-old child" with "all the skills of a well-trained artist." And, he added, "He puts them both together with *totally no* inhibitions."

The most vivid example of Andy's newfound confidence was his senior-year painting, *The Broad Gave Me My Face, But I Can Pick My Own Nose*, which depicts a young boy with his finger thrust deeply and unashamedly up his nostril. Aficionados of the work may have called it bold and expressionistic, but most of the judges at the 1949 Pittsburgh Associated Artists exhibition deemed "Nosepicker" an insult, and refused to hang it in the show. It was arrogant of him, they thought, to paint such an overtly rude gesture and call it art.

Yes, but in a funny way, the work was a fitting commencement piece, somehow conveying the idea that any boy could do as he pleased—pick his own nose, or his own life. In this spirit, Andy realized that while he could stay in Pittsburgh and settle into a predictable career of teaching art at a public school, he also could try something different. He couldn't stop thinking about the glamorous world of New York, and Philip Pearlstein thought they should pack up their portfolios and take their chances in the big city. He suggested they go together right after graduation.

Andy was apprehensive about leaving his mother, his brothers, and everything that was familiar, and Julia was reluctant to let him go. But Dawson Street had become small and confining and presented limited opportunities. Like his father before him, Andy decided that the only way to move up was to move out. It was time to leave Pittsburgh—his own version of Miková—to seek his fortune in a new world.

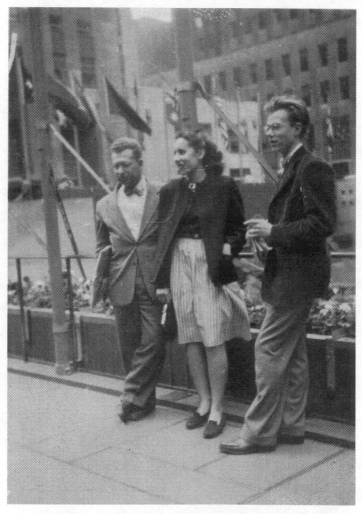

During a trip to New York City in 1948, Andy (*right*)
and his art school classmates Philip Pearlstein and
Joan Kramer visited Rockefeller Center.

Chapter 2

They always say that time changes things, but
you actually have to change them yourself.
— Andy Warhol

At the end of June, during a scorching heat wave, Andy and Pearlstein sublet a small sixth-floor walk-up in the East Village—a classic artist's garret with the bathtub in the kitchen. Mindful of their small savings accounts, they immediately started looking for work. Using the telephone directory as his guide, Andy made the rounds of magazine offices, hoping to persuade a friendly art director to look at his portfolio. One lucky day he dropped in at *Glamour* magazine. Andy was familiar with the *Glamour* of the 1930s and 1940s, when it was a fan magazine promoting "the Hollywood way to fashion, beauty, and charm." However, the new *Glamour* was designed to appeal to the postwar career girl, and Tina Fredericks, its art editor, understood her readers because she was young, ambitious, and accomplished, just like them.

Fredericks agreed to see Andy the day he stopped by, and she was so impressed by his work that she bought his whimsical blotted line drawing of an orchestra (signed *Andre* Warhola) for her personal collection. "His ink lines were electrifying," she said. "They

grabbed at you with their spontaneous intensity." Fredericks also hired him on the spot to draw shoe illustrations for an upcoming article. When Andy completed that job quickly, imaginatively, and professionally, she put him into her regular rotation.

His next *Glamour* assignment was particularly meaningful to him. Fredericks gave Andy the text for a series of articles with the umbrella title "What Is Success?" and asked him to come up with a concept to illustrate several pieces, including "Success Is a Working Marriage," "Success Is a Career at Home," and "Success Is a Job in New York." In the "Success Is a Job" installment, a small-town girl from Terre Haute, Indiana, writes about the secure, if "placid," life she gave up when she left home to pursue her dream of working in New York City. She describes the "you don't love us anymore" look in her family's eyes, the "excitement of New York job-hunting," and the elation of knowing that "I'd come to the Big City and landed a job—on my own."

In essence, this was *Andy's* story, and he knew exactly what to do with it. He sketched a fashionable, self-possessed woman sitting on the top rung of a ladder, with New York City at her feet. That was how he felt about his own promising new situation; minus the skirt, *he* was that figure on top of the world. Andy commemorated his magazine debut with a new name—simply Warhol. The final "A," a reminder of his Pittsburgh past, was gone.

In August, Andy and Pearlstein exited their hot little sublet, found space in a loft on West Twenty-First, and announced to their families and friends that they "had moved from one roach-ridden apartment to another." Their new landlady was Franziska Boas, a pioneering modern dance teacher who was the daughter of Franz

Boas, a famous academic who was considered the father of modern anthropology. She and her roommate conducted classes and held performances in one part of the loft, while her tenants, Andy and Pearlstein, occupied the other.

Unlike Pearlstein, who worked as a draftsman during the day so he could pay his rent and concentrate on his "real" painting at night, Andy made no distinction between his art and the commercial jobs he landed. *Everything* was art to him, and he was genuinely enthusiastic about doing his assignments. In true bohemian fashion, the roommates worked late into the evening, listening to music by Bartók, Mahler, and Stravinsky, and recordings of Edith Sitwell reciting poetry.

Even though Andy said he was lonely during his first months in New York, and claimed he often turned to the ubiquitous cockroaches for company, he and Pearlstein actually had a robust social life. They visited museums and galleries and went to see second-run movies in Times Square. Occasionally they even splurged on standing-room tickets for hit Broadway shows, such as *Death of a Salesman* and *Member of the Wedding*.

Andy also spent time with Franziska, whose pedigree and reputation for being a revolutionary force in the dance world made her somewhat of a celebrity. Her specialty was dance therapy, a way of using movement to improve both body and mind. Andy was flattered when she paid attention to him and urged him to "open himself up" emotionally. According to Pearlstein, with Franziska as his guide, Andy Warhola looked inward and "slowly metamorphosed into Andy Warhol."

For Andy, an important part of that metamorphosis involved a

dramatic change in his image. When he first arrived in New York, he dressed in a heavy white corduroy suit. Buttoned up and bow-tied, Andy looked like every other man in 1949: colorless, conformist, and completely without style in his baggy clothes and bulky shoes. If retailers had their way, 1950 was going to be the year that revolutionized the way these dowdy men dressed. They launched expensive—and extremely effective—advertising campaigns to convince gentlemen to purchase head-to-toe replacements for their outdated wardrobes—a new look for the new man.

Sensing that conformity would get him nowhere, Andy had something completely different in mind for his own new look and decided to dress down at the very moment most men felt compelled to dress up. He retired his suit, dug out his most rumpled chinos, slipped on old, worn shoes, and went out into the business world as his unique, scruffy self. For a finishing touch, he left his conventional portfolio at home and carried his artwork in a brown paper supermarket bag. Andy cultivated a look that was so disheveled, so vulnerable, so almost-homeless, that he made it seem as if his very existence depended on landing his next job. It was a look guaranteed to attract attention and assignments.

Also by design, Andy's behavior was as eccentric as his appearance. He was a naïf, a waif, and a kook . . . and some of his patter was pure hokum. "Hello," he'd say to a receptionist or an art editor who happened to answer the phone. "I just planted some birdseed in the park. Would you like to order a bird?" He carried a bouquet of fresh flowers and, Chaplin-like, handed out blossoms to delighted secretaries. His humor was odd, but it made people stop and smile.

Pursuing one job, Andy scrawled a childish note to Russell Lynes, an editor at *Harper's*. "Hello Mr. Lynes" he wrote in the crude speech bubble attached to one of his quirky blotted-line drawings of a face—*his* face. "My life couldn't fill a penny postcard . . . I graduated from Carnegie Tech now I'm in NY city moving from one roach infested apartment to another." Signed, Andy Warhol. The drawing, which conveyed technique, personality, wit, and *need*, stood out from the slick résumés submitted by more-conventional applicants. His bemused clients called him "Raggedy Andy," and "Andy Paper Bag" behind his back, but at least they called him, and he started getting regular assignments.

Several months into his New York adventure, Franziska Boas lost her lease, so Andy moved uptown to a basement apartment on Manhattan Avenue in Harlem. He shared the place with an astonishing number of roommates—seventeen in the space of a few months—most of whom were young, aspiring dancers. Like Andy, they were on their own in the big city, working all hours at odd jobs and sleeping in shifts in dormitory-like bedrooms divided between the boys and the girls. Life was chaotic, but fun. The roommates pooled their money for expenses, fought over the last slice of salami, and went out in a pack to watch their favorite actress, Judy Garland, in her new movie, *Summer Stock*. The girls worried about Andy because he seemed so helpless and so preoccupied with work. They made sure that he ate regularly, knowing he would be just as happy to subsist on candy and other sweets.

Eventually, the group disbanded, leaving Andy holding the bag for a large telephone bill. He stayed with a few friends before renting a dilapidated apartment on East Seventy-Fifth Street, and

as long as he had a drafting table and a mattress on the floor, he was oblivious to his shabby surroundings. And he wasn't lonely, since he'd purchased his first television—a 19-inch RCA black-and-white model—that became his constant companion whenever he was home. Understandably, his mother was concerned about her youngest son's ragged clothes and poor eating habits—all signs, she thought, of the lack of a woman's touch in his life. Julia made regular visits to New York so she could scrub and cook for Andy, but the rest of the time, she sat in Pittsburgh, worrying.

"Enough of that!" Julia decided in 1952. Until the right girl came along, *she* would be the woman in Andy's life. She impulsively sold the Dawson Street house, said good-bye to her family and friends, and showed up on Andy's doorstep, ready to get to work. In no time, Julia settled into a familiar routine. She rose at dawn, donned her housedress and babushka, and cleaned, shopped, prepared meals, and attended Mass. Matriarch, housekeeper, and muse all rolled into one, Julia dedicated herself to taking care of her "boy," as she had done his entire life.

Now that Julia was a New Yorker, Andy's brothers, Paul and John, and their young families were frequent visitors to the city. During one of their trips, Andy decided that it was time for him to learn to drive. Paul positioned him behind the wheel of his car, sat close by in the passenger's seat, and instructed him to pull away from the curb and head into traffic. Somewhere along Park Avenue, Andy panicked and crashed into the side of a taxi. He complained that Paul should have stopped the car, not understanding that there was only one set of brakes and that it was on *his* side of the vehicle. Paul, who was experienced in these matters, quickly paid the taxi

driver some cash for the necessary repairs, and Andy abandoned his ambition to get a license.

Andy joked about his mother's ongoing presence in his bachelor flat, saying that she could stay "until he got a burglar alarm," but it was both comforting and practical to have her around. Julia was good company, a born storyteller, a hard worker, and she happily took over the day-to-day responsibilities that Andy preferred to ignore. Like a gentleman with live-in help, he was free to concentrate on his work and social life, although the latter was not something he necessarily wanted to share with his mother. The concept of "coming out" had not yet come out, so Julia was oblivious to the fact that her "boy" was discovering that he preferred the company of other boys.

Not that Andy had much to hide from his mother when they started living together. Young New York professionals like Andy, whether heterosexual or homosexual, were not sexually liberated in the early 1950s. "New York life was heavy with romance and light on sex," observed the fifties memoirist Dan Wakefield. The twenty-somethings who flocked to the city were young, even naive, for their age and were likely to refer to themselves as "boys," "girls," and "kids" until they were thirty. In Wakefield's circle, they enjoyed innocent gatherings, like coed pajama parties. Adult sex was still a mystery, and an "atmosphere of romantic innocence prevailed," probably because of misinformation, inexperience, and the fear of what would happen (pregnancy, disease, maybe worse) for those who went "all the way" without the benefit of marriage.

At twenty-four, Andy was an innocent, indulging in crushes, but not much else. Truman Capote, the bestselling author of *Other*

Voices, Other Rooms, was a romantic obsession, and Andy was thrilled to live in the same city as his idol. He wrote to him regularly, sometimes enclosing little drawings with his letters, although Capote never answered. Then Andy started loitering outside Capote's Park Avenue apartment building, hoping to run into him. One day Andy recognized Nina Capote, the writer's mother, and struck up a conversation. She invited him upstairs, and Capote came home to find this odd young man sitting on his couch, chatting with Nina as if they were old friends. "He seemed one of those hopeless people that you just know nothing's ever going to happen to . . . the loneliest, most friendless person I'd ever seen in my life," Capote later recalled.

Andy was so encouraged by their encounter that he imagined a friendship and started calling the apartment daily . . . until Nina, who had a drinking problem and suffered terrible mood swings, answered the phone in a rage and ordered him to "stop bothering Truman." Andy backed off, but continued working on his illustrations of Capote's fiction, which he exhibited at the Hugo Gallery. *Andy Warhol: Fifteen Drawings Based on the Writings of Truman Capote* was Andy's first show. The reviews were tepid. "The work has an air of preciosity, of carefully studied perversity," one critic wrote, and no one bought anything. Most disappointing to Andy, his artistic offerings failed to spark a relationship with Capote.

There wasn't much time to brood over unrequited love, because work was coming in at a rapid pace. All the top magazines, including *Vogue* and *Harper's Bazaar,* wanted Andy, and he was equally popular with the art directors at publishing houses, department stores, and advertising agencies. He illustrated books, record albums, promotional materials, fashion ads and editorials, even place mats for

the Bird Cage restaurant at Lord & Taylor, one of the city's hottest lunch spots.

For the first time, Andy had a regular income, and a sizable one at that, which prompted him to move to a nicer and more spacious floor-through apartment on Lexington Avenue at Thirty-Third Street. Andy and his mother shared a barely furnished bedroom, while the rest of the place was stuffed with art supplies; piles of shoes, handbags, and other items he was hired to draw; collectables; and an ever-expanding population of Siamese cats, most of whom were called Sam. It was a colorfully chaotic home, with the television blasting in the background, the cats misbehaving, Julia being her cheerful and chatty self, and, at its center, Andy working—always on one deadline or another. Eventually he had to hire an assistant to help keep up with the work flow, and the apartment he shared with Julia became a factory of sorts. He even put his mother to work, as her distinctive, loopy penmanship was often the perfect accompaniment to his whimsical drawings.

Andy continued to present his raggedy persona to his business associates, but as he became more desirous of a social life, he felt increasingly self-conscious about his looks. His skin was pale and blotchy, his eyes were weak and required special glasses that were beyond geeky, his nose was bulbous, and his hair was thinning to such an alarming degree that he wore a hat most of the time to conceal his baldness. Andy expressed his insecurities about his appearance by altering a photograph that was taken of him looking into a mirror. Using a pencil, he sculpted his features into a finely chiseled nose and a taut, graceful chin, creating the glamorous profile of a Hollywood star. The mirror image, however, revealed the real Andy, with his glasses perched on his oversized nose.

Andy may not have been one of the "pretties," as he called the beautiful young men who were omnipresent in New York's artistic circles, but he was happy to discover that his physical shortcomings did not prevent him from attracting one, a smart young "pretty" named Carlton Willers. They met in the photo archives department at the New York Public Library, where the handsome art history student worked for the curator. Andy came in all the time to research images for his blotted line drawings, so there were many opportunities for the two to speak. Gradually, they struck up a friendship.

Willers immediately recognized that Andy was a person with "an innate sense of style and taste" who was masquerading as a frump. He wanted to be "like a prince who could afford expensive shoes but couldn't care less and treated them as worthless." To this end, Andy actually took good shoes and deliberately distressed them with everything from paint to cat urine to achieve a fine old patina. Then, when they looked properly beaten and broken, he wore them.

Willers understood the "Raggedy Andy" strategy, but he objected to the hat, and suggested that Andy think about getting a wig. At the age of twenty-five, Andy did just that, covering his balding head with a brown and gray hairpiece that, like so many "rugs," was supposed to look realistic but didn't. There was something off (but not "off" enough) about his appearance when he wore it, Andy decided, so he switched to a silvery white toupee that was "exactly wrong." No one would ever mistake it for the real thing.

The new-and-improved Andy had exciting prospects professionally and socially and, just like Cinderella, his transformation began with a shoe. In 1955, I. Miller, a prestigious shoe company,

hired Andy to create illustrations for their weekly *New York Times* advertisements. This was a very good moment to be a commercial artist. While aspiring painters tried futilely to find galleries and struggled to support themselves with menial day jobs, more open-minded creative types—both writers and artists—flocked to the more welcoming (and more remunerative) world of advertising. Since Andy's move to New York in 1949, advertising spending had jumped from $5 billion a year to a record $9 billion. America had more products and services to offer than ever before, and modern transportation systems made it fast and easy to make these products available throughout the country. Advertisers could take advantage of radio and fast-growing forms of new media, including television. And, just to make sure they were advertising in the right place, and to the right markets, ad agencies could substantiate their decisions with market research. Peacetime Americans had money to burn, and they depended on the "Mad Men" of Madison Avenue to tell them how to spend it.

The new, midcentury approach to advertising had started to emphasize nonconformity, humor, personality, even satire. I. Miller came to Andy for those very reasons: the company wanted its shoes to stand apart from conventional accessories, and Andy's finely and whimsically wrought drawings were anything but conventional. He treated shoes as if they had personalities: some were quiet and discreet, while others were loud and flamboyant. There were even instances when Andy emphasized only the heel, or the toe, instead of showing the whole shoe—which was an unusual approach to selling merchandise. His eye-catching drawings, accompanied by the name "Warhol," were exhibited on prime pages in the *New York Times* each week, winning customers for I. Miller and fans for Andy.

As his income and reputation grew, the naïf "Raggedy Andy" evolved into a sophisticate, and it was partly because of his friendship with a handsome and cultured set designer named Charles Lisanby. When they met in 1955, Andy was charmed by Lisanby's Southern gentleman demeanor and impressed by his connections in the theater world. Lisanby actually knew celebrities like the English photographer and designer Cecil Beaton, a luminary right up there with Truman Capote in Andy's mind.

Andy wanted to fit in with tastemakers such as Beaton, so he eagerly played Galatea to Lisanby's Pygmalion, investing in custom suits and cultivating a more dandified appearance. He started working out at a gym to build up his body and tried to minimize his bulbous nose and enlarged pores by submitting to a radical new dermatological procedure that involved spraying the skin with a freezing agent and "planing" it with a high-speed wire brush. The treatment was painful, the recovery was long, and, unfortunately, the results were disappointing. Andy still looked like Andy, but in better clothes.

Andy's self-improvement regime included another attempt at learning how to drive. In 1956, he obtained a new driving manual from the Automobile Association of America, studied it, and paid for road lessons for himself and Lisanby. But driving a car in New York City traffic still proved an insurmountable challenge for Andy, so he gave up on getting a license and resigned himself to being a perpetual passenger.

Andy's I. Miller shoe advertisements were his chief calling card, but he continued working in a variety of mediums, whether doing illustrations for high-end magazines or dressing windows for Gene

Moore, the legendary designer responsible for displays at Bonwit Teller and Tiffany's. Moore considered store windows a form of theater, and he paid close attention to story, scale, lighting, and drama. Whether the merchandise was a couture dress or a fabulously expensive diamond, Moore believed it had to be displayed in an imaginative environment, and the best way to create an artistic window was to hire an artist. Moore mined New York City's population of aspiring and out-of-work artists for his most creative window dressers.

Two of his "regulars" were Jasper Johns and Robert Rauschenberg. Like Andy, each was a young man who had moved to New York City (from South Carolina and North Carolina respectively) to break into the art world. At the moment, they were unknowns who aspired to be *real* painters, and as long as success eluded them (they couldn't afford the kind of apartment that had a bathtub), they took on odd jobs. Johns worked at a bookshop, while Rauschenberg was a janitor at an art gallery. Dressing windows was a more artistic way to survive. They used the pseudonym "Matson Jones" for their commercial, pay-the-rent job.

"I'd tell them what I wanted, and they'd go off and make it," said Moore admiringly, recalling a memorable window at Tiffany's that showed a diamond necklace stretched across a moody dessert landscape, waiting for a speeding car to run it over. De Beers actually objected to having their precious diamonds displayed in dirt, but Matson Jones's high-concept windows won raves from customers and columnists. Ironically, the formalistic "still lifes" and brooding "landscapes" Johns and Rauschenberg created for Tiffany's *were* works of art, even if the artists themselves considered them less significant.

Unlike Matson Jones, Andy enthusiastically embraced the art of window displays—and any other commercial assignments that came his way. He filled two Bonwit Teller windows with etchings of flowers, figures, and accessories to suggest the exuberant essence of a luxury perfume. On another occasion, he built a picket fence and covered it with fashionable graffiti.

As much as Andy enjoyed his work and the money it generated, he longed for recognition from an art gallery, especially after his old friend Philip Pearlstein showed his landscapes at the Tanager, a respected New York venue, in 1955. Poor Andy couldn't persuade an important gallery to take his drawings of cherubs and shoes seriously. And when he managed to exhibit them at fringe galleries such as the Bodley, or the Loft (a collective of illustrators), critics were likely to minimize his achievements, dismissing them as "clever frivolity," "odd elegance," or "sly."

It was difficult for any aspiring artist—not just Andy—to make a name for himself in the art world at the time because of the giant, lingering shadow cast by the Abstract Expressionists, the "action" painters who were New York's reigning talents. Everything about this male-dominated group was large, from their oversized canvases—so big that no easel could contain them—to their personalities and, in most cases, their enormous egos. Jackson Pollock, nicknamed "Jack the Dripper" by the press because of his revolutionary drip-paint-on-the-canvas technique, was the T-shirted, leather-clad, motorcycle-driving leader of the pack. In 1949, *Life* magazine featured a multipage spread about him, posing the question, "Is he the greatest living painter in the United States?"

Andy was the polar opposite of Pollock. Kooky, not crazy;

coy, not controversial; and the man *least* likely to get drunk, start a fistfight, or chase women, all of which seemed to be prerequisites for anyone who wanted to penetrate the inner circle of star artists. Andy was the master of the small gesture—the novel blotted line, the arch flourish, the knowing, double-entendre of a detail—and as an *advertising* artist, he was in a different, some would say lesser, category.

One place where Andy's drawings were prominently displayed and enthusiastically embraced was Serendipity 3, a chic little café on Manhattan's Upper East Side. Owned by three former window dressers with a flair for design, Serendipity 3 cleverly used freshly whitewashed walls and salvaged Tiffany lamp shades to brighten its tiny basement location, the backdrop for a menu of tempting desserts. The owners also added a carefully curated boutique of whimsical decorative items, enabling patrons to satisfy a sweet tooth and a shopping urge at the same time.

Andy, who never outgrew his passion for sweets, enjoyed popping in for a sundae or a piece of cake at the end of the day. On one occasion, he lamented to one of the owners, Stephen Bruce, that some of his best drawings had been overlooked when I. Miller selected shoes for the weekly *New York Times* ad. Bruce suggested framing the "rejects" and selling them in the Serendipity boutique. Andy agreed, and his colorful shoe portraits were in constant demand.

Andy enjoyed the steady income that commercial work brought him, and the man-about-town lifestyle that came with it. He was making enough money—as much as $70,000 a year (over $450,000 today)—to pay for fine clothes and meals at the best restaurants, in-

cluding the Café Nicholson, described as a place where "high society loves to meet high bohemia." Like Serendipity, it was owned and designed by a former window dresser, and it was so chic that it didn't need a menu: the chef, Edna Lewis, prepared whatever she felt like cooking that day. Andy regularly treated friends to dinner there because he loved being surrounded by luminaries, and he knew that on any given night he might see the filmmaker Jean Renoir, the writer Tennessee Williams, the socialite Gloria Vanderbilt, the actor Marlon Brando, and, of course, the ubiquitous Truman Capote.

Andy splurged on pricey orchestra seat tickets to hit Broadway shows, Grand Tier seats at the Metropolitan Opera, and impromptu limousine excursions to Coney Island, and, in the summer of 1956, he booked passage on a world tour with the seasoned traveler Charles Lisanby. They went to such exotic destinations as Rome, Amsterdam, Tokyo, and Bangkok. He sent postcards to his mother, but they gave no hint of the real drama that was unfolding in the faraway places he visited. Andy had hoped a trip might spark a romantic liaison with Lisanby. Instead, his overtures were rejected, and he brooded for most of the vacation. Andy had "gone around the world with a boy and not even received one kiss," he complained wistfully upon his return.

Andy was becoming more secure about being homosexual. The downside was that some of the men he longed for romantically, such as Lisanby, rejected him. But the upside was that he moved easily through New York's gay demimonde, a fashionable world populated by illustrators, set designers, costumers, and other artistic types. The community was closeted—homosexuality was illegal, so there was no such thing as being truly "out" in the 1950s.

But that "closet" was elite, and Andy sometimes found himself in the company of real celebrities, such as Greta Garbo. He shyly presented her with a paper butterfly, which she unconsciously crumpled and dropped. Later, Andy found it on the ground and claimed it as treasure.

Another high point for Andy was when one of his shoe drawings, appropriately named *Shoe*, was selected to appear in the *Recent Drawings U.S.A.* show at the Museum of Modern Art in New York. The exhibition included 150 drawings, selected from over 5,000 entries submitted by artists from all over the country. Andy got so carried away with the honor that he offered to donate *Shoe* to the museum's permanent collection. He received a reply saying that MoMA considered it unfair to accept a gift that would be shown so infrequently, a polite way of saying that they didn't want it, and adding that "the drawing may be picked up from the Museum at your convenience."

MoMA may have been blind to Andy's talent, but in January 1957, Andy received national attention when a selection of his most fanciful shoes appeared in *Life* magazine. A two-page spread entitled "Crazy Golden Slippers," showed his gilded footwear in all its glory and explained that each shoe represented a well-known personality. An oversized buccaneer boot was modeled after Elvis Presley, while an elaborate party shoe with a delicate spike heel was the essence of Zsa Zsa Gabor. An arch-looking shoe covered with plants and flowers was none other than Truman Capote, whose most recent work was a Broadway show called *House of Flowers*.

A year later, Random House published a satirical booklet enti-

tled *1000 Names and Where to Drop Them*, and listed Andy under the heading "Big Business." He was in good company, alongside Walt Disney; Elvis Presley's promoter, Col. Tom Parker; the actress Kim Novak; the choreographer Jerome Robbins; the Museum of Modern Art; and his childhood idol, Shirley Temple; among others. Andy said that it gave him a "real kick" to see his name grouped with celebrities.

He might have been satisfied with his status as a famous, highly compensated illustrator, but the emergence of an exciting new artist in 1958 turned the art world upside down. Jasper Johns, half of the window-dressing team Matson Jones, was hailed as one of the founders of the first new school of painting since Abstract Expressionism. For lack of a better term, Johns and his partner, Robert Rauschenberg, were called "Neo-Dadists." Like the revolutionary artist Marcel Duchamp, who featured an ordinary urinal in a 1917 exhibition and, with a mixture of humor and perversity, titled it *Fountain*, these young artists mixed everyday materials and media in a playful and provocative way. Johns claimed that he had a dream about painting a flag one night and woke up the next morning and did just that. His bold images of recognizable items such as flags and targets were shown at the Leo Castelli Gallery and were an overnight sensation, selling to important museums such as MoMA, and to private collectors. Several months later, Rauschenberg, the other half of Matson Jones, had his first showing at Castelli and was equally successful.

Andy watched longingly, envying their transformation from window dressers to critics' darlings, but he knew the score: if you wanted to be considered a serious artist, you weren't supposed to have anything to do with commercial art. Johns and Rauschenberg

hid behind their pseudonym and didn't flaunt their display work the way Andy did. He was proud of his accomplishments, but now that he had built a very public name for himself as an illustrator, Andy had to make sure his fabulous shoes weren't leading him in the wrong direction.

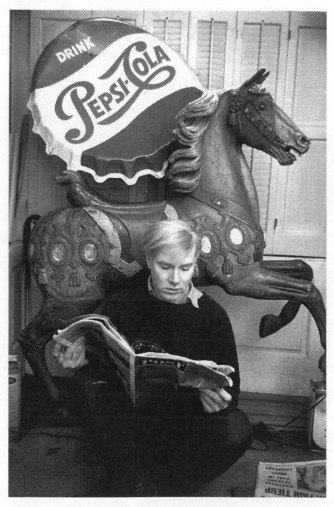

The quintessential collector, Andy surrounded himself
with objects, many of which influenced his art.

Chapter 3

Art is what you can get away with.

—Andy Warhol

In late January 1961, Andy attended Jasper Johns's new show at the Leo Castelli Gallery and purchased a sketch entitled *Light Bulb,* which was a straightforward graphite drawing of that most common of commonplace objects—a light bulb. Andy admired the artist, whose career had skyrocketed in such a short period of time, and although he was envious of his success, he was also a shrewd fledgling collector who recognized Johns as a good investment. However, the acquisition paid off sooner as opposed to later, because Andy found it inspirational. The idea of a common object becoming the subject of a work of art turned out to be an important "light bulb" moment for Andy.

He had been working on other people's assignments for so long, he wasn't sure he knew how to come up with an original idea, something new and different that would attract attention. One day, he placed a canvas on the sidewalk in front of his house and waited for pedestrians to walk on it, hoping to find a concept in the random pattern of their footprints. That turned out to be a bad idea. "In the end I had a lot of dirty canvases," he admitted. "Then I thought they were all diseased so I rolled them up and put them somewhere."

Whatever crazy notions he considered and dismissed, Andy couldn't stop thinking about that light bulb. Ultimately—and intuitively—he followed Mark Twain's advice to writers who were struggling with similar creative issues. "Write what you know," Twain said practically. Andy knew advertising and mass media. His house was filled with newspapers and magazines, some displaying his commercial illustrations, some he found interesting or entertaining. There were artists who would consider the photographs, advertisements, and comic strips in these publications too common or crude to be "art." Not Andy. He saw these images as vital symbols of daily life and decided to paint them.

Taking advantage of the large work space in his new house, he put brush to canvas during the winter of 1961. His primary muses were the seven New York City daily newspapers, especially the *New York Post*, the *New York Journal-American*, and the *Daily News*, and his first subjects were the superheroes of his childhood: Popeye, Dick Tracy, and Superman. Unlike his delicate renditions of shoes, perfume bottles, and cherubs, these paintings were *big* and bold. Executed in bright shades of red, white, and blue, and punctuated with some painterly drips, *Saturday's Popeye* (42½ × 39 inches), depicted a featureless but totally recognizable Popeye delivering a powerful "wham" of a punch to an unseen villain. *Dick Tracy and Sam Ketchum* (79 × 52½ inches) was even bigger—over six feet tall. *Superman, Nancy, Little King*, and *Batman* rounded out Andy's playful yet powerful assortment of comic strip portraits.

Thus inspired, Andy came up with one idea after another. He painted advertising images of a television set, an ice box, a vacuum, a drill, a belt called a rupture-easer, a water heater, Dr. Scholl's corn medication, an old-fashioned telephone, a Royal typewriter,

and even "before and after" drawings of a nose job. He developed an assembly-line process, setting up an opaque projector in one of his spare bedrooms and enlarging the picture to the size he wanted. Then, using the projected version as his guide, he painted directly onto the canvas. When he was finished, he often added expressionist flourishes with a dripping paintbrush and wax crayons.

Andy was so productive that winter that he filled the house with giant canvases. His goal was to exhibit them in a gallery, but the only venue that came his way was the department store Bonwit Teller. He had lost the I. Miller account earlier in the year when the company switched to a photo-based campaign, so Bonwit's was one of his principal clients, for both illustrating and window-dressing.

Occasionally, art director Gene Moore paid tribute to his most talented freelance artists (like Johns and Rauschenberg) by featuring their paintings in a window display. In April, a selection of Andy's new creations—*Little King, Saturday's Popeye, Before and After, Superman,* and *Advertisement*—served as background for a group of stylish mannequins wearing colorful spring sheaths and hats. Andy had previously likened department stores to museums, but this impromptu "exhibition" on Fifth Avenue did not assuage his appetite for the real thing—a career-launching show at Leo Castelli or one of the other important galleries in the city.

Andy was keenly aware of the importance of the right gallery (Dior never sold his originals from a counter at Woolworths, he pointed out), because he was becoming quite the collector. He visited galleries regularly and purchased works by such artists as Frank Stella, Ellsworth Kelly, and Jim Dine. However, every acquisition was a bittersweet reminder of his failure to cross over into the world of mainstream art. One day when Andy stopped by Castelli's to see the latest offerings, he

made a horrifying discovery. Ivan Karp, the director of the gallery and Castelli's right-hand man, pulled out a painting called *Girl with Ball*. Roy Lichtenstein, an art academic in New Jersey, was the artist. The unusual work showed a primitive cartoon image that had been lifted from a newspaper advertisement for a resort in the Catskills. Lichtenstein's cartoon painting looked very much like Andy's.

"Ohhh, I'm doing work just like that myself," Andy managed to say, despite his shock. And he *did* do work just like that . . . except Lichtenstein actually reproduced the Ben-Day ink dots in his comic strip homage. Karp didn't know Andy—they were meeting for the first time—but he was intrigued by his claim. Lichtenstein was new to the gallery, and Karp thought his work was unlike anything he had ever encountered. Best to check out the competition right away, he thought, so he agreed to stop by Andy's place to see his paintings.

Karp rarely declined an invitation to an artist's studio. He saw himself as an adventurer, a scavenger, a sleuth on the art beat, who enjoyed nothing more than the thrill of the chase. Even though Karp was often described in clichés—people said he was "the man with his finger on the pulse"; he had "his ear to the ground" and "his eye on the prize"—he was completely original, a self-made connoisseur. He was raised in Brooklyn, where he had an undistinguished education, had served in Europe during World War II, and had stayed on after the war for about ten months, visiting museums, absorbing culture, and teaching himself about art and architecture.

Back in New York, Karp took advantage of the GI Bill to study film. He worked as a film editor on commercial projects, started writing, and ended up covering art for the *Village Voice*. His new-found passion for art led him to accept a job at a gallery and, by 1959, he was working at Castelli, the white-hot center of the chang-

ing art world. It was the "outpost for really threatening new things," Karp believed, and he wanted to work in that kind of stimulating environment. Leo Castelli already represented Rauschenberg and Johns, and was eager to find new talent, so he hired Karp to be his gallery director and scout.

Karp showed up at Andy's townhouse, surprised by the sight of a single name on the bell. Most of the artists he visited were poor and lived in modern-day garrets. But this one seemed to have enough money to own a private residence in New York City. Karp had no idea that Andy was a successful illustrator, and Andy wanted to keep him in the dark (no need to give Karp the impression that he wasn't a *serious* artist). He had hidden his illustrations and banished his mother to her rooms in the basement.

Karp described the house's atmosphere as "dense Victorian" because there was so much clutter—Andy's carousel horses and other campy artifacts took up a lot of space. The rooms were dim because Andy had covered the windows with fabric to keep out the light. But the strangest thing about Andy's place was the noise level. The two men had to raise their voices to be heard over the sound of a record player blasting a popular tune over and over again. Andy admitted to playing the same song for the entire day so he could get to know it inside out. He also turned on the television, tuned into opera on the radio, and read a magazine, all at the same time. He liked to be bombarded by media because he believed it served as a kind of white noise that cleared his head. Fortunately, Karp was passionate about music, so he snapped his fingers and danced to the beat while he moved from canvas to canvas.

Andy's comic book paintings were as promised, Karp noted. Similar to Lichtenstein's in that they had been inspired by images

from comic strips and advertisements, they were also different in that Lichtenstein was more confident and experimental in his approach. Bold as they were in terms of their odd subject matter, Andy's comics had their share of drips and "the echo of abstract expressionism in his brushwork," according to Karp. Never one to mince words with artists, Karp gave Andy his honest opinion. "These blunt, straightforward works are the only ones of any consequence," he said, pointing to Andy's hard-edged painting of a dance diagram, and one of an old-fashioned telephone. "The others are all homage to Abstract Expressionism." "You can't do a painting without a drip," Andy argued halfheartedly, although he was happy that Karp suggested otherwise, because he also preferred the paintings that were stark and *unexpressionist*.

Karp then explained that he doubted Leo Castelli would be able to represent Andy, because the gallery had scheduled an upcoming show for Lichtenstein and the two artists would conflict with each other. But he did offer to introduce him to collectors and dealers. Karp knew everyone of consequence in the art world, so his unofficial godfathering would get Andy's work seen by all the right people.

Andy was disappointed, but he knew that Karp's assessment was accurate. And he wasn't hearing it for the first time. When his friend Emile de Antonio came over for a drink one afternoon and spotted two different paintings of a Coke bottle resting against the wall, he echoed Karp's reaction. "One of these is a piece of shit, simply a little bit of everything," he said of the bottle that included Abstract Expressionist hash marks. "The other"—the clean, cold, representational one—"is remarkable," he praised. "It's our society, it's who we are, it's absolutely beautiful and naked, and you ought to destroy the first one and show the other." Andy trusted De and took

his advice to heart. That, combined with Karp's evaluation, led him to an important decision. When it came to comics, even Andy had to admit that Lichtenstein did it better. It was time to move on, but where, he wondered, would he find his next big idea?

Andy routinely asked his friends "What should I paint?" Sometimes the question was a sincere inquiry; other times, it was just a flattering greeting—a variation on "how are you" that Andy used to suggest he valued the person's opinion. More often than not, he had to feign interest in the innocuous answer that followed, so he was surprised to get an intriguing retort from Muriel Latow, an art dealer who owned a small gallery on East Sixty-Third Street.

Latow was smart, brash, and, at the moment, extremely low on funds. She was in a terrible mood because her gallery was in serious trouble. One chilly November night, friends who were trying to cheer her up talked her into dropping in on Andy for an after-dinner coffee. She knew him fairly well and had spent several Saturdays witnessing his shopping sprees in antique stores and resale shops all over town. But Latow regretted saying yes the moment Andy opened the door.

Tonight, she found his dark, overstuffed house gloomy and oppressive, and she had no patience for his endless questions about *his* future "How can I make more money?" "What will make me famous?"—because she was so worried about her own. When Andy repeatedly asked her what he should paint, she told him that he would have to pay fifty dollars up front before she would give him her answer, implying that she had the fabulous idea he wanted. She sounded so serious that Andy pulled out his checkbook, filled in the date—November 23, 1961—and gave her the money she demanded.

"What do you love most?" Latow asked, suspecting that she

knew the answer. All Andy ever talked about was money. As expected, "Money!" was indeed his immediate reply, and the idea to paint dollar bills took root. They excitedly discussed the possibilities—Andy could paint crisp new bills, folded bills, torn bills. And wouldn't it be fun to charge people real money for pictures of money?

In better spirits and determined to give Andy his fifty dollars' worth, Muriel offered another idea. He should paint something common, something recognizable . . . maybe like a can of soup. Campbell's Soup, Andy's favorite lunch from childhood (and one he continued to eat), suddenly seemed like an interesting prospect. Let Lichtenstein paint comic strips. Andy would elevate the lowest of lowbrow images, a product that had absolutely no pretense of being art. The utilitarian can and its label were exactly what Oldenburg had in mind when he wrote in his manifesto, "I am for art that grows up not knowing it is art at all." The humble can of soup never aspired to be a work of art, which made it the perfect subject for a truly contemporary painting.

The simple can that caught Andy's eye came into existence in 1897, when Campbell's introduced its revolutionary condensed soup. What made it revolutionary was the fact that customers added their own water, which meant that Campbell's could package their product in a smaller can, save money on shipping, and charge less. The original label was a dullish orange and blue, but a company executive redesigned it after he attended a Cornell football game and saw the players in their spanking new red-and-white uniforms. The brighter, contrasting colors provided a more vibrant background for the Campbell's logo, written in script to suggest the distinctive signature of the company's founder, Joseph Campbell.

Each label indicated the variety of soup inside the can. In the

early years, the selection was limited to a few choices. The ever-popular tomato was so important to the brand that the company provided farmers with special seeds with which to grow the perfect Campbell's Soup tomato. In 1900, the Paris International Exposition awarded Campbell's a gold medal for its world-famous product. Other winners that year were the Eiffel Tower, talking pictures, and the diesel engine. The handsome medal depicted the goddess Victory flying over the fair, carrying a triumphant winner on her back.

Back home, Campbell's proudly replicated the medal on its soup can, placing a gold medallion decorated with an engraving of the Exposition design under the word "condensed." Continuing the French motif, gold fleurs-de-lis circled the bottom of the can, suggesting a champion's crown. With or without a medal, Campbell's Soup was a winner. Propelled by acclaim, well-placed advertisements in ladies' magazines, and, eventually, sponsorship of popular radio shows such as *Amos 'n' Andy*, the company experienced rapid growth. As early as 1911, Campbell's discovered that its chief advantage in the marketplace was that condensed soup was democratic. Research showed that the product appealed to customers in all economic classes. "A great majority of the people, regardless of income, eats one or more of the 21 varieties," one study revealed. Andy was living proof. He ate Campbell's Soup when he was a poor boy in Pittsburgh, and he still ate it now that he was a well-heeled professional living in a townhouse in New York City.

Andy ran across the street to Gristedes, a leading Manhattan supermarket, to stock up on cans of every variety, from tomato, vegetable, and chicken noodle to Pepper Pot and Scotch Broth. Within the week, he was hard at work on his first soup can painting of Campbell's Tomato Rice. The idea was new and daring, but Andy's

approach was old-fashioned and timid. After he painted the recognizable red, white, and gold can, he couldn't help adding several drips and crayon lines, signs that he was reluctant to part with the tried-and-true techniques from his Ab-Ex bag of tricks. The painter is present (and a little sloppy), these markings seemed to say.

But as Andy started experimenting with his new subject, he found the confidence to drop the drips. Referencing a magazine advertisement that promoted the "M'm! M'm! Good!" pairing of a sandwich and a hot cup of Campbell's Soup, and an image lifted from Campbell's corporate stationery, Andy painted several distinct versions of the famous can. He decided to paint a series consisting of all thirty-two varieties, each painting measuring a uniform 20 by 16 inches, and incorporating touches of gold-and-silver metallic paint. His cans would look just like the real thing, so uniform in appearance that they would appear to be tumbling off an assembly line, or marching toward a supermarket shelf.

Andy became fascinated with serial images, painting *100 Soup Cans, 200 Soup Cans,* multiple dollar bills, Coca-Cola bottles, S&H Green Stamps, and airmail stamps. The concept of the repeated image was one of the basic tenets of modern-day advertising. According to a character in Frederic Wakeman's novel *The Hucksters,* a popular exposé of Madison Avenue corruption, two things make good advertising: "One, a good simple idea. Two repetition. And by repetition, by God, I mean until the public is so irritated with it, they'll buy your brand because they bloody well can't forget it." Repetition was also a way of demystifying an image. When Andy painted something over and over again, doing so was the visual equivalent of listening to the same song repeatedly. At a certain point, he "got it," and he expected that others would "get it," too.

Multiple images, or "multiples," also connected Andy to a larger movement that was redefining postwar America. From automobiles to hamburgers, from motels to houses, mass production was the cornerstone of the new consumer economy. In Chicago, a hardworking businessman named Ray Kroc took a successful California hamburger franchise called McDonald's and turned it into a blockbuster national chain by opening one identical location after another. In New York, Bill Levitt, a land developer with a big idea, applied the principles of mass production to the construction business and created low-priced, standardized housing in a community that he named Levittown, one of America's first suburbs. And in Tennessee, a builder named Kemmons Wilson, who had trouble finding a suitable motel for a family vacation, opened quality-controlled inns—Holiday Inns, to be specific—along the highways traveled by the cars that rolled off Detroit's assembly lines.

These entrepreneurs were betting that the modern consumer valued consistency, uniformity, and quality control, and would appreciate that a McDonald's hamburger in Texas was the same as a McDonald's hamburger in Maine, that a room at one Holiday Inn was interchangeable with a room at another, and that an affordable Levittown prefab was a guarantee that your home would be as nice as your neighbor's. In a more philosophical way, the movement represented the democratization of privileges—travel, dining out, and home ownership, for example—that previously only wealthy people could experience. In the new economy, yesterday's luxuries became today's brands.

As the nearly $12 billion advertising industry promised, when the right brands became familiar, they were deemed trustworthy. Andy saw a bond developing between consumers and products, and he cap-

italized on that connection in his art. The images (or brands) he selected to paint—whether Campbell's or Coke—were so identifiable that he seemed to be communicating in a sort of visual shorthand.

That winter, Andy's ideas came so fast that he had to work constantly to keep up with them. Turning out cans, dance diagrams, and whimsical paint-by-number landscapes, he realized that he could be even more productive if he combined painting with the industrial process of silkscreening. Andy made some of his dollar bills this way and liked the results. It amused him to mass-produce images of mass-produced images.

While Andy was experimenting with new techniques and processes, he was trying to come up with the right "Andy" persona for this important new chapter in his life. In the late 1950s, "Raggedy Andy" had evolved into "Andy the dandy," who dined in the best restaurants and attended the opera. Now, thanks to some candid advice from his friend Emile de Antonio, Andy realized that, once again, it was time for some serious self-reinvention.

The subject came up when the two men were having dinner at a restaurant. "Why don't Bob and Jap [Rauschenberg and Johns] like me?" Andy asked, referencing a coolness he felt when in the presence of the rising stars. They should have had a lot in common with each other, considering that they were all artists who had worked as window dressers; that they knew the same people and went to the same events; and that Bob and Jap, although more private about their sexuality, were gay, just like Andy. In fact, they were a couple.

Andy half hoped that his friend would tell him that he was being paranoid, and that he was only imagining their disapproval. But De bluntly confirmed his worst suspicions. "Okay, Andy, if you really want to hear it straight, I'll lay it out for you," he told him. "You're

too swish and it upsets them . . . these two guys wear three-button suits. The major painters try to look straight; you play up the swish." De also pointed out that "real" artists were put off by Andy's success as a commercial artist. Starving artists had to work at odd jobs to support themselves. Andy, however, was making a lot of money as a top illustrator, and his success caused resentment.

Andy was hurt by De's frank assessment. He insisted that he got a kick out of being swish and campy because it was fun to watch the effect his over-the-top behavior had on people, and that *he* shouldn't have to change. But Andy knew his friend was right. If he wanted to be taken seriously by the art world insiders he admired, he needed a new image. He had to move quickly, because Ivan Karp had offered to bring influencers and potential customers to Andy's house to see his work.

Andy hid his commercial drawings *and* his assistant, whose presence would have been a dead giveaway that Andy was an artist for hire. Then, in a misguided attempt to appear exotic, Andy answered the door wearing a Venetian mask and gave Karp and his companions—and, on one notable occasion, Leo Castelli himself— masks to cover their faces. Karp suspected that Andy wore the mask to hide his bad complexion, but he also wondered if he were playing a prank on his visitors. The rooms were dark, like those in a fun-house, and at least one record player, sometimes two, blasted the hit tune du jour while Andy receded into the shadows. He may have thought he was being "artistic," but there was still something undeniably *campy* about the way he behaved.

Castelli, who had represented way-out Surrealists when he worked in Europe, was completely unprepared for the studied weirdness that was Andy. His studio was a mess and his paintings

seemed downright odd to the cosmopolitan dealer. Karp sensed that Castelli was uneasy and anxious the whole time he was in Andy's presence. "Leo was very uncomfortable with the situation and very likely with the art," Karp recalled. Castelli politely explained that he was representing Lichtenstein, so "the two of you in the same gallery would collide." But he was *really* thinking that he didn't understand Warhol. "I just felt the paintings were not interesting," Castelli said later. "You really weren't quite sure what he was going to do."

Karp was more successful at matchmaking when he introduced Andy to the brilliant new curatorial assistant at the Metropolitan Museum. Henry Geldzahler was as unusual as his name. Born in Antwerp in 1935, and raised in a privileged household in New York City, Geldzahler was the smart kid—and later, the smart young man—who dazzled everyone with his quick mind. His physical imperfections—the fact that he was short, a little chubby, and moonfaced—disappeared as soon as he started talking. And Geldzahler could talk about anything . . . especially the exciting new world of contemporary art. He studied at Yale and Harvard and, in 1960, was invited to join the curatorial staff at the Metropolitan. The only problem, from Geldzahler's perspective, was that contemporary art was a very low priority at the Met. The museum's trustees were so conservative that some of them laughed out loud when they were shown works by eminent Abstract Expressionists.

But Geldzahler was not deterred. He made such a convincing case for the importance of being knowledgeable about contemporary art—ignoring it, he said, would be like skipping a volume in an encyclopedia—that his superiors encouraged him to identify New York's most promising new artists and get to know their work. He turned to Ivan Karp, an acquaintance from summer vacations in

Provincetown, for suggestions. Geldzahler loved making his way around the art world and quickly found himself at its center. He was young and open-minded, a breath of fresh air in a staid institution. When the telephone operator at the Met complained that he received more calls than any other curator, he reminded her that he was the only one who worked with *living* artists.

There were times when Geldzahler and Karp went exploring together, traveling from neighborhood to neighborhood, loft to loft, studio to studio. Excitedly, they started connecting some very important dots. Roy Lichtenstein was painting comics. James Rosenquist, who supported himself by painting signs and billboards, was incorporating giant advertising images in his oversized works. And the ever-experimental Claes Oldenburg had just opened an exhibition called the Store, where he personally sold handcrafted interpretations of everyday objects such as shirts, hats, shoes, cigarettes, oranges (and they were all for sale, just like in a real store) blurring the line between art and commerce. Bombarded by colorful images that had been appropriated from all forms of media, Karp and Geldzahler realized that they were witnessing the birth of an electrifying new art movement.

"I felt like I was going berserk," Karp explained. "I was actually tremulous from day to day. I remember writing in my journal, 'There's continuity here! . . . these artists don't even know each other! It's got to be an atmosphere, a national atmosphere!'" Geldzahler compared it to a science fiction movie, with "artists in different parts of the city, unknown to each other, rising up out of the mud and staggering forward with your paintings in front of you."

This generation of artists was the first to grow up in the age of media, "television, the daily newspapers, weekly magazines,

and the billboards and movie screen," said Geldzahler, calling their work "a knowing response to our environment," and a representation of "the new American landscape," a landscape dominated by popular culture. They painted what they considered the essential symbols of daily life . . . a figure from a comic strip, an article of clothing, a fragment of a billboard or an advertisement, even a can of Campbell's Soup.

As for that soup can: On one of their art excursions, Karp introduced Geldzahler to Andy. Unlike Castelli, Geldzahler was enchanted by the visit to Andy's house. He prided himself on his ability to walk into a gallery, or a studio, and know *instantly* if he wanted to look twice. At Andy's, he wanted to look everywhere. Even the campy Carmen Miranda shoes caught his eye. There was an instant rapport between the two men. Geldzahler saw Andy as someone who was "plugged into the zeitgeist" (later, he would credit him with being "the unconscious conscience of the sixties). Andy, in turn, recognized Geldzahler as a one-man finishing school. "Oh, teach me one fact every day and then I'll really know a lot," he implored his clever new friend. Andy called their quick-blooming, all-consuming relationship a "five-hours-a-day-on-the-phone-see-you-for-lunch-quick-turn-on-the-Tonight-Show friendship." Not a romance, although both men were gay, but a true meeting of minds and ambitions.

With the help of Geldzahler and Karp, Andy met all the right people. Collectors who came to the house were very responsive to his work, although there were a few stumbles. Andy recalled an instance when a potential buyer recognized that he had been a famous illustrator and asked to see his drawings. Andy complied, only to find that the man's interest evaporated on the spot. "I could actually

see him changing his mind about my paintings," Andy marveled. After that experience, he had a "firm no-show policy" about commercial art.

Foremost in Andy's mind was the pursuit of a dealer and a gallery. He was still hoping to land at Castelli. Meanwhile, he needed someone—*anyone*—to offer him his first one-man show. All the other up-and-coming artists had been picked up by galleries and were enjoying their solo moment in the limelight. By early 1962, Dine, Rosenquist, Lichtenstein, and Oldenburg were being shown and reviewed. Andy dutifully attended their exhibitions, and he was a member of the audience at one of Oldenburg's Happenings at the Green Gallery. Dressed in a jacket and a tie, like most of the spectators, Andy looked strangely formal next to Oldenburg and the other players, who wore costumes and writhed on the floor.

Andy admired Oldenburg and bought one of his papier-mâché shirts from the Store. He also invited Oldenburg and his wife, Patty, to come to his house to see his canvases. Artists often traded work with other artists, so Andy assumed he would end up with a second Oldenburg when the artist picked out which Warhol he wanted. They all found themselves in an uncomfortable situation when, after looking through Andy's paintings, Oldenburg decided that he didn't really want *anything*. He and Patty left empty-handed. What did it say about his work, Andy thought, that he couldn't even give it away?

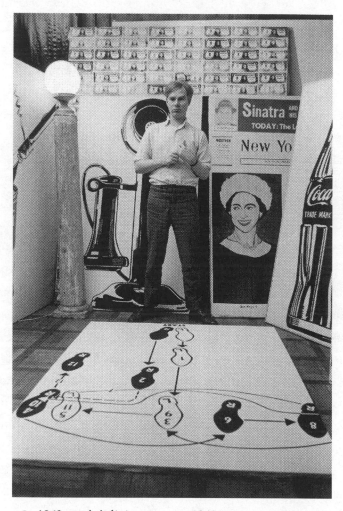

In 1962, Andy's living room at 1342 Lexington Avenue
doubled as a studio and was filled with the artist's early
Pop paintings, including a Coca Cola bottle, a Campbell's
Soup Can, a dance diagram, and dollar bills.

Chapter 4

Pop Art took the inside and put it outside,
took the outside and put it inside.

—Andy Warhol

T hings turned around for Andy in May 1962, when Hollywood came calling in the form of a dynamic young California art dealer named Irving Blum. Known as "the Cary Grant of the art world" because of his dashing looks, debonair demeanor, and upper-crust accent, Blum was smart, devilishly charming, adventurous, and entrepreneurial. After serving overseas in the air force in the 1950s, he moved to New York to pursue a career in the theater. When that ambition didn't work out, Blum fast-talked his way into a sales job at Knoll Associates, a company that sold high-end modernist furniture. Customers trusted Blum and often asked him to find art to accompany their purchases. He had such a good eye that he eventually left Knoll and headed for Los Angeles, where he joined the up-and-coming Ferus Gallery.

Blum traveled to New York periodically, visiting galleries and studios to stay abreast of artists and their trends. He had visited Andy once before and was intrigued by his Royal typewriter painting and some of his comic book figures, but hadn't been interested

enough to make any real overtures. On this visit, he stopped in at Andy's townhouse to see his new work.

Stepping over piles of magazines and colorful clutter that seemed to be a foot deep in spots, Blum greeted Andy, whom he found "plump and cherubic" and very sociable. He expected to see more paintings of cartoon figures. Instead he came face to face with one of Andy's starkly beautiful red, white, and boldly outlined Campbell's Soup cans, and was so impressed—especially after Andy told him that he intended to paint all thirty-two varieties—that he instantly offered him a show at the Ferus. A one-man show was Andy's dream, but he hesitated at the thought of such a momentous event happening in faraway Los Angeles, where it would be invisible to important critics and his New York friends.

In the early 1960s, Los Angeles was a remote outpost in the art world, especially when it came to contemporary art. Movie stars and studio heads were more interested in Old Masters and Impressionists, if they were interested in art at all. Yet the Ferus, one of the city's newest and most interesting galleries, was ultracontemporary. Founded by Walter Hopps, a maverick young curator, and Ed Kienholz, an iconoclastic artist, the Ferus was conceived as a true cooperative of present-day West Coast artists. Actually, it was more of a clubhouse for the artists and artistic types who gathered there—a place where they could exhibit their works, see films and fashion shows, and hear poetry. Hopps and Kienholz were passionate art advocates and ringleaders, but they didn't know much about profit and loss. Everyone had a great time, but no one made any money.

Six months into the operation, Kienholz decided that he would rather concentrate on his large-scale installations and sculptures than on the business of selling art. Simultaneously, Hopps overheard

a visitor to the gallery, who turned out to be Blum, giving another visitor a hard sell regarding one of the paintings on display. Soon after, Blum bought Kienholz's share in the Ferus for $500 and became Hopps's enthusiastic new partner. Blum had a plan. He aspired to transform the Ferus into a national gallery, "to show the best of what was going on in this country, and that meant both coasts," and a Warhol soup can show was exactly what he wanted.

Sensing Andy's ambivalence about a California show, Blum remembered from his previous visit that the artist's favorite subject was movie stars, movie studios . . . *anything* to do with movies. With exquisite timing, he played his trump card. "Andy, movie stars come into the gallery," he pointed out. Actually, they didn't, with the exception of Dennis Hopper, who was more of a friend and a patron of the arts than a bona fide star. However, the possibility that his paintings would be seen by *celebrities* in *Hollywood* was enough to convince starstruck Andy that a Ferus show was everything he ever wanted. He agreed to provide work for an exhibition that very summer.

Andy rushed to complete thirty-two soup can paintings, checking each variety off the Campbell's product list as it was finished, and sent them to Blum a few weeks in advance of the July 9 opening. He was too busy to travel to California, but he trusted Blum to come up with an appropriate way to hang them. Blum decided that a horizontal line of bright red-and-white canvases would look dramatic against the Ferus's stark white walls, but he ran into a problem at the last minute when he tried to execute his idea. No matter how many times he adjusted the paintings, they looked a tiny bit crooked. Then it occurred to him that they should be displayed on a shelf, just like at the supermarket, or in a kitchen cabinet. Blum ran a narrow ledge

along the gallery walls, rested the paintings on it, and cleverly presented Andy's art work as product. He sent out a handsome invitation featuring Andy's portrait of a can of Pepper Pot to the gallery's clients, artists, and friends, and hoped there would be a lively turnout for the Monday-night opening.

La Cienega Boulevard, home of the Ferus and dozens of other galleries, was *the* place to be on Monday nights because of its weekly Art Walks. The galleries stayed open well into the evening, and crowds of pedestrians strolled from exhibition to exhibition, drink in hand, enjoying the partylike atmosphere. *Time* magazine called it "the best free show in town" and marveled that society matrons and scruffy art students walked the same beat. Regulars communicated with their friends by tucking notes (e.g., "I'll be at thus-and-such gallery at 8") under the arm of a crouching nude sculpture that served as a kind of bulletin board. The art world in Los Angeles was much smaller than that in New York, so everyone—collectors, artists, critics, and spectators—knew everyone else at these Monday-night promenades.

Andy was both an unknown and an outsider, so his opening failed to draw a big crowd. "Not many people came," recalled Shirley Neilsen Blum, an art professor and Walter Hopps's wife at the time. Andy's Campbell's Soup cans may not have been seen by many people that night, but the buzz they created certainly was heard. The concept of a can of soup being served up as a work of art provoked a very noisy controversy.

A block from the Ferus, the Primus-Stuart Gallery seized the opportunity to give the competition some good-natured ribbing. Their front window displayed a pyramid of Campbell's Soup cans with a Turkey Vegetable perched at the top. A small sign explained,

"Do Not Be Misled. Get the Original. Our Low Price—Two for 33 Cents." The *Los Angeles Times* lampooned the cans in a cartoon that showed two long-haired intellectuals (with bare feet) staring at Andy's paintings, debating their virtues. "Frankly the cream of asparagus does nothing for me, but the terrifying intensity of the chicken noodle gives me a real Zen feeling," offered one of the highbrows.

Jack Smith, a journalist with the *Los Angeles Times*, was as whimsical as the paper's cartoonist when he described Andy's show. In a column titled "Soup Can Painter Uses His Noodle," Smith recounted his first impressions of the cans and a conversation with Irving Blum. Smith said that he suspected "Mr. Warhol might have had his tongue in his cheek," but Blum dismissed that notion. "This young fellow is deadly serious and fresh as the moment," the gallerist argued, praising Andy for his "terrifying, Kafkaesque intensity." Smith wasn't sure about the intensity part, especially after he took a final look at Warhol's can of consommé, but if he didn't know exactly what to think about the cans, he clearly enjoyed writing about them.

Predictably, given the critical reaction and the small turnout, sales were slow. However, a few of Blum's regulars agreed to pay one hundred dollars for a Warhol soup can, and one of them was the rebellious young actor Dennis Hopper. Hopper and his wife, Brooke Hayward, were the coolest kids in Hollywood. She was the daughter of the much-married super-agent-turned-producer Leland Hayward and the late, legendary actress Margaret Sullavan, who had died of an accidental drug overdose in 1960. Dennis and Brooke had met and fallen in love in New York while performing in a short-lived stage production of *Mandingo,* then had moved to Los Angeles with Brooke's two sons from her previous marriage. Young (Dennis was twenty-five and Brooke twenty-four) and exceedingly

attractive, the Hoppers managed to fit in with everyone, from old-guard Hollywood, such as Vincent and Mary Price, to members of the new generation, including Brooke's almost-step-siblings Jane and Peter Fonda. (Margaret Sullavan was married to Henry Fonda for two months in the early 1930s.)

Collecting was their mutual passion. They loved paintings, sculptures, and antiques, but the couple suffered a serious setback when their little house in Bel Air burned down in the 1961 fires, destroying most of their art. The young marrieds were committed to rebuilding their collection, even if it meant using Brooke's unemployment check to acquire new works.

As it turned out, Hopper had a lot of time to devote to the art scene because his film career was in limbo. After making a big splash in two successful James Dean movies, *Rebel without a Cause* and *Giant,* the skilled and charismatic newcomer seemed to be a rising star, until he locked horns with the veteran director Henry Hathaway on the set of the Western *From Hell to Texas.* When they disagreed about how a scene should be played, and Hopper stubbornly resisted direction for an outrageous eighty takes, Hathaway retaliated by spreading the word that Hopper was difficult, making it impossible for him to get a studio job. He worked in episodic television, taught himself photography, and befriended the artists whose works he collected.

The Hoppers rarely missed a Monday night on La Cienega, although Brooke was unable to attend Andy's opening because she had recently given birth to their daughter, Marin. Hopper saw the Warhol paintings at the Ferus and immediately told Blum he wanted to buy one. When he came home to his wife and announced, "I've just bought a major painting . . . a soup can, a tomato-soup can!" Brooke

was sure he had lost his mind. "What the hell are you going to do with it?" she asked, assuming it would have to hang in the kitchen.

Their disagreement came to an abrupt end when Blum called his clients to tell them that he had decided to keep all thirty-two cans as one giant work of art instead of selling them off individually and, as a matter of fact, *he* was the buyer. With Andy's approval, Blum arranged to pay a hundred dollars a month over the course of a year. When the exhibition ended, he claimed the paintings and hung them in his apartment, grouping the cans in four rows of eight.

Back in New York, still in a Hollywood state of mind, Andy was mining his vast collection of fan magazines and studio glossies (sometimes autographed) for images of his favorite movie stars, including Natalie Wood, Warren Beatty, Tab Hunter, and Troy Donahue, and, in August, he started turning out his first silkscreened paintings based on photographs.

First he painted the canvas, then he added the silkscreened image. As Andy explained, "You pick a photograph, blow it up, transfer it in glue onto silk, and then roll ink across it so the ink goes through the silk but not through the glue. That way you get the same image, but slightly different each time. It was all so simple— quick and chancy." Finally, he placed finishing touches of color on top of the silkscreen.

The new process was working so well that when Andy heard that Marilyn Monroe had committed suicide on August 5, he immediately decided to memorialize the tragic star with "screens of her beautiful face." In *Gold Marilyn*, he depicted the world-famous seductress with colored eyes and lips, and a halo of blond hair, floating on a background of deep gold. Sexy, glamorous, *and* religious at the same time, the painting was a modern-day icon, similar to the

ones Andy spent hours contemplating at church as a child. It was a beautiful portrait, but with a twist, a *Warholian* twist, in fact. The image was appropriated from a movie publicity still and the colors were off, even a little garish, at the same time as they were pleasing. Andy's latest works, from soup cans to movie stars, suggested that he was moving forward with confidence and, most important, a style all his own.

Fall 1962 promised to be his best season. He was included in several prestigious group shows, one curated by Walter Hopps at the Pasadena Art Museum, and one, entitled *The New Realists*, at the venerable Sidney Janis Gallery in New York. Then Eleanor Ward, the flamboyant doyenne of the Stable Gallery in New York, had a falling-out with the artist she was planning to exhibit in November and offered Andy the coveted one-man-show slot. He was thrilled, knowing the gallery had been the home of such past greats as Willem de Kooning and Pollock.

A young crowd turned up on November 6, the night of Andy's opening. At the entrance, visitors were greeted by his enormous *Gold Marilyn* (7 × 5 feet), which set the stage for the unusual mixture of paintings inside. Spectators gathered around Andy's *Dance Diagram*, a step-by-step guide to the Lindy, which was displayed ingeniously on the floor, and saw *210 Coca Cola Bottles, Do It Yourself,* a paint-by-number sailboat, and several candy-colored Marilyns (whimsically called "flavors" by Ivan Karp), among other paintings.

With this show, Andy landed in the forefront of a hot, new, as-yet-unnamed art movement. Acute observers, including Geldzahler and Karp, noticed that art was changing, and that it seemed to involve vibrant images of "pretty girls" and "pop bottles," in the

words of the architect Philip Johnson. But no one was sure what to call it. "Neo-Dadist" was hard to say; "New Realists" was nondescript; and "Commonist," the worst description of the bunch, suggested dreary art from the Soviet Union.

Only a brand-new word would do, and it had to be something as smart, snappy, and *now* as the art itself. That word was "Pop," one of the first cultural imports from the new "Swinging" England, landing in America via the critic Lawrence Alloway and the artist Richard Hamilton. They used the term "Pop" in 1957 to describe an emerging art scene in London, one that playfully yet knowingly celebrated consumerism. Hamilton defined "Pop" for a friend, writing that "Pop Art is: Popular (designed for a mass audience); Transient (short-term solution); Expendable (easily-forgotten); Low cost; Mass produced; Young (aimed at youth); Witty; Sexy; Gimmicky; and Glamorous." But his most prescient observation was that Pop Art was "Big Business."

In December, the Museum of Modern Art held its equivalent of a town meeting—it called it a symposium—to debate the validity of the controversial new art. Some of the stodgier participants behaved like Chicken Little, claiming that the sky was falling (and that painting was dead) because upstarts were regurgitating media without endowing it with form, substance, or a point of view. But Henry Geldzahler, one of the panelists, offered a younger, and decidedly fresher, take on the subject. According to him, the landscape, literally and figuratively, was changing. "We can no longer paint trees with great contemporary relevance," he argued, "so we paint billboards." He also pointed out that the world was moving faster in all arenas. Art movements no longer had to evolve over the course of decades, or even years. "This is instant art history," he said.

Whether the experts were for it or against it, they decided to go with Alloway's term and call it "Pop." As predicted, Pop Art instantly became popular. People loved to say "Pop" because it made such a happy sound. And the media loved the clever wordplay Pop inspired. " 'Pop' Goes the New Art"' headlined the *New York Times,* while *Time* magazine punned, "Pop art, much as it may outrage Pop, not to mention Grandpop, is the biggest fad since art belonged to Dada." Journalists may not have taken it seriously at first, but they gave the controversial subject a lot of ink.

Geldzahler noted that "no movement in the history of American Art was named and received more quickly," and he related a telling anecdote to illustrate his point. One day, a mechanic came to his apartment to install an air conditioner and noticed a Warhol Marilyn leaning against the wall. "What's that, Pop Art?" he asked. Even the average workingman could identify Pop Art at a glance. Recognizing Pop Art was one thing; liking it was another. Someone asked the owner of Claes Oldenburg's soft sculpture telephone if it really worked. "Yeah," interjected a cynical Pop detractor. "Pick it up and a voice says 'Hello, schmuck!' "

Andy himself offered a succinct definition of the new movement. "The Pop artists," he said, "did images that anybody could recognize in a split second—comics, picnic tables, men's trousers, celebrities, shower curtains, refrigerators, Coke bottles—all the great modern things that the Abstract Expressionists tried so hard not to notice at all." And how did those Abstract Expressionists feel about passing their hard-won baton to their modern-minded successors? They were outraged. Willem de Kooning made a scene at one of the Pop exhibitions and then tried to push his way into the after-party. "Not tonight, Bill," said the gallerist hosting the event

as he turned away the volatile artist, fearful that he would be hostile to the guests of honor.

Andy and his fellow Popists did not need the approval of an irascible generation of artists on their way out, not when patrons and museums were so welcoming. Philip Johnson bought the incomparable *Gold Marilyn* from the show at the Stable Gallery and donated it to the Museum of Modern Art. When offered the painting, MoMA did not suggest that it would be "unfair to accept a gift that would be shown so infrequently," nor did it tell the artist to make arrangements to pick it up. This time, it said an emphatic yes to a Warhol, confirming that Andy was on his way up.

The handsome young poet Gerard Malanga caught
Andy's eye and brightened his mood when he started
working at the Firehouse in June 1963.

Chapter 5

Oh when will I be famous, when will it happen?
 —Andy Warhol

Andy was working on so many projects simultaneously, painting everything from celebrities to catastrophes, he found that it was becoming impossible to continue using his house as a studio. "My work area at home was a total mess. The canvases were spread out all over the living room and the ink from the silkscreens was getting on everything," he lamented. Even Julia, a consummate housekeeper, couldn't maintain order in the midst of such chaos. The only solution for Andy was to get a proper studio.

He found the ideal location a mere two blocks away, in an old, abandoned firehouse at 159 East Eight-Seventh Street. The quaint two-story building still bore the sign "13 Hook and Ladder Company 13," although the fire department had moved to a larger location on East Eighty-Fifth Street. Andy arranged to pay the city of New York $150 per month, which bought him space and charm, though few amenities.

There was no heat or hot water, and the old building was in such disrepair that the hole for the fireman's pole turned out to be only one of many treacherous openings in the floor, forcing Andy to hopscotch from one side of the room to the other. It was difficult

to work on inclement days (or to store canvases), because the roof leaked. However, with all of its flaws, Andy's firehouse was a roomy alternative to his living room on Lexington.

One day at lunch, Henry Geldzahler showed him the front page of the *New York Mirror*. The headline "129 Die in Jet!" was accompanied by a gruesome photograph of a plane crash in France. "It's enough life, it's time for a little death," Geldzahler said, pointing to the picture. Pop Art didn't always have to be sunny and playful, he suggested. It could—and should—have a dark side. Andy understood and was inspired to work on his version of "129 Die in Jet." Starting with this image, he commenced a series of Death and Disaster portraits, using newspaper and magazine images of suicides, car crashes, an electric chair, an exploding atomic bomb, and even a botulism poisoning, to express his—and the country's—growing fascination with mortality.

With all these projects, Andy needed help. He had to work faster, *much* faster. However, he was finding it difficult to finish large silkscreen paintings on his own. The process of preparing the oversized canvases, pushing the paint through the screens, then cleaning the equipment was physically challenging. He mentioned to a few people that he was looking for a proper studio assistant, and his friend, the poet Charles Henri Ford, came up with the perfect candidate, a college student who, miraculously, had silkscreening experience.

Gerard Malanga was twenty years old, and, in many ways, his background seemed quite similar to Andy's. His father and mother, Gerardo and Emma Malanga, were Italian immigrants who came to the Bronx from the old country. Like the Warholas, they were a little older than most couples with young children, and Emma indulged

her boy with good clothes and the sometimes unusual luxuries he requested, such as a portable typewriter and a subscription to *National Geographic* magazine. Like Andy, Gerard studied drawing and was pronounced "gifted" ("overgifted," actually), and he was the first member of his family to go to college. But if Andy recognized traces of himself in Gerard's biography, all similarities ended when he saw the young man's face.

Unlike Andy, Gerard was beautiful. With his soulful eyes, chiseled features, sensual mouth, and perfect physique, he was the quintessential young romantic—"a cross between a beatnik and a movie star," as one college friend described him. Gerard also had an intriguing dash of Bronx edginess: he was handsome, but not pretty; tough, but still vulnerable. And, to top off his appeal, he was also a serious poet—yes, a *poet*—who started publishing his prizewinning work in literary magazines at the tender age of sixteen.

Everything fascinated him; the Third Avenue elevated train, cruise ships, old photographs, classic movies, Hollywood trade papers. He claimed that seeing Orson Welles's *Citi*ẓ*en Kane* at the age of twelve awakened his artistic soul and inspired him to become a poet. That may have seemed an unattainable ambition in the Bronx in 1955, but a few years later, when he was a senior in high school, Gerard found himself in the classroom of a remarkable woman who was able to make his dreams come true. His teacher, Daisy Aldan, was a poet, translator, and editor who produced beautiful poetry anthologies and routinely invited her celebrated poet friends to visit her classroom.

Aldan became Gerard's muse and mentor, helping him find his voice as a writer. She also launched him into the New York literary scene. An introduction to the poet Kenward Elmslie led to invita-

tions from other poets and artists, including Willard Maas and his wife, Marie Menken.

Maas, who had been a very promising poet in his youth, taught literature at Wagner College on Staten Island and made experimental films, while Menken, who worked at the Solomon Guggenheim Museum, was also a noted avant-garde filmmaker. They were famous in artistic circles for hosting memorable salons at their penthouse apartment in Brooklyn Heights. Sometimes the party—and the attendant drinking—went on for several days. Andy and his friends later called them "the last of the great bohemians" and "scholarly drunks." Maas and Menken were such a volatile couple while under the influence that their behavior inspired Edward Albee to create the antagonistic characters George and Martha in his 1963 Tony Award–winning play, *Who's Afraid of Virginia Woolf?*

When Gerard turned up at one of their salons, Maas and Menken were so enchanted they instantly saw him as the reincarnation of Arthur Rimbaud, himself a beautiful teenage poet. Like Aldan, they became his patrons and protectors, and when Gerard was unable to return to the University of Cincinnati for his sophomore year due to financial constraints, Maas arranged for him to transfer to nearby Wagner, with a full scholarship.

Gerard did well at Wagner and was appointed editor of the college literary magazine. He created quite a sensation on campus because young women—especially good girls from conservative backgrounds—found his edgy romanticism irresistible. He was considered so handsome that a student jokingly entered his name as a candidate for homecoming queen—and Gerard won!

His poems attracted all the right attention from the older literary crowd, partly because they were good, and partly because

he was a young and forceful presence amid the aging greats of the 1940s and 1950s. A charming upstart, he reminded them of their glory days, full of sex, passion, and ambition. Gerard's poetry won prizes, one awarded by the US poet laureate, Robert Lowell, and another presented by the esteemed poet Marianne Moore, but success never went to his head. He understood that he couldn't simply live off his contacts and that he had to support himself. He took a part-time job silkscreening fabrics at a factory owned by one of Daisy Aldan's former students, Leon Hecht, and it was this seemingly irrelevant credential that made him uniquely qualified for a job with Andy Warhol.

They met for the first time at a poetry reading at the New School in early June 1963, although they had seen each other once before at one of the Mass-Menken parties, where Gerard remembered Marie chasing Andy around a table to give him a motherly kiss. Andy hired the young man on the spot, agreeing to pay $1.25 an hour, and arranged for him to start work a few days later.

Gerard was nervous during his early days at the Firehouse because his employer seemed a little odd and he was unsure of what to expect. Andy overheard him talking to a friend on a pay phone, whispering "Frankly, I think he's going to put the make on me," but that didn't happen. Andy saw Gerard as "a sweet kid" who was "in sort of a permanent reverie."

Andy and Gerard settled into a routine that often included going home to the townhouse for lunch. Delighted to have company, Julia served the "boys" hamburgers stuffed with onions and icy glasses of 7 Up. She liked Gerard and fussed over him as if he were Andy's younger brother. These days, she spent so much time alone in her below-stairs quarters, cleaning, singing songs from the old country,

and preparing packages for her relatives who still lived there, that a visit from Andy and his friends was a welcome distraction.

When they weren't working, Gerard discovered that Andy was happy to accompany him to "every arty event and movement in the city, from poetry readings to screenings of underground films," as Andy described the activities they shared. Andy bemoaned the fact that "they all seemed to be held in dank, musty basements," but he was a good sport and followed Gerard's lead. People got used to seeing Andy and Gerard, Gerard and Andy, all over town. Andy even started wearing Gerard's Wagner College sweatshirt as if, magically, he could absorb some of the younger man's beauty by simply putting on his clothes.

As it turned out, Andy was beginning to feel a bit more comfortable in his own skin. His image was still a work in progress, and his primary concern at the moment was his weight. A photograph of him in *Time* disturbed him because he was convinced he looked fat, something he blamed on his unhealthy diet of candy and rare meat. "I loved them both," he confessed. "Some days I'd just eat one or the other all day long."

If he wanted to become a new, lean Andy, he had to give up these bad habits. Fortunately, there was an easy solution available to compulsive eaters: diet drugs. Everybody was taking them—housewives, writers, truck drivers, and movie stars. Even President Kennedy relied on the infamous Max "Dr. Feelgood" Jacobson and his amazing vitamin "energy" shots, which consisted of liquid methamphetamine, steroids, enzymes, hormones, solubilized placenta, bone marrow, animal organ cells—everything but snips and snails and puppy dog tails—to get through the day.

Andy's diet drug of choice was a pill called Obetrol. As pre-

scribed by his doctor, a fourth of a pill a day did the trick in terms of curbing his appetite. However, in addition to producing the desired weight loss, the pill had a wonderful bonus effect. Obetrol banished all feelings of fatigue and promoted concentration. With Obetrol as his fuel, Andy discovered that he could stay awake most of the night, getting by on only two or three hours of sleep. He felt incredibly energetic and loved what he called that "wired, happy go-go-go feeling in your stomach that made you want to work-work-work."

Obetrol was extremely popular in the sixties, but it was taken off the market in 1973, after diet drugs were investigated by the FDA. Eventually, it was reformulated to exclude methamphetamine, although it still contained peppy amphetamine salts. In 1996, a clever drug company took Obetrol to a new level by turning its secondary effect—enhanced concentration—into the drug's *primary* effect, and rebranded it as Adderall, a treatment for attention-deficit/hyperactivity disorder, or ADHD. So, in a sense, Andy Warhol and an entire generation of speed enthusiasts were actually taking *Adderall*. Whatever its name at the time, the drug enabled Andy to be astonishingly productive.

Andy's first important portrait commission came from Robert Scull, the art world's newest, flashiest, and most talked about collector. Scull was an unusual hybrid: a street-smart taxi tycoon and, improbably, a prescient art connoisseur. The entrepreneurial owner of a diversified business, including a large taxi fleet called "Scull's Angels" and a thriving taxi insurance company, Scull was a transportation wizard. But his *real* passion was art. He and his wife, Ethel, whom he affectionately called "Spike" (because he hated the name Ethel), were the acknowledged pop and mom of Pop Art. How they achieved that lofty position is a story in itself.

Born Ruby Sokolnikoff, the son of a Jewish tailor, Scull grew up on the Lower East Side of Manhattan. Young Scull took any odd job that came his way and even manufactured soap in his bathtub, which he would peddle in the neighborhood; this was when he was only nine years old. When a customer complained that the soap was inferior and burned his skin, the enterprising boy sent him to a doctor for treatment *and* demanded a referral fee from the consulting MD.

When Scull wasn't busy hustling, he had a pastime he assiduously kept secret from the other kids in the neighborhood. His grandfather had introduced him to the Metropolitan Museum, and he loved spending his free time there, wandering through the galleries and teaching himself about art. He was a quick study and started "collecting" cheap reproductions of Old Masters to hang in his room.

A shortage of funds and polish did not deter Scull from wooing the Upper West Side princess Ethel Redner, whom he met on a blind date. She was the pampered daughter of a taxi mogul—so pampered that she ordered champagne the first time they met without giving any thought as to whether Scull could afford it. As a matter of fact, after paying the check, he barely had enough money for the subway ride home. Robert and Ethel experienced an opposites-attract kind of chemistry, and they quickly ascertained that they shared a love of art when Ethel revealed that she was studying at the Art Students League. After a whirlwind courtship, the young couple married and settled into their version of bohemian life—a tiny apartment on West Fifty-Seventh Street, a few blocks from the Museum of Modern Art.

Scull tried to make a living working as a photographer and graphic designer, but reality intervened, and he joined the Redner

family's taxi business. He succeeded beyond his (and his father-in-law's) expectations, eventually opening his own company, named Scull's Angels. As more and more money came in, Scull found himself in a position to buy the art he loved. Better still, he befriended the New York artists he collected, including the already illustrious de Kooning and Mark Rothko, and won privileged access to their studios.

When Rauschenberg and Johns emerged as the successors to the Abstract Expressionists, Scull cultivated these new artists with quasi-religious fervor, buying everything their dealers would sell to him. He tried to scoop up all the works from one Jasper Johns show, but Leo Castelli advised him that it would be "vulgar" to buy everything. If possible, he made handshake deals with the artists themselves while the paint on their canvases was still wet. He even funded the opening of the Green Gallery because it was another way to gain insider status and get first crack at quick-selling Pop pieces. Then it occurred to Scull that, with his eye for talent, he could find and cultivate emerging artists *before* they became famous.

Like Ivan Karp and Henry Geldzahler, he made the rounds of studios and identified artists who interested him. "What do you need?" he asked, offering them money, supplies, encouragement, whatever it took to make them productive. Meanwhile, he paid them the ultimate tribute by buying their exciting new work at a time when its validity was still being debated. He took a lot of ribbing for purchasing Johns's *Painted Bronze (Ale Cans)* (which were just that, painted bronze beer cans), Oldenburg's *Big White Shirt with Blue Tie* and *Assorted Food on a Stove,* Rosenquist's billboardesque *Silver Skies,* and the additional Campbell's Soup cans Andy created after the Ferus show. He gave struggling sculptor John Chamberlain a

Deborah Davis

stipend so he could stop working as a hairdresser and concentrate on fashioning his powerful metal creations. Scull was thrilled to think that his early patronage was shaping art history. "I don't believe in anything but my own intuition," he said, secure in his taste. More important, he was having fun.

So was Ethel. The Sculls' very public support of the hot new Pop movement catapulted them to the center of the culture, while also allowing them to climb higher and higher up New York's social ladder. Slender Ethel became a style icon by wearing the latest fashions. Little ensembles by Courrèges, and see-through gowns by Yves Saint Laurent were topped by her sleek mane of honeyed hair, artfully coiffed by the best stylists at Kenneth's ultrachic salon.

Only an eleven-room apartment on upper Fifth Avenue would do when the Sculls needed a stunning new backdrop for their famous collection. Ethel teasingly called the new place "our tenement on Fifth Avenue" because the heat, hot water, and elevator service could be spotty. However, since they were usually out at gallery openings, dinner parties, galas, fashion shows, fund-raisers, and other see-and-be-seen events, they were too busy to be bothered by such inconveniences. When Ethel was home, she prowled through her art-adorned rooms with a bottle of Windex, scrubbing the smallest smudges from her pristine white walls.

The press covered the Sculls' every move, fascinated by this gutsy couple who had successfully stormed the city's toughest social barricades. Many gossip columnists and reporters were disdainful of their rapid rise. They called them "art arrivistes" and seized any opportunity to use the words "taxi" and "Bronx" (the location of Scull's business) when describing them. They also lampooned their "Beverly Hillbillies" enjoyment of their new status. The Sculls

– 92 –

were studying French, reading Marshall McLuhan, and summering in the Hamptons, the *New Yorker* reported, as if upward mobility were a crime. When asked by an impolite journalist if he was using art to get ahead socially, Scull was wholeheartedly affirmative. "It's all true," he said. "I'd rather use art to climb than anything else."

Naysayers often missed the point when it came to the Sculls. With every dollar they spent, they happily proved the adage "New money is better than no money." Tom Wolfe, the brilliant social observer, was the only writer who truly "got" the Sculls. In his article "Bob and Spike," which appeared in the *World Journal Tribune,* he celebrated their earthy prosperity, their leap from "hoi polloi to haute monde," and their not-so-secret route to celebrity, which he summed up as *"collecting whacked-out art."* He called them "one of the great social success stories of New York since World War II." What did it matter if there were a few disappointments on the way up, or if they experienced the occasional snub. Robert Scull's ebullient philosophy was "Enjoy," and enjoy he did.

He and Ethel were loud, colorful, over-the-top, common, shocking, maybe even a little offensive—just like Pop Art itself. They were a living, breathing version of the work they collected. And they made no apologies: whatever the snobs and staid old guard thought, they knew *they* were the beautiful people—the city's most happening couple, having a helluva time just being themselves.

In 1963, Robert Scull arrived at a difficult moment in a collector's life: he wanted to commission a portrait of Ethel in honor of her upcoming birthday, but he admired so many artists he found it difficult to choose one. Portraits were a tricky business in the 1960s. A classic likeness, rendered in oils, could end up looking very old-fashioned (and didn't feel very "Spike").

Deborah Davis

Andy was Scull's solution. "Paint my wife," he said, trusting the artist who had created *Gold Marilyn* to come up with an idea that would be as au courant as Ethel herself. As it happened, Andy had a bold new concept in mind for the portrait. In the June issue of *Harper's Bazaar,* he worked on a "New Faces, New Forces, New Names in the Arts" piece that was illustrated with photographs from a photo booth. The feature included the dancer Edward Villella, the writer Donald Barthelme, the ubiquitous Henry Geldzahler, and Andy himself, among others. Andy installed each of the subjects (including himself) in a photo booth, and each was posed by him to look fresh and spontaneous. As his editor Ruth Ansel enthused, they were "out of focus, front, side, feet showing, heads cut off, everything wrong and everything right because of it. I loved them." *That's* the kind of portrait he envisioned for Ethel Scull.

Ethel knew Andy would be working from a photograph, so she assumed that he had booked a studio session with Richard Avedon or some such master of the lens. Looking her most glamorous in classic Yves Saint Laurent, she followed when he said "All right, we're off," but she had no idea where they were headed. Much to her surprise, she found herself in Times Square, of all places, at a photo booth in a seedy arcade. *A photo booth?* Was *this* the setting for her great portrait, she asked herself.

Ethel may not have held that booth in high esteem, but there was a time when the Photomaton, as it was originally called, was one of New York City's most popular attractions. Invented in 1921 by Anatol Josepho, a young and enterprising Russian immigrant, the Photomaton was a coin-operated booth that took the place of a photographer's studio. The first one opened in Times Square in 1926. Customers entered, put in a coin, sat before the camera,

and posed. Within eight minutes, a strip of eight sepia-tint photos emerged from the machine. *Like magic.* "Just picture yourself" was the clever slogan, although each machine had white-gloved attendants to help confused customers follow the steps. *Smile. Look to the right. Look to the left.*

Long lines gathered at all times, especially before and after the theater. The Photomaton was open until 4:00 a.m., so there were many opportunities to get that special, speedy memento. It was so popular that, in 1926, an astounding 280,000 people—including honeymooners, sheiks, and politicians—had their picture taken during the first six months the revolutionary booth was open.

The Photomaton received a few makeovers and name changes over the years—in 1935, a Cleveland dentist named Joseph Klein figured out how to make it so fast that finished photos came out in a record 25 seconds—and eventually the machine's name changed to "Photomatic." They were everywhere—in arcades, bus stations, department stores, movie theaters. Teenagers enjoyed mugging for the camera because there were no disapproving adults in the booth. And some artists, including Avedon himself, used the lowly photo booth to create interesting portraits of Marilyn Monroe and Truman Capote, among others. The simple little camera with its quick flash of light actually made people look good

Andy was a fan, largely because the serial images shot in a photo booth represented an intermediate step between still photography and movies. The machine captured spontaneous, successive images and, more important, it caught *movement*. A portrait in motion— that was his modern concept for this commission. He placed the mystified Ethel in the booth, instructed her to "watch the little red light," and began feeding a hundred dollars' worth of quarters—

enough for four hundred photos—into the machine. "Now start smiling and talking," he said, "this is costing me money!"

Ethel froze. She didn't know what to do with her face or her hands until Andy stepped in and started directing. He poked her, made her laugh, and led her through some old Hollywood "they had faces then" poses. Sunglasses on, sunglasses off, hand to face, hand to hair, pensive, puzzled, and open-mouthed with delight. Every so often, they switched booths because the photos printed differently depending on how much toner was in the machine. Eventually, Ethel relaxed in front of the camera and Andy achieved exactly what he wanted.

Back at the Firehouse, Andy selected thirty-five images to be enlarged, silkscreened, and colored in varying tones of red, green, blue, yellow, orange, and black and white. When it came time to assemble the enormous finished work (each individual image measured 20 by 16 inches) at the Sculls' apartment, Andy invited Ethel and Robert to determine the placement and order of the prints. He loved the idea of a serendipitous grouping. The result was *Ethel Scull Thirty-Five Times*, a "portrait" that consisted of thirty-five canvases, displayed in five rows of seven. There was nothing static about the portrait. In fact, it bordered on the cinematic. "It was a portrait of being alive," said a very happy Ethel Scull, who hung it on the wall of her library. Laid out like frames of a film, it made her look—and feel—like a movie star.

Andy and Gerard were also working on canvases that were destined for the Ferus Gallery. Blum proposed that Andy show a selection of representative works, but Andy had something more specific in mind. He was intent on bringing his version of Hollywood to Hollywood, with a flashy exhibition inspired by two of Tinseltown's biggest stars—Elizabeth Taylor and Elvis Presley.

Taylor, who had one of the most recognizable faces in the world, was arguably Hollywood's most famous celebrity, and between marital crises and health scares, she generated more melodrama than any long-running soap opera. So storied were her romantic escapades that columnist Art Buchwald complained that she was constantly bumping *real* news—war, racial strife, nuclear testing—from the headlines. She had started as a child actress and catapulted to stardom in 1944 with her winning performance in *National Velvet*. Her first adult success was *Father of the Bride* in 1950 and, that same year, eighteen-year-old Taylor stunned and delighted her fans by becoming a bride in real life. Her marriage to Conrad "Nicky" Hilton, her first of many, lasted only nine months, and was followed one year later by her marriage to Michael Wilding. They had two children, but divorced in 1957, the year she embarked upon her *next* marriage, this time to producer Mike Todd.

Taylor adored Todd, a flamboyant, self-made man with a big personality and a penchant for spoiling his beautiful young wife. It was a very good year for the smitten couple: his film *Around the World in Eighty Days* won the Academy Award for Best Picture, and the newlyweds also welcomed a baby girl, Liza. But their happy times came to an abrupt end when Todd was killed in a tragic plane crash near Grants, New Mexico. Taylor was also supposed to have been on the private aircraft that evening, but stayed home with a cold.

Though she was inconsolable, she received a great deal of support from Todd's best friend, the singer and actor Eddie Fisher, who was also the husband of Taylor's close friend and fellow MGM star Debbie Reynolds. In 1959, Fisher and Reynolds divorced and Taylor and Fisher married (most fans sided with girl-next-door Reynolds, the wronged wife). It was a scandal of epic proportions,

superseded only by the *next* chapter in Taylor's love life, her even more scandalous affair with Richard Burton, which began on the set of their film *Cleopatra*.

Rumors about the tempestuous Taylor-Burton romance dominated the media in 1961, and journalists went to great lengths to come up with proof of their illicit relationship. Then, as if "Le Scandale," as Burton called it, wasn't enough to keep readers hooked, in March of that year, Taylor contracted a deadly, antibiotic-resistant form of pneumonia and was so ill the newspapers reported her on her deathbed. She survived against all odds and, in 1964, went on to marry Burton (for the first time).

Taylor was considered the most beautiful woman in the world ("Ohhhh. She's so glamorous," Andy said), and *Cleopatra* was, at the time, the most expensive movie ever made, costing approximately $44 million ($320 million in today's money), nearly bankrupting Twentieth Century Fox. These were two very good reasons for celebrity-obsessed Andy to create various images of Taylor, including one called *Men in Her Life* that showed her flanked by Mike Todd and Eddie Fisher. When Andy first painted Taylor, his real fascination with the fabled actress stemmed from the fact that he thought she was going to die. After she rebounded from her life-threatening bout of pneumonia, he created his Silver Liz canvases for the Ferus (based on publicity shots from her film *BUtterfield 8*, for which she won the Academy Award for Best Actress in 1960), adding bright colors to her lips and eyes to suggest that she was once again full of life.

Andy and Gerard also worked on a series of Elvis Presley canvases for the Ferus show. Like Elizabeth Taylor, Elvis was a transmedia star, famous for his records, concerts, movies, and sensational

lifestyle. After a string of blockbuster songs and popular films, the phenomenally successful young entertainer became an international story in 1958 when he was drafted into the US Army and stationed in Germany. He served for two years, won an honorable discharge in 1960, and immediately went back to recording and acting. A typical Elvis film—*G.I. Blues* was his first after his army stint—usually had a silly plot, undistinguished performances, and second-rate songs. But fans loved them anyway because they were powered by high-octane Elvis.

Flaming Star, Elvis's next film, departed from the tried-and-true, croon-and-gyrate formula. He played a cowboy, but not one of the singing variety. His character was a troubled "half-breed" in the Old West, caught between two unwelcoming worlds. The dark drama even called for poor, misunderstood Elvis to die at the end, and showed him riding off to his grim fate. A publicity shot for the film—an image of Elvis drawing his gun on an unseen enemy—inspired Andy to create a series of six-foot silkscreens, so tall and lifelike it seemed that Elvis "was in the building."

That June, there also happened to be a *real* movie star in Andy's orbit. It would be his first, and he was very excited. Henry Geldzahler brought Dennis Hopper and Brooke Hayward to Andy's house to see his work. Andy was very impressed by the beautiful young couple and reveled in Brooke's top-tier connection to old Hollywood. As for the handsome, brooding Hopper, in addition to his roles on the big screen, he had played Billy the Kid in the television series *Sugarfoot.* Andy watched the show and loved Hopper's rebel image, especially the crazy look in his eyes.

On this occasion, the Hoppers had come to Andy's as art collectors, not celebrities, and they were instantly drawn to a particular

Warhol. One of the most famous paintings in the world, Leonardo da Vinci's *Mona Lisa*, was touring America that winter and was on view at the Metropolitan Museum. The visit was covered by so many important newspapers and magazines that she became a bona fide celebrity, drawing crowds of fans and amassing significant "box office." Thanks to her, the Met was enjoying record-breaking lines, ultimately attracting 1,077,521 visitors—a milestone that would not be surpassed for another fifteen years, when an exhibition of artifacts related to Tutankhamen, aka King Tut, became the blockbuster of 1978.

Andy memorialized *Mona Lisa*'s big moment in a series of paintings, and the Hoppers decided to buy one entitled *Double Mona Lisa* for their collection. The artist and his new friends were getting along famously when they were interrupted by the sudden arrival of twenty-five-year-old David Hockney, an up-and-coming British artist whom Andy had met earlier that day at the Stable Gallery, along with his American friend Jeff Goodman. The young men were such good company that Hopper invited them to join Andy and Geldzahler on a visit to the set of the television show he was shooting. *The Defenders*, a popular, socially minded courtroom drama starring E. G. Marshall and Robert Reed, was filming in East Harlem, and Hopper's episode, "The Weeping Baboon," called for him to play a patricidal murderer (typecasting for Hopper) who insists that he is insane. Still blacklisted by mainstream Hollywood, Hopper depended on television assignments such as this to keep his career alive.

Excited by the prospect of visiting a movie star on a real set, Andy, Geldzahler, and Hockney arranged to go the very next day. On the set of *The Defenders*, Hopper pulled out his camera and photographed his guests to commemorate their visit. Andy, wearing

movie star sunglasses, looked slightly uncomfortable with a cigarette dangling from his lips. Hopper was so tickled by Andy's childlike enthusiasm for all things Hollywood that he insisted Andy come visit Los Angeles. He promised that he and Brooke would welcome him by hosting a genuine "movie star party" in his honor.

Andy was thrilled because with the upcoming show at the Ferus, he actually had a reason to travel to Hollywood in September. If there previously had been any doubts about going, Hopper's invitation convinced him that, this time, he *had* to be there.

SET OUT

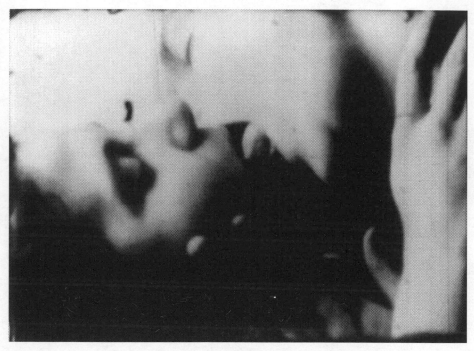

Naomi Levine, Andy's first superstar, shown
in a still from his 1963 film *Kiss*.

Chapter 6

Movies were pure fun, art was work.

—Andy Warhol

A ndy may have imagined himself speeding along unexplored American highways, but he was missing two key ingredients: a driver's license and a car. His first priority was to find someone who owned both and who might be inclined to drive all the way to Los Angeles. Fortunately, he didn't have to look very far. His friend Wynn Chamberlain had a brand-new Ford Falcon station wagon and an appetite for adventure. A tall, affable Midwesterner, Wynn was a fellow artist—a Pop Realist painter and a generally creative type—who had been spending a lot of time with Andy and Gerard that summer. He had not been to LA since a tour of duty in the navy several years earlier, and he was happy to join Andy as both companion and chauffeur, but he didn't want to drive the whole way himself. He pointed out that the trip would go much faster if there were a second driver.

A solution presented itself a few weeks before the planned departure when Henry Geldzahler dropped by for a visit with an odd-looking figure in tow. His diminutive, somewhat goofy, and animated companion needed no introduction. He was Taylor Mead, the infamous vagabond, poet, and actor best known for his win-

some performances in underground films, including Ron Rice's *The Flower Thief* and Vernon Zimmerman's *Lemon Hearts* (with Taylor playing all eleven parts). Forget the movies, Taylor told anyone who would listen—his life was even more interesting than the off-beat characters he played.

Born in Detroit, Michigan, on New Year's Eve, 1924, Taylor was the son of a wealthy Democratic politico boss, Harry Mead, and his wife, Priscilla. The scion's holiday arrival was no cause for celebration in the Mead household. Taylor's parents were estranged, *so* estranged that his mother wanted to abort him when she first learned she was pregnant. ("Sheer luck that I was alive in the first place," he always said.) Unfortunately, Priscilla's attitude did not improve after her son was born. Taylor's head was oversized and one eye drooped (the result of either "an accident at birth because my head is so big and brilliant that the forceps slipped" or a street fight, depending on which tale Taylor was spinning), so he always looked quizzical.

It was a face only a mother could love, but apparently not *his* mother, who left her infant in the care of neglectful servants. Taylor's childhood was so horrible that, at the tender age of four, he decided to strike out on his own. Dressed in a little red suit, he boarded a bus and managed to get thirty miles from home before anyone noticed he was traveling alone. He was given an ice-cream cone and promptly returned to the not-so-warm bosom of his family. Taylor had a habit of exaggerating the Dickensian elements of his childhood, but there were also times when he spoke adoringly of his mother.

Priscilla died when Taylor was thirteen, forcing him to bounce back and forth between boarding schools and his father's home in Detroit. To say that Harry Mead did not understand his unusual progeny was an understatement. A conservative Democratic chair-

man, liquor control commissioner, and head of the local WPA, he had absolutely nothing in common with his flamboyant and unabashedly homosexual son, who knew that he was gay by the time he was twelve.

Disenchanted with the bourgeois life he was supposed to lead, and still a four-year-old runaway at heart, Taylor left home with fifty dollars in his pocket, hoping to find his place in the world. He moved constantly, from New York City to San Francisco and Los Angeles; from slums to prisons; from poetry clubs to the Pasadena Playhouse, where he studied acting. Sometimes he had to beg, borrow, and steal to get by, but Taylor always managed to find humor in the darkest situations. He was no ordinary hobo, he insisted. Instead he called himself "a drifter in the arts."

During one of his extended stays in New York in the late 1950s, Taylor read Jack Kerouac's bestselling picaresque novel *On the Road*, the story of two charismatic beats on their way to California in a fast car, and had an epiphany. The book "put me on the road," he said. He immediately headed for the hipster-friendly terrain of North Beach, San Francisco, where a new cultural movement was afoot. His constant companion was his transistor radio, one of the first portables.

Ron Rice spotted Taylor reciting his offbeat poetry in a coffee house and cast him as the lead in his experimental film *The Flower Thief*. It was a minimalist production: the film stock was left over from World War II, the budget was a whopping $500, and the plot—the picaresque adventures of a beatific fool who wanders through the city's beat landscape clutching an oversized teddy bear, a wilting blossom, and an American flag—defies summary. Yet Taylor was such an outstanding comic presence that fans compared him to Charlie Chaplin and Buster Keaton. "The source of his art is the

deepest and purest of all: he just gives himself, wholly and without reserve, to some bizarre autistic fantasy," wrote Susan Sontag of Mead. "Nothing is more attractive in a person, but it is extremely rare after the age of four," she added drolly.

Although he was becoming well known for his films and poetry readings, Taylor's real claim to fame was his ubiquity: he knew everyone and seemed to turn up *everywhere*—at parties, clubs, Happenings, openings, and at Andy Warhol's townhouse.

During this impromptu visit, Taylor and Geldzahler sat down to Bacardi and Cokes and sandwiches (prepared and served by Julia, who emerged from her kitchen retreat to fuss over Andy's guests), and the three men paid homage to each other. Taylor had just read an article about Pop Art in a magazine and thought Andy's work was brilliant. "You are the Voltaire of America. You're giving America just what it deserves—a can of soup on the wall," he enthused. Andy, as usual, was thrilled to be in the presence of someone he considered a star, especially since he had become so interested in underground film.

Eventually, the conversation came around to Andy's upcoming exhibition at the Ferus and the trip that would get him there. Taylor was so adept at traveling cross-country—he had done it at least five times—that he would be a great addition to the group. And, as Andy was shocked to hear, he actually had a license, so he could share driving duties with Wynn. "I frankly couldn't believe from looking at Taylor that he really knew how to drive," Andy remarked. Then again, he was frequently surprised by the people who could drive and the people who couldn't. Drivers were supposed to be alert and focused. Taylor, he said, "looked so chronically relaxed you felt that if you lifted him up by the back of his neck, his limbs would just dangle. I mean, he looked like he didn't have a nervous system."

The Trip

Nervous system aside, Taylor was actually an expert driver. He grew up in Detroit, after all, and his friends were Fords and scions of other automobile families. Cars were omnipresent. Without knowing about his skills at the wheel, Andy decided that Taylor, with his "slight smile on his face and in his eyes," and his "pixyish," "elfin" personality, would be good company. And how appropriate to bring a star, even one of the underground variety, to Hollywood. Taylor agreed and signed on for the trip.

There was still an empty seat in the car, and Andy decided to fill it with a squire as faithful and resourceful as Don Quixote's Sancho Panza: his own Gerard Malanga. Gerard was supposed to finish his silkscreening job at the Firehouse and head back to Wagner College in September. He was a young man with all sorts of responsibilities. Willard Maas had arranged a full scholarship for him that year; his classes were about to start; and, as editor of the Wagner literary magazine, it was his job to oversee the mechanicals and get the spring issue to the printer—all compelling reasons to decline Andy's invitation and get back to real life.

On the other hand, Gerard could think of several good reasons to jump into the car. He had never taken a road trip, and this one—going all the way to Los Angeles and back—promised to be a sensational first. Leaving town would also offer him a quick escape from a troubling situation at home. His parents had separated, and the fact that they thought it permissible to take time off from their marriage gave Gerard the idea that *he* could take a break from responsibility as well. He imagined how liberating it would be to drive away from deadlines, duties, expectations, and the sadness at home. The semester would be waiting for him when he got back, he rationalized. At that moment, he wanted to be free.

As Andy was finalizing plans for the trip, he made sure to reach out to friends and fellow artists in California. Claes and Patty Oldenburg had recently moved to Los Angeles with their cat, Charlie, and were preparing an exhibition at the Dwan Gallery that was, coincidentally, scheduled to open the night after Andy's show at the Ferus. Patty was pleased to hear that Andy would be coming to LA and sent him a postcard decorated with palm trees to whet his appetite for sunny California. "It is so beautiful here . . . everyone is blonde & sandy," she wrote. She loved the beach and the balmy weather after the "dirty, loud city streets of New York," She asked Andy to write back with his travel information, promising to meet him at the airport. It never occurred to her that her friend would be *driving* all the way from New York to LA.

Meanwhile, Andy was trying to finish his paintings for the Ferus. Lately, however, he was finding these images static. His ideas were evolving and wanted to come to life. He had simulated movement in his portrait of Ethel Scull by assembling her photo booth poses and styling her gestures to suggest motion. It occurred to him that if he made movies, he wouldn't have to simulate anything: his images would really *move*. Though Andy was intrigued, he didn't know the first thing about filmmaking.

Luckily, his friend Emile de Antonio—the same friend who encouraged him to move from commercial art to painting—was there to introduce him to New York's exciting new world of underground film. De, who was always in the vanguard of cultural movements, had become a documentarian and a charter member of the New American Cinema Group. Founded by Jonas Mekas, a Lithuanian émigré who came to America after World War II and immediately became an impassioned champion of avant-garde film, the group consisted of twenty-three disillusioned filmmakers who banded

together to take a stand against what they called the corrupt com-
mercialism of mainstream, or "official" cinema. Their manifesto
stated that fresh winds were blowing in the worlds of painting, po-
etry, sculpture and theater, and that cinema was no different. They
argued that slickness of execution—the kind that could be seen in
big-budget Hollywood movies—was "a perversion covering the
falsity of their themes, their lack of sensibility, their lack of style."
Mekas was so opposed to multimillion-dollar extravaganzas—espe-
cially the headline-grabbing *Cleopatra*—that he suggested it would
be smarter to buy a huge lump of gold with the money and charge
admission to see that at Radio City Music Hall. "Why go through
all the trouble of making a movie?" he wondered.

These filmmakers had a different kind of movie in mind—low-
to no-budget, free of stars, studios, and producers, and not subject
to censorship or licensing. "We don't want false, polished, slick
films . . . we prefer them rough, unpolished, but alive; we don't want
rosy films—we want them the color of blood," they proclaimed. To
make this new kind of cinema available to everyone, Mekas and his
associates opened the Film-Makers' Cooperative, a film distribution
center run by "ourselves," they boasted. Headquarters was Mekas's
loft on Broadway, where filmmakers including Ron Rice, Jack Smith,
and Barbara Rubin came and went at all hours, eager to share their
new ideas and latest footage. At the end of the day, it was not unusual
for a weary Mekas to curl up under his editing table and go to sleep.

In addition to projecting footage at his loft, Mekas hosted late-
night screenings at the Charles Theater and, later, at the Gramercy,
offering filmmakers the opportunity to show their works—and
works in progress—to an appreciative audience of avant-gardists.
Sometimes these insiders were joined by "ordinary people" who

imagined that "underground" films were racier than those playing at their local theater—and, in 1963, they were usually right. Commercial movies such as *How the West Was Won*, *Son of Flubber*, and *McLintock!* were spanking clean. Movies that even alluded to sex— *The V.I.P.s*, *Irma la Douce*, and the omnipresent *Cleopatra*—kept things decorative and demure. But *everything*—nudity, sexual pairings of all kinds, including homosexual, drugs, and other decadent behavior—could be seen in films of the New American Cinema because nothing was taboo; breaking rules meant breaking ground.

Andy attended these screenings with various friends—de Antonio, Charles Henri Ford, John Giorno (the handsome young stockbroker/poet who was his latest crush), and Gerard. The films were deliberately primitive, with amateur casts, erratic photography, and nonexistent production values. As a contemporary artist, Andy was *supposed* to like them, and he did, to an extent. But he wondered why they weren't more glamorous. "They're so terrible," he complained to Giorno one night, after seeing a particularly challenging underground film at the Bleecker Street Cinema. "Why doesn't somebody make a beautiful movie? There are so many beautiful things!"

Andy had some ideas, and he was eager to get started. First, he needed a camera. Gerard was a good source of information because he had worked with Marie Menken on some of her film projects and knew his way around a Bolex, the underground filmmaker's camera of choice. The Bolex was to movie cameras what Campbell's was to soup: a great, democratic innovation that brought filmmaking to the masses. It was so lightweight and easy to use that *anyone* could make a movie. That was the intention of its inventor, Joseph Bolsky, who had founded his own company in 1927 and had pioneered the development of a handheld movie camera. He named his camera

"Bolex," a combination of the first two letters of his last name and the last letters of Rolex, the expensive Swiss watch famous for its space-age technology. According to Bolex ads, "America's foremost cameramen," including several Academy Award winners, "prefer the Bolex H-16," which promised to give "professional results to the amateur . . . with absolute ease."

Gerard and Charles Henri Ford accompanied Andy to Peerless Camera to help him pick out his H-16, which was outfitted with a zoom lens and an automatic motor drive attachment. He was eager to start using his new toy, but he was the first to admit that he didn't know what he was doing. "How do you focus it?" he asked his filmmaker friends repeatedly. They tried to be patient with him, but the only way to learn to use the camera was to start shooting, so Andy packed his Bolex and headed for Old Lyme, Connecticut, where Wynn Chamberlain had rented a summerhouse on an estate owned by a family of nudists.

Wynn was a gregarious host who welcomed a diverse crowd of artists, filmmakers, and personalities. According to Andy, Wynn's place was packed with as many as forty guests at a time, and anything could happen during a hot summer weekend. "People were up all night wandering around the grounds smoking dope or playing records back at the house. Every weekend was a nonstop party," with no demarcation between day and night, he reported.

There was a reason for this widespread insomnia. Like weight-conscious Andy, his friends were taking Obetrol, or some form of amphetamine, for appetite control and recreation, which meant that no one was getting much sleep. Seeing so many people awake at all hours prompted Andy to ponder a larger philosophical question: Did people take speed because they needed more time, or

did they have more time because they took speed? In either case, he decided that sleep was becoming obsolete and needed to be memorialized, a conclusion that inspired the idea for his first film. He would make a movie about a person sleeping and he would call it *Sleep*.

Wouldn't it be fabulous to film Brigitte Bardot sleeping for eight hours, Andy suggested to Gerard. Even *he* knew that the French bombshell was not a realistic choice, but he did know someone within reach who was perfect casting. His friend John Giorno loved to sleep, deeply and photogenically. Unlike most people, Giorno actually looked good while sleeping. Andy arranged to film him over the summer, and spent whole nights with his Bolex trained on Giorno's unconscious body. There were a few stumbles along the way because Andy was still learning how to use the camera. But he was off to a good start, and he soon had enough footage to think about putting together an eight-hour film (if he showed the same shots multiple times).

Andy had the opportunity to see an experienced filmmaker in action at Wynn's that summer. Jack Smith, a living legend in the world of the New American Cinema, was shooting his underground extravaganza *Normal Love*. Andy had seen Smith's previous film, *Flaming Creatures*, which Calvin Tomkins at the *New Yorker* described as showing "fantastically draped beings, male and female" who "parade their genitalia before the camera, and eventually indulge in a ridiculous orgy that seems to coincide with an earthquake." A complex scenario that unfolded in only forty-three minutes, the short film packed such a wallop and outraged censors to such a degree that, by 1964, it had been banned in twenty-two states and four countries.

Normal Love involved more clothing (and less "deviant" behavior than *Flaming Creatures*), but it was equally flamboyant. Smith's

cast included Andy, Gerard, Patty Oldenburg (whose husband designed the giant, three-tiered cake that served as a stage), the poet Diane di Prima (who was in such an advanced state of pregnancy that she was poised to give birth), the actor and transvestite Mario Montez, and other adventurous houseguests who frolicked on the cake and in the woods, outfitted in everything from bikinis to vintage dresses—and that was on the men. Andy wore a flouncy gown, a red wig, and sunglasses, and proved his agility by shimmying and chewing gum at the same time.

While he was "acting" and watching Smith at work, Andy learned some valuable lessons. He noticed that Smith plucked his cast from anyone who happened to be around that day, and he kept shooting until his players were so bored they couldn't go on. The real beauty of being a filmmaker, Andy decided, was that a director could be at the center of a group yet outside it. Painting was a solitary experience, even with an assistant. Making movies was more social—easier in so many ways—and lots of *fun*. Best of all, with the camera in front of him, Andy could get very close to people but at the same time stay very far away.

Andy was tentatively circling the periphery of the independent film world, looking for a way in, but Gerard was already an insider, with privileged access to the people at its epicenter. In New York's pulsating cultural underground, Gerard met Naomi Levine, a freethinking young woman who cast herself in the role of liberated downtown artiste. With her voluptuous body, unruly mane of curly black hair, unconventional style of dress (she was always happiest without clothes, she said, à la Marilyn Monroe), and adventurous attitude, Naomi was a flamboyant embodiment of the new woman—the new *liberated* woman, whose finishing school was Helen Gurley

Deborah Davis

Brown's controversial advice book *Sex and the Single Girl* and Betty Friedan's feminist manifesto *The Feminine Mystique*.

Naomi Levine had the advantage of being both enlightened and affluent. Her father was a successful theatrical lawyer who maintained his family handsomely in a large apartment on West Twelfth Street, in one of Greenwich Village's most beautiful buildings. Like so many young rebels, Naomi purported to want a more bohemian lifestyle than she enjoyed at home, so she moved to the East Village, the scrappy habitat of serious writers and artists. Since she was used to a high level of comfort, *her* place was located on scenic East Tenth Street, the lone block of luxury in a neighborhood of tenements and low-income projects.

Naomi wanted to have a career—preferably something in the arts. She thought she might be a painter, until she encountered the far more intriguing (and accessible) world of independent film. She started spending time at the Film-Makers' Cooperative, where she met Jonas Mekas himself. Confident that she could be a filmmaker, Naomi began shooting her first film, *Yes*. Mekas was enormously supportive after he saw some early footage and wrote about Naomi in his Movie Journal column in the *Village Voice*. "It is like no other movie you ever saw," he promised, extolling *Yes*'s virtues. "No man would be able to get her poetry, her movements, her dreams . . . Naomi's own beauty."

In the same column, he praised the work of another up-and-coming female filmmaker who was a regular at the Coop. Barbara Rubin was a complicated young woman—a teenager, actually—who had just come out of rehab after having been addicted to amphetamines, prescribed by her family doctor for weight loss. Upon her release, a concerned relative found her a job at the Coop, probably thinking she would fit in perfectly with the creative types who

hung out there. And she did, especially after she borrowed Mekas's Bolex and set out to make a movie.

The subject was an unlikely choice for the seemingly fragile young woman. *Christmas on Earth,* as Rubin titled her film, consists of two half-hour reels of in-and-out-of-focus images of men and women, genitalia and all, engaged in extreme (and sometimes unidentifiable) sexual activities. In other words, she filmed an orgy. Shot in an apartment over a short period of time, the film follows the activities of an enthusiastic and energetic group whose bodies are largely disguised with black-and-white paint.

Christmas on Earth is extremely low on plot, but the film has a certain gynecological charm, mainly because it goes where no camera had gone before. Some of the close-ups—which are disturbingly close-up—turn the naked body into a landscape and prompted one critic to wonder if he was looking at a painting by Georgia O'Keeffe. Viewers found the film shocking (and would still find it shocking today), but what was most amazing was the sheer girl power that radiated from the film's fearless young director.

There was (and still is) a controversy surrounding *Christmas on Earth* that further enhanced Naomi Levine's reputation as an utterly liberated woman. Who was that fearless actress who performed with absolute abandon for Rubin's penetrating camera? Naomi Levine, insiders guessed, because she enjoyed flaunting her body and being the most outrageous girl in town.

Mekas's enthusiastic evaluations of their fledgling work turned Barbara Rubin and Naomi Levine into downtown celebrities, the filmmakers to watch that season, and Naomi, for one, enjoyed her new status as an underground star. She delighted in confusing people with her seemingly contradictory personality. One minute she was a hard-

ened revolutionary, at the center of the action, wherever it was, pro-
testing everything from war to movie censorship. The next, she was
a romantic, using her camera to create images that were "languorous,
lovely, with naked children, flowers, and nature everywhere." Naomi
expressed her softer side by drawing "huge, colorful, sad, almost
tragic flowers" on everything. At the same time, she was relentlessly
flirtatious: the experimental filmmaker Ken Jacobs called her "madly
sensual Naomi Levine." She was the avant-garde's answer to Jayne
Mansfield, uninhibited to the point of being exhibitionist.

When Naomi wasn't busy being a "star," she was a clerk at the
Manhattan toy store FAO Schwarz. But most evenings, the edgy
darling set out to seduce. She fluffed her curly hair, dressed in re-
vealing clothes, and transformed herself into the underground "it
girl" people expected to see. To complete her sexy boho look,
Naomi threw on a fur wrap and sucked on a lollipop, a very provoc-
ative way of announcing that she was available. She could be spot-
ted at every art opening and every screening, always looking to
attach herself to the next big thing.

The next big "thing" on Naomi's radar was Andy Warhol. Ru-
mors about *Sleep* were circulating through the underground net-
work, so Naomi was eager to meet the Pop artist—turned filmmaker.
In July, Gerard offered to introduce Naomi to Andy at a perfor-
mance of the play *The Brig*, at the Living Theater. Andy and his
companions, Wynn Chamberlain and John Giorno, were dressed in
tuxedos that night because they were headed to a party at the Mu-
seum of Modern Art following the show. Naomi tagged along with
the elegant trio and felt an instant connection to Andy. She found
him to be a very gentle person, and she was attracted to that side of
him. She also thought that he had a "marvelous sense of humor."

Naomi looked at Andy and saw a potential conquest. The fact that he preferred men was not likely to deter her ("The New Bohemian rebels against the either-or restrictions of hetero- and homosexuality," wrote John Gruen in his analysis of modern mores). And when Andy considered the wild, uninhibited, and exhibitionistic Naomi, what he saw was his first superstar.

Andy had been looking for a way to bring glamour and (dare he even *think* it) a touch of old Hollywood to his films, and meeting Naomi Levine inspired him to come up with an audacious idea. He was working on a silkscreen that summer—a moody meditation on an image from the 1932 movie *Dracula*, starring Bela Lugosi. In it, the charismatic actor who transformed Bram Stoker's bloodthirsty vampire into a mesmerizing antihero is poised to bite the throat of actress Helen Chandler. The moment is dangerous, yet intensely sexual. Andy titled his version of their dark embrace *The Kiss*.

With one foot in fine art and the other in filmmaking, Andy decided to take the same concept and reinvent it for his camera. He recruited Naomi and the French film critic Pierre Restany to lock lips for one hundred feet, or three minutes, of film, an intimate coupling he called *Kiss*. Andy and Gerard set up his Bolex in Naomi's apartment and framed a *very* close close-up, one that paid homage to the classic movie clinches of the past, yet allowed for the forthright sexuality that was the hallmark of new underground cinema.

Kiss also served as Andy's sly commentary on movie censorship, or the Hays Code, which was in force from 1934 to 1968. The "guidelines" set forth in the Movie Production Code were supposed to keep Hollywood moral, and guideline number 25 prohibited "excessive or lustful kissing." Any kiss that lasted longer than three seconds suggested the kind of passion that was bound to lead

to something else, thereby violating the code. Of course, ingenious filmmakers found ways to circumvent the silly rule: in *Notorious,* the director, Alfred Hitchcock, instructed Cary Grant and Ingrid Bergman to pause—and resume—their kiss every few seconds, instead of indulging in one long kiss that would get cut by the censors.

Unlike Hitchcock, Andy told his "actors" to kiss, kiss, and kiss some more, as long as he kept the Bolex rolling. They obeyed, but their embrace was more polite than passionate. Less than a minute into the shot, Naomi started to laugh and pulled away from her partner. It seemed that Restany's moustache was tickling her to the point where she couldn't concentrate on their kiss. Determined to keep going, Andy asked Gerard to step in and take over. He did. Gerard was a masterful kisser with all the right moves, and he wasn't shy about performing them on camera. Suddenly, the chemistry between the kissers was palpable, and sexual fireworks ensued.

As for Naomi, she responded in kind. If she looked engaged, she probably was. "Anything that happens on a set happens—there is no acting," she told Jonas Mekas in a *Village Voice* interview. "When I kiss I am kissed and I have kissed." Other men, including the poet Ed Sanders of the band the Fugs, and the Living Theater actor Rufus Collins, appeared with Naomi in subsequent *Kiss* segments, but her extended make-out session with Gerard ignited the screen, probably because she was trying to make Andy jealous.

Naomi was hurt because Andy, whom she considered her new best friend, showed no interest in bringing her to Hollywood. Somehow, she imagined a romance budding between them, but Gerard had something to say about that. "She was crazy about him as so many crazy girls are," he observed dismissively. Naomi usually got what she wanted from men because she was young, sexy, and fearless. But this potential

conquest was beyond challenging, to say the least, and required her to be clever. Determined to join Andy on the West Coast, Naomi planned her own trip. She was going to Los Angeles to raise money for the Film-Makers' Cooperative, she announced self-importantly. She would stay with John Chamberlain and his wife, Elaine, who had moved to Topanga Canyon. And, unlike Andy, she would fly.

While filming *Sleep* and *Kiss*, Andy had an ingenious idea. In addition to wanting to infuse his movies with a little glamour, he was also looking for an alternative to the frenetic shooting and editing styles that characterized most underground films. He came up with two solutions: he used a stationary camera—one that "watched" almost voyeuristically—and he projected the finished film at a slower speed of sixteen frames per second, instead of the conventional twenty-four frames. The difference was almost imperceptible to the eye, a slight displacement of time. But it registered on the viewer because it was a little "off"—the classic Andy "wrong thing in the right place/ right thing in the wrong place"—and made it difficult to look away. Even the most jaded cinephiles felt as if they were seeing something new. The languorous pace, combined with the silent black-and-white image, put a classic "yesterday" spin on a thoroughly modern concept.

Filmmakers were at the center of the New York universe that September, when the city hosted its first official film festival, a ten-day celebration of twenty-one feature films, including Luis Buñuel's *The Exterminating Angel*, Joseph Losey's *The Servant*, Alain Resnais's *Muriel*, Robert Bresson's *The Trial of Joan of Arc*, and newcomer Roman Polanski's *Knife in the Water*. The New York Film Festival underscored the new synergies in the world of contemporary culture by commissioning the artist Larry Rivers to paint a giant billboard advertising the event. Barriers were being broken

and different kinds of artists were working together—with cameras and brushes, with canvases and movie screens, and even with billboards. Uptown, downtown: the new art was *everywhere*.

When Andy opened the September 20 issue of *Time*, he found a cover story that was a lengthy love letter to the New American Cinema. According to the French New Wave director François Truffaut, it was time to abandon the old ways of filmmaking. "A borrowed camera, some cheap film, a friend's apartment, friends to play the parts, and above all the faith, the rage of the cinema—the rage to storm the barricade, to use this way of expression—the way of the future, the art of the future," he preached. Truffaut's impassioned rant sounded very much like Claes Oldenburg's manifesto, when he said, "I am for all art that takes its form from the lines of life itself, that twists and extends and accumulates and spits and drips, and is heavy and coarse and blunt and sweet and stupid as life itself."

Fueled by these new philosophies, new energy, new lightweight equipment (like Andy's Bolex), and stimulating new techniques, movies, *Time* suggested, "have suddenly and powerfully emerged as a new and brilliant international art, indeed as perhaps the central and characteristic art of the age." The article confirmed what Andy had been thinking all summer—*filmmaking*, not painting, was the art of the future.

If Andy had any doubts about his position in this new constellation, Jonas Mekas, the king of independent cinema, gave him the warmest of welcomes. Mekas wrote in his column, "Andy Warhol . . . is in the process of making the longest and simplest movie ever made: an eight-hour-long movie that shows nothing but a man sleeping. But this simple movie will push Andy Warhol—and has pushed me, and a few others who saw it, some of it—further than

we were before." There it was, in the *Village Voice,* proof positive that Andy Warhol was a bona fide filmmaker.

Andy was so preoccupied with making movies that he found it difficult to concentrate on anything else. However, there was work to be done at the Firehouse. Irving Blum needed the Elvis and Liz canvases in Los Angeles in advance of the show. He assured Andy that "interest is passionate and feverish and the collecting community is in daily contact for word on the arrival of your series," which was probably a bit of an overstatement, given the tepid reception to Andy's previous show.

When it was time to ship his works to the Ferus, Andy took the lazy (and cheap) way out. He sent Blum a big roll of life-size Presley images and a pile of stretcher bars, the sight of which made the dealer very nervous. "You mean you want me to cut them?" he asked, hoping that Andy would come early to do the job himself. Andy responded that he was too busy to come before the show, but pointed out to Blum that there were specific stretchers to match specific paintings— single images, double images, and triple images, their sizes predetermined by Andy. "He couldn't be bothered to cut the *Elvises,* but he made sure I cut them the way he wanted," Blum recalled with bemusement. Andy further complicated the installation by specifying that he wanted the pictures hung edge to edge, creating a logistical puzzle for Blum. The Silver Liz portraits were somewhat manageable because they were 40-inch squares that could be displayed in the rear of the gallery. But the *Elvis*es were different sizes, and blocking out the appropriate wall space was a real challenge.

While Blum struggled to find solutions, Andy started packing for the trip. In his new filmmaker state of mind, it was his Bolex, not his paints, that he carefully placed in his suitcase.

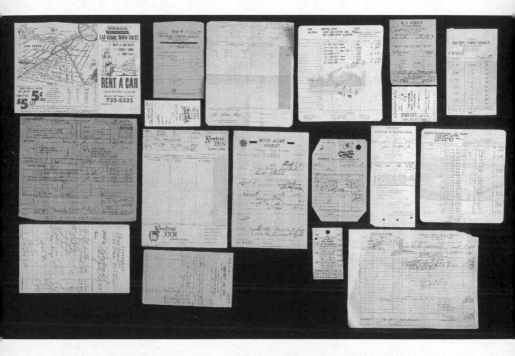

The researcher's dream: a notorious pack rat, Andy saved the receipts from his cross-country trip and they paint a vivid picture of his travels.

Chapter 7

It was a beautiful time to be driving across America.

—Andy Warhol

L ate in the afternoon on Tuesday, September 24, Wynn turned onto Lexington Avenue and pulled up in front of Andy's house. Taylor was sitting next to him in the front seat, poised to ride shotgun, and Gerard was in the back. It had been a beautiful day for a drive—sunny, cool, and clear, the temperatures in the midsixties—but the travelers decided to set out in the evening, figuring that it would be faster (and that they would avoid traffic) if they drove through the night. The door to the townhouse opened and Andy emerged with his bag, a stack of magazines, and his mother. Julia was happy that her boy was driving instead of flying, but it still made her nervous to think he would be traveling so far from home. She offered one last brave wave before going inside and returning to her kitchen. She was comfortable there, surrounded by pictures of her grandchildren, Christ, and President Kennedy, but it would be a lonely place without "my Andy" for the next two weeks.

Wynn's black station wagon was dusty after a summer of shuttling back and forth between New York and Connecticut, but even in its sullied condition, the stalwart vehicle was no ordinary car. The Ford Falcon was the automotive industry's answer to Pop—a rev-

olutionary reinterpretation of the most common of objects—and it would forever change the way that people thought about cars.

The Falcon was born in 1957 when, according to Detroit folklore, a Ford Motors' executive was struck by an idea while attending church one Sunday morning. Robert Strange McNamara represented a new breed of businessman-accountant whose management style was built on running numbers, or statistics, instead of using seat-of-the-pants experience. In 1943, during World War II, McNamara and a team of brilliant business brainiacs were recruited by the Army Air Forces' Office of the Statistical Control to train their analytical eyes on the science—and business—of warfare. Statistics, information, and systems were the weapons they wielded against waste, inefficiency, and mismanagement. These "civilian-soldiers," as they were called, were cocky intellectuals who used their business school skills to build "the most elaborate management information system of the pre-computer era," modernizing antiquated military operations that had been in force since the previous world war. Consulting their numbers, they determined how many planes to keep in rotation, how much fuel to store, how many pilots to have on hand, and other such operational issues. They asked practical, if irreverent, questions (given the territorial ways of the military), such as "Can't the Army and the Navy share bombers?" Data drove decision-making, and once "data-processing" entered the armed forces lexicon, the statisticians in the office became the equals of the generals on the battlefield.

This, of course, prompted an internal war. The analysts were usually at odds with the generals, who were suspicious of the college boys and their gutless number-crunching. But there was no denying that these new age statisticians optimized the military's use of

manpower and weapons, and in doing so, changed how wars were fought. McNamara was credited with persuading Major General Curtis LeMay to replace the practice of high-altitude bombing in Japan with targeted strikes on civilian population centers, a more deadly—but ultimately more effective—form of warfare.

When the war ended, the ten-man statistical control team was out on the street, looking for employment. McNamara and his buddies identified Ford Motor Company as an antiquated company that needed to adapt to modern times. The company was fragmented, with no statistics or centralized information about production costs, profit, or loss. In fact, information was so sketchy that no one at Ford knew the actual cost of making a car. The army whiz kids, including McNamara, impetuously (and some would say impertinently) sent Ford a telegram boasting that they could save the failing automaker. Young Henry Ford II was so impressed and, honestly, so desperate, that he instantly hired the team and let them loose with their primitive calculators.

McNamara worked his way up from controller to the all-powerful position of group vice president in charge of cars and trucks. When he surveyed the vehicles Ford had to offer, he spotted both a problem *and* an opportunity. The most popular cars in America were oversized because in the US of A bigger was always perceived as better. Ford's bestselling models, including the Fairlane and the Thunderbird, were large, long, wide, and heavy, with prominent grilles and tail fins that made them look even heftier. Some Americans were starting to warm up to smaller European cars, such as the spunky "think small" Volkswagen Beetle, prompting McNamara to wonder if every driver needed—or wanted—a car that weighed four thousand pounds.

Deborah Davis

The answer came to him that day in church. What Ford needed in its lineup was a "compact," a car that would be cheaper to produce, cheaper to buy, and cheaper to run, "something plain, inexpensive, and economical to meet the transportation needs of Mr. and Mrs. America." It did not have to replace the big family car sitting in most American driveways; the compact could extend the market by introducing buyers to the concept of the *second* car—the one a housewife might use to run errands. McNamara quickly outlined all the nuts-and-bolts specifications for his brainchild on the back of his church program, giving little thought to its "look." But in the three years that followed, McNamara's numbers added up to one of the most iconic and bestselling cars of 1960, the Ford Falcon.

The Falcon debuted as a trim little two-door sedan and a two- or four-door station wagon. At 2,400 pounds, the car appeared small, and it was 32 inches shorter than a full-size Ford. Yet tests proved that the interior was big enough to hold six men, with plenty of headroom for their ubiquitous fedora hats.

Ford sold 435,000 Falcons in its first year, validating McNamara's vision and prompting Henry II to promote him to president of the company. Two months later, McNamara received an even bigger promotion when he was invited by President John F. Kennedy to become the country's secretary of defense. By 1963, McNamara was ensconced at the Pentagon, masterminding the war in Vietnam, with Detroit a distant memory.

Wynn Chamberlain was one of the thousands of Americans who purchased a Falcon station wagon when the new model rolled out in 1963. Prior to this trip, the car had served as a utilitarian vehicle, solid, dependable, and big enough to transport passengers and canvases. On this September afternoon, Andy opened the

door and stepped into his "ride" to Hollywood. Its interior design was perfectly aligned with his Pop aesthetic. The car was minimalist, just like Andy's Coca-Cola bottles and Campbell's Soup cans. And, it was the product of an assembly line, just like his silkscreens. The dashboard was unadorned, almost elegant in its simplicity, with the ignition on the left, Porsche-style, and a series of pull knobs for the headlights, wipers, choke, temperature controls, and the all-important cigarette lighter lined up neatly under the speedometer and gauges.

The Falcon had practical virtues, too. It was surprisingly roomy, Andy discovered, when he sat next to Gerard in the spacious backseat. They could spread out comfortably, although the patterned vinyl seats were so slippery (there were no safety belts to keep passengers in place) that they slid around whenever Wynn or Taylor, depending on which roughrider was at the wheel, made a sudden turn.

What was it like to drive the Falcon? The six-cylinder engine could be noisy; the steering was a little flaccid, requiring many turns to the wheel; and the car's top speed was below ninety miles per hour. The twelve-gallon gas tank was on the small side—the Ford Thunderbird, for example, held twenty gallons. Low capacity would not have been a problem for McNamara's target customer— the housewife using the car to make quick trips to the store—but *this* Falcon needed to cover approximately 2,800 miles in five days, and under the best road conditions, might average 25 or 30 miles to the gallon, or 300 miles per tank. Gas wasn't expensive—a gallon of regular cost about thirty to thirty-five cents—but travel time was precious, and the car would have to be refueled at least nine times during the trip, which worked out to almost two gas stops a day.

On the plus side, the Falcon was the little engine that could, with

solid pick-up and a smooth, dependable ride. Its admirers called it "pleasant" and "peppy," the quintessential "cheap and cheerful" car. It was also bright and airy. The Falcon's generous window allotment included front and rear vents that opened and closed, and a window on the tailgate that could be raised and lowered with a hand crank. With so much glass, the car was like a greenhouse on wheels. More important, the wraparound windows provided passengers with an almost panoramic view of the ever-changing landscape, which made it the ideal vehicle for a sightseer on a cross-country trip.

The Falcon wagon offered seventy-six cubic feet of storage space behind the rear seat, which folded down to extend the already generous cargo area. The travelers took advantage of that real estate by placing a mattress in the back; the idea was that when Wynn was driving, Taylor could sleep, and vice-versa. However, it didn't take long for Andy and Gerard to realize that this impromptu bedroom was the best seat in the house. Lounging on a mattress was a very comfortable way to ride, so they appropriated the space and, according to Gerard, enjoyed being chauffeured to LA.

Since they were reclining where the luggage was supposed to be, Wynn had to stow their bags on the roof rack. The experienced travelers in the group knew to pack light—Taylor could traverse Europe with all his belongings stuffed into one small backpack. But Gerard, who was not yet a world traveler, had brought a giant suitcase that seemed to contain everything he owned.

Space was tight, and the proverbial clock was ticking, but spirits (as well as a few members of the group) were high. Andy had his Obetrol, and there was always a joint handy for those who were inclined to smoke. It was time to pull away from the curb, hit the road, and keep driving.

The Trip

According to a Port Authority time stamp on Andy's first toll receipt (until 1970, vehicles paid both when leaving and entering Manhattan), the speeding Falcon exited New York City at precisely 6:52 p.m., one minute after sunset, on Tuesday evening. With Wynn at the wheel, they started the journey west by heading south on the New Jersey Turnpike, driving about fifty miles to the exit that led to the Pennsylvania Turnpike.

Soon it was dark, but that didn't matter because there was absolutely nothing to see. Veteran road-trippers knew that the long, monotonous road traversing Pennsylvania seemed to take *days*, not hours, to cover. For the next 316 miles, until they switched highways near Pittsburgh and began to put the giant Keystone State behind them, Andy, Gerard, Wynn, and Taylor entertained themselves by getting to know each other. They were friends—sort of—but the dark car offered an intimate setting that promoted storytelling. With every passing mile, their personalities emerged.

In broad strokes, Wynn was quiet; Gerard was a dreamer; and Andy was a hypervigilant observer, nervous about the questionable attention spans of the quirky drivers in the front seat. Immediately, Taylor assumed the role of flamboyant raconteur and car clown. He was always onstage, even in the Falcon, where he had the most captive of audiences. Andy described Taylor's particular style of delivery as "slow, easy, if-anyone-happens-to-care." He had a habit of lifting up his chin and staring out the window at the end of a story, which was fine, as long as he wasn't driving.

The California trip prompted Taylor to reminisce loquaciously about beat hangouts in San Francisco, Venice Beach, and Greenwich Village. Everybody loved Taylor, according to Taylor. Tennessee Williams had come to one of Taylor's poetry readings and was so

enthralled by his poem "Fuck Fame" that he had sent him money. Taylor also described a strange man with long, stringy hair and a ukulele who called himself "Tiny Tim," who sang old-fashioned songs such as "Tiptoe through the Tulips." But the dropped name that captured everyone's attention was Bob Dylan.

Born Robert Allen Zimmerman in 1941, Dylan came up with his new name in 1959 while he was a student at the University of Minnesota. Echoing Andy's own sentiments about birth and self-reinvention, Dylan said, "You're born, you know, the wrong names, wrong parents. I mean, that happens. You call yourself what you want to call yourself. This is the land of the free." Dylan dropped out of school and moved to New York City, where he sang in coffeehouses. His voice was so unusual, so challenging, and so disturbing that the writer Joyce Carol Oates, who heard him perform at the time, described his sound as being "as if sandpaper could sing."

Taylor had seen the young folksinger play at a Village club back in 1960, when he was still a nobody, and he admired Dylan's work so much that he'd pronounced him a poet and given him a book of his own poetry. He looked "like a lost angel," Taylor recalled. Dylan's first album, *Bob Dylan*, did not sell many copies, but other singing groups, such as Peter, Paul, and Mary, recognized the power of his music and started to record his songs.

One year later, in May 1963, Dylan's second album, *The Freewheelin' Bob Dylan*, which featured the soon-to-be-classics "Blowin' in the Wind" and "A Hard Rain's a-Gonna Fall," was released to acclaim. Taylor ran into Dylan a second time. "And *now*, now when he's a big sensation and everything, he asked me for a free copy of my second book," Taylor laughingly recounted to his travel companions. He refused, telling Dylan, "But you're *rich* now—you can

afford to *buy* it!" "But I only get paid quarterly," the parsimonious singer replied lamely.

Whenever they made one of their frequent stops for gas, Taylor revealed another talent. In addition to being a great storyteller, he had a knack for persuading handsome young gas jockeys— guys who were absolutely straight—to accompany him behind the building for a quick session of oral sex. They were "trade" in the strictest sense of the word. Taylor "gave" and they "received." But it was incredible that his goofy charm worked on "he-men" in backwoods America. Andy was both intrigued and annoyed. He was jealous that Taylor was getting so much action in unexpected places and might have wished they could have traded places, but he was also in a hurry to get to California and counting every wasted minute.

Despite the fact that Andy wasn't driving, he was definitely captain of the ship because *he* was paying all expenses. Whenever possible, he proudly used his Carte Blanche credit card to pick up the tab. Credit cards, those thin pieces of plastic that magically took the place of money, were a relatively new phenomenon in 1963, but were fast becoming a status symbol, and Andy loved to flaunt it.

The first all-inclusive credit card, the kind that later cautioned customers "Don't leave home without it," whether for a dinner or a cross-country road trip, was the brainchild of a man who suffered an embarrassing experience at a New York City restaurant. In 1949, Frank McNamara (no relation to Robert), an executive in the financial world, was basking in the afterglow of a lavish meal at a fine dining establishment. When he reached into his pocket to pay the check, he was horrified to discover that he did not have his wallet. In this pre-ATM era, his only solution was to call his poor wife, who

was all the way out on Long Island, and ask her to race into the city with the requisite amount of money.

McNamara fumed all night, but by the next morning, had an idea. Why not start a credit system that would eliminate the need for cash? In short order, he founded the "Diners Club." Members, who were selected on the basis of their high net worth, were invited to pay a one-time fee of six dollars a year for the privilege of using a plastic credit card to charge their meals and other purchases at participating establishments. Once a month, cardholders received a comprehensive statement of their charges, which they were expected to pay in full. The establishments, in turn, were charged a 5 to 7 percent commission on the charges billed to the card. At its start, the Diners Club had 200 members (mostly friends and acquaintances of McNamara's) and 14 participating restaurants. Nine years later, 1,000,000 members and 30,000 businesses were associated with the card.

McNamara's simple yet practical idea revolutionized the perception of people who used credit. In the past, buying on credit was a sign of financial need: a person who couldn't afford a refrigerator, a car, or even a new suit bought "on time" to spread out the payments. The new credit card flipped that paradigm on its head: men and women of means were permitted to defer payment because they had the money in the first place. *Life* magazine said that a credit card was a status symbol, an indication of "inexhaustible potency," and cardholders were considered part of such an elite group that some businessmen actually included their credit card memberships on their résumés.

Alfred Bloomingdale, who became the president of the Diners Club, predicted that "twenty years from now there will be only two

classes of people. Those with credit cards and those who can't get them." Fortunately, Andy's sizable income qualified him to be one of the chosen. Although the Diners Club and its chief rival, American Express, were the top credit card companies, Andy signed up with the underdog, Carte Blanche, which was underwritten by the Hilton Hotels corporation and had a large international network. Its name conjured up images of casinos in Monte Carlo, tuxedos, and wealth.

Andy consulted the company's handy establishment guide—a prestigious leather-bound booklet sent to cardholders—and, whenever possible, he patronized restaurants that accepted the card, partly because charging was a convenient way to pay, but mostly because presenting the card at the end of the meal signified that Andrew Warhola had truly made it—a thought which must have crossed his mind when they came *this close* to Pittsburgh after exiting the turnpike in New Stanton, Pennsylvania. "This is where I come from. Let's get through here in a hurry," Andy said, urging Wynn to step on it before memories pulled him too deeply into his bittersweet "Hunky" past.

Artist Wallace Berman's imaginative reworking
of the Hoppers' invitation to Andy's "movie star
party" at their home in the Hollywood Hills.

Chapter 8

You sure get to know the Top Forty when
you make a long road trip like that.

—Andy Warhol

D aylight on Wednesday, September 25, unveiled a bright
new landscape for the travelers. Finally, the interminably
wide state of Pennsylvania was behind them, and they were
about to cross from Ohio to Indiana. At some point they had op-
timistically, if perhaps rashly, decided to drive straight through to
Amarillo, Texas—eleven hundred miles from Columbus, Ohio—
without indulging in a comfortable night's sleep at a motel. Until
then, the mattress in the back of the car would have to suffice as a
bedroom. That decision, which seemed weirdly rational in a speed-
ing car in the dead of night, was less palatable by day, but they were
determined to push themselves. It was difficult to say who had the
harder time: Wynn and Taylor, who had to alternate lengthy shifts
at the wheel, or Andy and Gerard, who sat passively in the back.

As the crow flew, the route was straightforward: they would
continue heading southwest until they reached Saint Louis, and at
some point they would pick up Route 66 and continue west all the
way to California. That was easier said than done. American roads
were undergoing a radical transformation as a result of the National

Interstate and Defense Highways Act of 1956, a pet project of President Dwight D. Eisenhower, and drivers those days never knew which routes would be open or closed for construction.

In 1919, Eisenhower, then a young army officer, traveled with a transcontinental motor convoy that took two long months to cross the United States. Decades later, Eisenhower reflected on the experience and what America could learn from it. Could a country that had antiquated roads transport troops and defend itself from an invasion, he wondered. And wouldn't the economy benefit from a network of highways that could move goods—and cars and people, for that matter—faster and more efficiently? During World War II, the sight of the autobahn, an ultramodern system of highways in Germany, convinced Eisenhower to support the largest public works program in American history—the construction of 41,000 miles of interstate highways at a projected cost of $30 billion (funded by taxes on gasoline and diesel fuel) over twelve years.

Construction started immediately, and by the time the project was completed in 1992 (many years and an additional $84 billion later) America was, indeed, transformed. With I-80, the world's first contiguous transcontinental highway, the convoy that moved at a snail's pace in 1919 would now be able to cover the same distance in two weeks instead of two months.

Unfortunately, the federal highway project was still in its infancy when Andy set out on *his* trip, so the travelers had to alternate between old roads and partially completed freeways. There were patches of the newly-built I-70 after Pittsburgh, but most of the time they had to follow Route 40 and contend with slowpokes who were not in a hurry to get to a "movie star party" in Hollywood.

Fortunately, the Falcon had a good radio, and the car raced and

rocked to the beat of pop music. East of Saint Louis, it was still pos-
sible for the travelers to hear the same songs Andy listened to at
home. He loved the girl groups who sang about love and loss, going
steady and breaking up (concerns that should have been too juve-
nile for a thirty-five-year-old man), and called them "honey-loves."
Their infectious lyrics and buoyant tempos raised the energy level
in the car. The number one song on the *Billboard* chart that week
was "Be My Baby" by the Ronettes, followed by "My Boyfriend's
Back" by the Angels. Andy's favorite song—the one he played over
and over again in the studio—was "Sally Go 'Round the Roses," by
the Jaynetts.

It sounded like a typical teenage lament, but there was some-
thing mysterious about "Sally Go 'Round the Roses" that sug-
gested drugs, or perhaps even an illegitimate baby, to some listeners.
Oddly, there were even theories that "Sally" alluded to a surrepti-
tious lesbian relationship. Whatever it meant, it was the cool song
that September—the one with deep, impenetrable meanings—and
Andy loved listening to it.

The other popular music was the surfer sound, a sweet reminder
of the long, hot days of summer and, in Andy's case, a taste of the
sun culture he was eager to experience in California. Coast to coast,
the two songs on every station's playlist were "Surfer Girl," a ro-
mantic ballad by the Beach Boys, and "Wipe Out," a fast-moving
instrumental by a group called the Surfaris. Celebrated in music and
movies, surfing and its catch a wave, live-for-the-moment philoso-
phy created a nationwide craze for beaches, bikinis, and boards.

While they were listening to the radio, the "boys" in the back-
seat had the option of reading. "I'd brought about fifty magazines
with me," Andy said, and he probably wasn't exaggerating. He

loved magazines with the passion of a hoarder, filling his house with piles of fashion, news, fan, tabloid, and pictorial periodicals. Sometimes he looked through them to see illustrations he had done on assignment, but he was just as likely to scour fan magazines for the latest news about his favorite stars.

Andy had packed everything from a stash of movie and teen magazines to *Vogue* and the latest issue of *McCall's*, although he was definitely not in the latter magazine's target audience. The large-format glossy billed itself as the "First Magazine for Women" and boasted 8.4 million subscribers with an emphasis on upscale suburban housewives. The September issue contained a dishy diatribe by Clare Boothe Luce on the potential impact of New York governor Nelson Rockefeller's scandalous divorce and speedy remarriage on his political career, and a think piece by the hostess with the mostest, Perle Mesta, about the charms of opulent Newport, Rhode Island.

The article that really captured his imagination, however, was a memoir by Hope Cooke, the twenty-two-year-old American who married Palden Thondup Namgyal, the crown prince of Sikkim. From her kingdom in the Himalayas, the crown princess described her new life with her husband, a widower seventeen years her senior, and his three young children. The story of their romance was a real showstopper. Cooke met the prince while she was vacationing in Darjeeling. For her, it was love at first sight, but there was no fairy-tale ending to their first encounter. Instead, Cooke returned to America to continue her studies at Sarah Lawrence, while the prince went back to ruling his country. They did not see each other or communicate for two years . . . until Cooke returned to Darjeeling for a second vacation. Magically, the prince appeared immediately upon her arrival, and they were drawn to each other as if no time had passed.

Finally, Cooke had her Cinderella moment. The couple got engaged, and then hosted a royal wedding that lasted five days and was the prelude to an incredibly privileged life in a beautiful palace in the clouds. Cooke settled into a royal routine and began her trip to happily-ever-after. She renounced her American citizenship to be with her prince and (horrors!) was dropped from the Social Register.

The story impressed Andy, but not because of its high romance. "How could an American debutante marry a guy and go off to live with him in Sikkim?" he asked himself. Cooke's rapturous description of her exotic new home was wasted on him. He was American through and through, and said he "couldn't imagine living in a tiny, nothing little place in the Himalayan Mountains." For that matter, he pointed out, he never understood how Grace Kelly could leave America for Monaco, but her move "didn't seem nearly as sad as going to Sikkim."

McCall's was full of controversial stories that month, including a heated discussion by the writer Gael Greene and the anthropologist Ashley Montagu about the hottest of topics, sex and the college girl. Something was in the air on campuses throughout the country. According to Greene, "Sex has become more explicit, more public . . . no longer exclusively the product of the bohemian, the intellectual, or the neurotic," and she saw this development as potentially positive as long as young women set their own limits and didn't succumb to peer pressure. Montagu, on the other hand, called relaxed morals on campus "carnal anarchy," and cautioned in a very fifties way that, in the new sexually permissive climate, "The sweetheart of Sigma Chi becomes the plaything of Fraternity Row."

Andy also subscribed to *Look*, and the September 24 issue con-

sidered America's rising tide of immorality so important a subject that "Morality USA" was that week's cover story. "Do We Need a New Code to Solve Our Crisis of Immorality?" and "Is Sexual Morality Gone?" the headlines asked. There was a sense that a sexual revolution was in the works, especially among young people, and that there was no way to stop it.

Andy was already shattering those sexual codes with his first films. In *Kiss,* he took the new "immorality" and put it on-screen by showing Naomi Levine in a succession of steamy embraces with men she barely knew (and just a few months later, he would *really* cross the line by filming *Blow Job,* a thirty-five-minute close-up of a young man's face as he reacts to offscreen oral sex from an unseen partner). The magazines were right: repression was becoming a thing of the past, and sex was stepping into the spotlight.

The serious magazines offered provocative reading and were a good barometer of the country's mind-set, but Andy still enjoyed his childhood pastime of scouring fan magazines for the latest gossip about his favorite stars. Hollywood was endlessly fascinating, and it was especially so for Andy at this moment, when he was about to see it in person for the first time. The magazines he usually read, including *Motion Picture, Modern Screen, TV Radio Mirror, Photoplay,* and *Teen Life,* often featured the same cover stories in much the same way that equivalent magazines, such as *People* and *Us,* do today, and there were two ways for a celebrity to score that prime real estate: a star had to be at the center of a scandal, or a studio had to be promoting an upcoming release. Elizabeth Taylor was the exception—or the rule. She was always at the center of a scandal and she always had a new film to flog. That month's *TV Radio Mirror* promised to tell readers "What Liz Taylor Knows about STEAL-

ING a Man!" while *Motion Picture* offered the inside story on "A Baby for Burton, Why Liz Must Give Him One." Andy was delighted to see that the luscious headshot on the cover—all hair, eyes, and lips—looked very much like the *Silver Liz* he was about to exhibit at the Ferus.

Another popular story in the September fan magazines involved two hot young actors named Troy Donahue and Suzanne Pleshette. He was the blond heartthrob who had thrilled teens with his performance in the 1959 star-crossed-lovers drama *A Summer Place* and in the 1961 tobacco dynasty melodrama *Parrish*. Andy loved Donahue's golden-boy good looks and made him the subject of several screen prints. Pleshette, Donahue's girlfriend and leading lady in the films *Rome Adventure* and the upcoming *A Distant Trumpet*, was a sultry brunette who began her acting career in the New York theater before moving to Los Angeles.

When the costars met on the set of *Rome Adventure*, Donahue had a reputation for being a wild, self-absorbed young man who was in danger of short-circuiting his career. Previously, there had been rumors about drinking—and the damaging accusation that he had been abusive to his former girlfriend, Lili Kardell. Thanks to the levelheaded Pleshette, he was better behaved in September 1963. Donahue seemed to be a new man, and gossip columnists at every magazine had one question for the lovebirds: When were they going to get married? Two years of steady dating could mean only one thing—that the glamorous young stars were secretly "playing house," which was not acceptable in an industry where contracts held morality clauses. An engagement and, better still, a wedding would put a more respectable spin on their relationship.

While Andy was sitting in the car, reading all the intriguing de-

Deborah Davis

tails about Troy and Suzanne's love life (and the advance hype for his upcoming movie, *Palm Beach Weekend*), the Hoppers sent out invitations to their upcoming "movie star party," and started receiving responses from their guests, *including* Donahue and Pleshette. The Hoppers were the youngest and hippest couple in Hollywood, but when it came to party invitations, they were strictly old-school. They sent out a rather formal card (too formal for the occasion, according to the etiquette guide Amy Vanderbilt), carefully writing "Mr. and Mrs. Dennis Hopper" in Palmer Method script over the printed line "request the pleasure of your company," then filling in the "what" ("at a cocktail party for Andy Warhol"), "when" (Sunday, September 29), and "where" (1712 N. Crescent Heights Boulevard, Los Angeles 46, California). The favor of an RSVP was requested.

Wallace Berman, one of the invitees, turned his response into a unique work of art. Berman was one of the original Ferus artists and a legendary figure in the California art scene because of his first solo show, which had been held at the gallery in 1957 and was raided by the LAPD, who shut it down and fined the artist for displaying lewd materials. Berman was so spooked by the experience that he was reluctant to show his work publically, so he focused on creating personal collages and *Semina*, a magazine dedicated to radical art and literature.

Berman used his collage technique to transform his invitation from the Hoppers into the opposite of a polite, social communiqué. He scrawled "Accepted. WB" in the upper corner and glued a torn, sepia-toned photograph of two masked couples engaged in lovemaking over the body of the card. The effect was strange and darkly erotic. Then he attached a stamp to the card and mailed it

back to the Hoppers on September 25. Recognizing that their prosaic invitation had been elevated to a work of "assemblage art," as such collages were called, the Hoppers framed it and added the latest "Wallace Berman" to their collection.

The other guests offered less imaginative but equally enthusiastic responses. They were happy to attend a party hosted by the famously fun-loving Hoppers. In addition to Berman, Donahue, and Pleshette, other young, up-and-coming actors such as Sal Mineo (who had appeared with Hopper in *Giant* and *Rebel without a Cause*), Dean Stockwell, John Saxon, Robert Walker Jr., Russ Tamblyn (best known for playing Riff, the hotheaded leader of the Jets in the film version of *West Side Story*), and Peter Fonda, Brooke's almost-relative, said yes. From the art world, the Hoppers expected Irving Blum and some of his Ferus artists, John Coplans from the magazine *Artforum* (which was located in an office above the Ferus), and the visiting New Yorkers, Claes and Patty Oldenburg, among others. The Hollywood hosts were pulling together the kind of intimate, celebrity-studded evening that starstruck Andy had always dreamed about but never imagined was within reach.

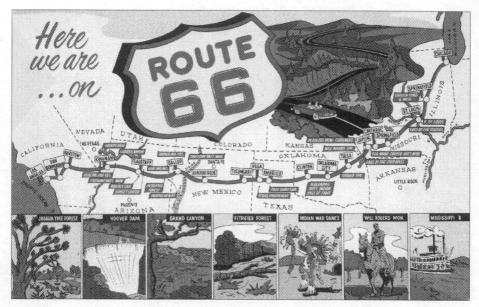

A vintage postcard promotes the attractions on storied
Route 66, which Andy saw firsthand on his trip.

Chapter 9

We sat in a booth over on the side—
and were, in fact, a sideshow.

—Andy Warhol

S aint Louis! The sight of the city was a welcome reminder
that the travelers had covered almost one thousand miles
since leaving New York the night before. Unlike Manhat-
tan, the vista showed more sky than skyscraper—but it was ex-
citing for Andy and Gerard to see the historic Mississippi River
for the first time. They were also able to see the foundation of the
soon-to-be-spectacular Gateway Arch, a giant monument com-
memorating the time when Saint Louis was the actual gateway to
the west—a time when explorers, cowboys, pioneers, migrant fami-
lies, and travelers just like Andy passed through on their way to the
fabled American frontier.

Initially, there was some controversy as to what form the city's
monument would take, but in 1947, a Finish American architect
named Eero Saarinen beat out the competition (including his own
father, Eliel Saarinen), with his elegant design—a soaring, gravity-
defying arch wrapped in stainless steel. The project was plagued
by financial and bureaucratic problems, so construction did not
begin until early 1963, but by the time the structure was completed

in 1965, it was 630 feet high and had the distinction of being the tallest man-made monument in the United States.

The "boys" were hungry after their long night on the road and wanted to get out of the car to stretch. Andy consulted his handy, leather-bound directory of Carte Blanche dining establishments to find a place to eat. He took these recommendations very seriously, partly because he could use his credit card, and partly because he believed that the restaurants listed in the guidebook maintained high standards worthy of the card.

A traditional steak house seemed like a good choice in a city famous for its beef. But Taylor, who was more sophisticated than his companions (and a real Midwesterner, as well as a longtime vegetarian), was not impressed with the chosen restaurant. He immediately dismissed it as being "knotty pine," meaning that it pretended to be authentically Western when it was actually a touristy rendering of the cowboy aesthetic. Andy, however, was as charmed by the ersatz "West" as by the real one. After all, Elvis was no more a cowboy than he was, but he certainly looked good in the outfit.

Leaving Saint Louis, the quartet continued their journey west on Route 66, one of the few roads that lived in legend. Variously nicknamed the "Main Street of America," the "Mother Road," and the "hipster's highway," it was the shortest and most direct route between the Great Lakes and the Pacific Coast, and it would take them through seven states (they skipped Illinois)—Missouri, Kansas, Oklahoma, Texas, New Mexico, Arizona, and California—before ending, literally, on the shore of the Pacific Ocean. In addition to being a direct, as-the-crow-flies solution to cross-country travel, Route 66 was a world-famous attraction. Like a Disneyland theme park ride (although considerably longer), it offered a panoramic

view of American life, one where tourists could see everything from the place where a young Abraham Lincoln had practiced law to one of the banks robbed by the outlaw Jesse James. And, just like a theme park ride, Route 66 was conceived to make money.

The father of this famous highway was an Oklahoma businessman named Cyrus "Cy" Avery who, at various times in the 1920s, worked in real estate, coal, and oil. But his *real* passion was roads and highways. Automobiles were relatively new at the time, so roads had to be built, or developed, to accommodate them. Avery was happiest when studying maps and plotting routes from one location to another. In 1921, his unusual expertise won him the presidency of the Associated Highways Association of America, as well as seats on Oklahoma's State Highway Commission and the American Association of State Highways. When the US secretary of agriculture needed someone to help plan a complex interstate highway system for the entire country, Cy Avery was the obvious choice.

He was very good at the job, until it was time to determine the route from Chicago to Los Angeles. In this instance, Avery voted with his heart, not his head. The new road *had* to pass through his home state of Oklahoma, he insisted, and cover as much of Oklahoma as possible, because he knew it would bring prosperity to the people who lived there. Avery got his way and looked forward to the grand opening of "Route 60," as he thought the new highway would be called, until he learned that rival planning officials from the East had claimed that route number for their Virginia–Missouri road. Avery was forced to settle for his second choice, the number "66." He was bitter at first, but he came to appreciate the alliterative sound of the new digits.

A born showman who understood the value of publicity, Avery







inspired. A few hours later, they switched highways in Saint Louis, and persistent Cynthia offered a second idea. "Get your kicks on Route 66," she suggested playfully, after seeing a sign.

Troupe loved *that* idea. "That's a darling title! Goddam. That's a great title!" he said. As they drove, the couple blocked out a song that re-created their cross-country itinerary. The map was his muse as he named several of the places they saw from the road. Troupe showed an early version of his song to Nat King Cole, and its catchy lyrics and jazzy, twelve-bar-blues beat appealed to the singing sensation. Cole recorded it that very year and it became an immediate hit. It also became the road's unofficial anthem.

In the late forties and fifties, thriving families took to the road in brand-new cars—mom and pop in the front, kids in the back—pursuing that popular new American pastime, the family vacation. The carnival-like atmosphere that characterized so much of Route 66 appealed to parents and children alike. There were motels with televisions, air-conditioning, and swimming pools (all for a few dollars a night); restaurants like Pop Hicks that specialized in barbeque, hamburgers and shakes; and exotic zoos, such as Zelda Davis's Alligator farm and the Regal Reptile Ranch—affordable activities that entertained the whole family.

While these travelers were enjoying good, clean fun on their sunny vacations, the writer Jack Kerouac and his buddies had a more nocturnal experience. Kerouac was inspired to plan his first road trip in 1947 after hearing Nat King Cole sing "Route 66," and the "get your kicks" part is what appealed to him the most. For Kerouac, Route 66 became the "Benzedrine Highway," as the writer and poet Charles Plymell christened it, referring to the drugs that beat drivers ingested to stay awake during their speedy, late-night

treks to and from California. It was these cross-country midnight runs that Kerouac described in *On the Road*.

Television's coolest portrayal of the road trip, and the one sure to have inspired Andy to set out in a speeding car, was the groundbreaking CBS series *Route 66*. In each episode, two young adventurers, Tod Stiles and Buz Murdock (played by blond, clean-cut, and handsome Martin Milner, and his dark, brooding counterpart, George Maharis), stopped in quintessentially American towns and became involved in local dramas as they made their way to the West Coast in a flashy Corvette.

From the first strains of its jazzy Nelson Riddle theme to its vérité-style, handheld shots of the leads in their fast-moving convertible, *Route 66* signaled that it was anything but a conventional ride. For one thing, it was the first television series to be shot on location. The veteran writer Stirling Silliphant traveled to the selected location a few weeks in advance to scout the story. Inspired by the locals and their setting, he would then develop a scenario that was organic to that particular place. An episode set on the beaches of Malibu, for example, was built around surfers. When a script was near completion, the actors and the crew headed for the location and raced through a week of production. Later, when the episode aired, many viewers discovered for the first time that each part of the country had a look all its own.

Part travelogue and part gritty soap opera, the show inspired widespread wanderlust. "Maharis and his companion, Martin Milner . . . probably incited more Sunday drivers onto the open road than the Automobile Club of America," said the *New York Times*.

Thanks to iconic books, songs, and television shows, Route 66 had such a long and colorful history that Andy and Gerard—the

cross-country neophytes—had great expectations. However, when Andy saw the storied mother road, for the first time, he might have thought he was back in his neighborhood in Pittsburgh, or on Main Street in Anywhere, USA. In Saint Louis, the "highway" passed through nondescript neighborhoods, where the closest thing to a roadside attraction was a midsize, white clapboard building with a long line of ice-cream aficionados waiting to be served. Busloads of customers flocked to Ted Drewes, a Route 66 favorite that was the home of family-made frozen custard so thick and creamy it was affectionately called "concrete."

The view got more interesting when they exited the city and drove past some of the flashy motels that dotted the route. Andy considered roadside motels to be very American and admired the ones rendered in the sleek style called Streamline Moderne, which featured rounded edges and glass-brick walls. In addition to having these flamboyant design flourishes, Route 66's flashy Coral Court Motel offered guests an unusually "moderne" solution to infidelity: the rooms had private, attached garages with interior entrances, so no one could see misbehaving couples coming or going.

Taylor was determined to improve the quality of the food on the trip and staged a mutiny over the square, sterile (and usually inferior) restaurants Andy had selected from his credit card guide. There were great Carte Blanche places in big cities, he acknowledged, but here on Route 66, the designated eateries were "semi-elegant shit" with "bourgeois people," he sniffed. He wanted a more authentic roadside experience and put his diminutive foot down, insisting they follow the veteran road-tripper's first rule of thumb or, as Jack D. Rittenhouse expressed in *A Guide Book to Highway 66*, "Any time you see several huge trucks parked outside a road-

side café, you can usually be assured of excellent coffee and possibly other food as well, for these men who make long drives know where to stop."

In 1946, Rittenhouse penned the first ever Route 66 guidebook, which he described as "a mile-by-mile complete handbook on how to get the most fun from your trip." He conducted his research from the driver's seat of a 1939 American Bantam coupe, riding the route "from dawn to dusk at 35 miles per hour." Somehow, Rittenhouse managed to scribble copious notes on a pad while he was at the wheel, collecting practical information about Route 66 locations (directions, population, and availability of gas, food, and lodging) *and* helpful tips.

But Taylor didn't need a guidebook to tell him where to eat. He had stopped at great diners and roadside restaurants during his previous cross-country excursions, and he knew the locations of homespun places that served the kind of *Diners, Drive-ins, and Dives* food he craved. In Missouri, the best meals could be had at the Tri-County Truck Stop and at another truckers' favorite called the Diamonds; in Oklahoma, Clanton's Café (known for its chicken-fried steak and "calf fries"—breaded bull calf testicles with a horseradish sauce) and the Rock Café were the places to go; and in Shamrock, Texas, the Art Deco marvel, the U-Drop In was touted as being the best place to eat between Oklahoma City and Amarillo.

"I'm leaving this tour right now if we don't eat where *I* want to eat for a change," Taylor said emphatically when confronted with the possibility of a culinary disappointment. He was tired of "bland food and bland people." Andy capitulated, promising him he could pick out the next restaurant, although he suspected Taylor was more

interested in seducing truckers than in having a good cup of coffee. Somewhere in Missouri, Taylor started firing out directions to Wynn, who was at the wheel, navigating him toward the nearest stop. The Falcon pulled into the parking lot at the Diamonds, an enormous truck stop surrounded by . . . trucks. Taylor described the restaurant as looking like "a rather grandiose rotunda." The original place, which called itself the "world's largest roadside restaurant," had burned down in 1948 and was reborn with a Streamline Moderne design. The owners wisely maintained separate dining rooms for the truckers (who took their food and their time very seriously) and the ordinary customers.

The hungry foursome headed inside, looking anything but ordinary. Tall Wynn, goofy Taylor, ghostly Andy, and hipster Gerard were an odd-looking group under *any* circumstances. But here, where cowboy boots, big-brimmed hats, and a masculine swagger were the norm, they were practically freaks in a sideshow. They sat down in a booth, self-conscious because all eyes suddenly turned in their direction. "I don't know what it was exactly, about the way we looked," Andy said a little disingenuously, when he recalled the incident a few years later. But he insisted that the "alien alert" started flashing the moment they walked in, prompting curious locals to move closer for a better look.

The place was filled with clean-scrubbed teens who looked completely different from the young people in New York City. Back home, "the Liz Taylor-in-*Cleopatra* look—long straight, dark shiny hair with bangs and Egyptian-looking eye makeup," was all the rage, according to Andy. That, or the spirited new look coming from swinging London, where the young fashion designer Mary Quant was slashing hems to create daring miniskirts, and the vi-

sionary hairdresser Vidal Sassoon was slashing locks to give women short, geometric hair styles.

Such was not the case at this truck stop, where Andy noted that the girls still dressed like bobby-soxers, in ponytails and starched blouses, and the boys sported crew cuts or slicked-back farmer's hair. In the last two days, Andy had also seen girls wearing cashmere sweaters paired with formfitting fifties skirts, a look that hadn't been current for years. America was so large that it could take three years for the latest fashions, trends, mores, everything, to spread inward from the coasts (let alone London) to Main Street, USA. The kids were friendly and curious, especially after they heard that the interlopers were from faraway New York City. Trying so hard to be cool, they awkwardly used beatnik vernacular, like "dig," which was amusing at first. But it was hard to enjoy the meal under such relentless scrutiny. Andy left the restaurant vowing to Carte Blanche it for the rest of the trip, no matter how much Taylor complained.

The green rolling hills of the Ozarks passed by in a flash as Wynn or Taylor, whoever was at the wheel, pushed the accelerator to the limit. They crossed the Missouri state line into Galena, Kansas, and followed Route 66 for a short thirteen-mile stretch before entering Oklahoma. At this point, the travelers faced a crucial decision. Andy was so nervous about being late for the Hoppers' party that he pressured the drivers to keep up their breakneck pace. It was a good time to power through the state because September was Oklahoma's busiest month, starting with the annual Will Rogers Rodeo in Vinita, and continuing with *two* state fairs—one in Oklahoma City, beginning on the twenty-first and one in Tulsa on the twenty-sixth. These fairs were among the country's best, and they attracted anywhere from 80,000 to 100,000 people, who flocked

to see the rodeo, the NASA Spacemobile, auto racing, flowers, food, and even an art show. Given their need for speed, the sensible thing to do was to abandon Route 66 and take advantage of the faster Will Rogers Turnpike to Tulsa, and the connecting Turner Turnpike to Oklahoma City.

Andy and his fellow travelers spent the night at the
Town House Motel in Amarillo, Texas.

Chapter 10

Everywhere we drove through was so
different from New York.

—Andy Warhol

I
t wasn't until the Falcon crossed the state line from Oklahoma into Texas that the curtain went up on the American West, unveiling a landscape that was both stunning and completely alien to Andy and Gerard. They saw for the first time the vast Texas plains—sunbaked land "so wide-open you can see into the middle of next week," locals liked to boast. "It is a region almost as vast and trackless as the ocean," reported Captain Randolph Marcy, an explorer who saw the unspoiled terrain in 1849, when it was home to Native Americans including Kiowas and Comanches, and vast herds of buffalo. In 1963, the only silhouettes on the landscape were windbreaks—staggered rows of trees that had been planted to prevent the strong northern winds from carrying dust, rain, and snow to the region.

Gerard found the view hypnotic. He knew that he should be using his time more productively: the mechanicals for the Wagner literary magazine, along with a drawing board, were still packed away in his oversized suitcase, awaiting his attention. However, these nagging reminders of school, home, and responsibility be-

came less relevant with every passing mile. It was much more fun to talk and joke with Andy and the guys, to listen to music, and to stare out the Falcon's panoramic windows at the changing landscape and Texas's omnipresent blue sky, which seemed to take up three-quarters of every view.

While driving through the Panhandle, Gerard noticed something strange. He kept seeing water, or what he thought was water, in the distance. Sometimes it appeared to be a lake on the horizon, other times a puddle on the road. But whenever the car got close to where the water should have been, it disappeared. Gerard realized that he was seeing *mirages*, something he had read about in stories and seen in films, but had never observed in life. It was an exciting first for a boy who had grown up in the Bronx. Interestingly, a mirage isn't an hallucination or figment of the imagination: it is an optical phenomenon. The image of the "water," caused by a collision of light rays and air temperature, is really there and can be photographed, even though the water does not exist.

Despite the fact that there was a scientific explanation, Gerard viewed the mirage as pure poetry. The shimmering, elusive roadside image inspired him to write a poem about man, nature, and the mysteries of perception, weighty ideas for a twenty-year-old on a road trip. But, Gerard was no ordinary twenty-year-old. He was an artist painting with words, as he did in his roadside musing, which he titled "Mirage." He even laid out the poem in two lanes, just like the highway.

Mirage

Water
Plays about
the edge of the horizon
in what seems to be
something central
to the earth
in its struggle
with the sun,

as if, seen
wavering thru air
that steadily becomes
inseparable
from the road
that leads to
silver surfaces,
miraculous and vague

Shall this recognition
of sea in prairie heat
not also touch us
from which we are deceived
by the very sea
which draws us,
more penetrant and flat
where the road recedes,

as we approach the point
from which the sea
appeared advancing inland,
like this road
directed West
with something
of the sea
that disappears?

We are credulous
of our own sight
not to deny the distances
which restrict us
to this land
that edges in
upon an unfamiliar sea
we never seem to reach.

It is the heat
that will soon
reach the apex
of its gradual intensity,
as we approach,
with surety and speed,
likeness of sea,
upon the open road.

©GERARD MALANGA

While Gerard was reveling in the natural wonders Route 66 had to offer, Andy was fascinated by the road's man-made attractions. From the comfort of his backseat mattress he saw an astonishing variety of sights. The incongruous Art Deco structure and tower of the U-Drop Inn; a statue of a giant cobra poised to strike in front of the Regal Reptile Farm; the world's tallest totem pole, a fourteen-foot tall kachina doll, an oversized milk bottle, salvage yards, abandoned cars, and other novelties. In true sideshow fashion, everything on Route 66 was larger than life.

Most of all, Andy enjoyed seeing the neon signs and billboards that lined the road. Of course the illustrator-turned-Pop-artist appreciated the outdoor advertising that dominated the landscape. Andy loved billboards because they were giant-size pictures, primitively rendered in primary colors, just like his Pop Art creations. In the early days of advertising, they started out as simple pictorial advertisements for local businesses, often designed to deliver a message to people who couldn't read (hence the emphasis on images instead of words).

But after World War I, outdoor advertising became big business, and strategically placed billboards became powerful selling tools. Americans were buying cars and spending more and more time on the road. A billboard could sell anything and everything, from mufflers to crackers, if advertisers took into consideration the "aesthetics of speed." A driver in a moving car perceived a sign differently from a person who was on foot or in a slow-moving vehicle, so billboards had to find novel ways to capture the attention of people who were in motion.

Burma-Shave, a company that made grooming products for men,

created signs designed specifically to be seen from a moving car. In a typical campaign, they placed six successive signs on a road, each one delivering part of a riddle and ending with a punch line and the brand name, as in, "Hardly a driver / Is now alive / Who passed / On hills / At 75 / Burma-Shave." Travelers were entertained by these clever messages and looked forward to spotting them. And the company was so confident about its roadside notoriety that it developed a set of signs about itself. "If you / Don't know / Whose signs / These are / You can't have / Driven very far / Burma-Shave."

Popular as they were, the Burma-Shave signs were on their way out in the 1960s because cars were moving faster and faster, leaving no time for a driver (or passengers, for that matter) to digest much text. Persuasive messages had to be "simplified, abstract, and streamlined" or, in the words of the advertising guru Frederick Kurtz, an effective billboard is "short, quick, confronts one suddenly, is gone in a flash." In outdoor advertising, a picture *was* worth a thousand words. Pithy slogans became popular because they could be seen, absorbed, and remembered in the few come-and-go seconds available to get the job done. Some of the more successful campaigns in the early sixties included those for Morton's Salt, with its raindrops, umbrella, and the line "When it rains, it pours"; Budweiser, with its cutout of a stunning blond water-skier and the slogan "Where there's life . . . there's Bud!"; Wilson's Ham, which promised, "No waste, Great taste"; and everybody's favorite, Coppertone's bare-bottomed "little miss Coppertone" with her impertinent puppy tugging at her bathing suit and the promise "Fastest tan under the sun."

These billboards were hits, but some were misses. Ford cre-

ated an ambitious, if somewhat misguided, campaign to advertise its brand-new Falcon. Although the car was meant to be for the masses, the concept was highbrow. Paying homage to Michelangelo's iconic Vatican fresco *The Creation of Adam,* the giant board showed two hands with extended index fingers . . . wrestling for custody of the Falcon's keys.

There were political billboards promoting candidates and issues ("Nixon This Time") and movie billboards hawking upcoming releases (such as Alfred Hitchcock warning "The birds is coming!"—a slogan that sparked many a debate about proper grammar). And rather than allow an unrented space to go to waste, billboard companies supplied public service messages. A serious one showed a wheelchair and the chilling line "You can get the chair for careless driving," while a more whimsical message suggested "Let Him Skip His BATH Tonight," calling itself "A Public Service for LITTLE BOYS." A popular old standby that worked well in any location was Smoky the Bear warning, "Only you can prevent forest fires."

Placement was even more important than message. High-traffic roads drew more cars, and more cars meant more drive-by "looks." The number of potential viewers became an advertising metric that determined the lease price of the billboard in much the same way as "hits" determine the price of Internet advertising today. In 1963, a road as active as Route 66 displayed as many as twenty billboards in the space of a mile because the real estate was so desirable.

Whatever the subject, size, or location, billboards turned America's landscape into a giant shopping emporium. Andy loved to shop,

so he enjoyed the colorful panoply of products and services he saw through the car window. America was a wonderland, he thought, a gallery of enormous images, and it was all so *now*! To him, this was the new art.

Ironically, where Andy saw art, others saw blight. Environmentalists called billboards "landscape leprosy" and "billboard rash." In the early sixties, Peter Blake, an architect with high ideals, wrote *God's Own Junkyard*, a muckraking condemnation of the manmade plague that was destroying the country's landscapes. Blake urged Americans to stop the "systematic 'uglification' of the United States." Yet it was a difficult war to wage. Beautification was considered the province of "scenic sisters," garden club women who had nothing better to do than whine about something as trivial as landscape and scenery when America's businesses had *real* work to accomplish.

Do-gooders tried repeatedly to introduce antibillboard legislation, but the proposed regulations failed to gain much traction. Billboard lobbyists were a powerful force in Washington because the companies they represented had a special relationship with politicians. During elections, candidates were given free signs, so what sane politician would voice opposition to his benefactors knowing that the space would end up going to his opponents?

At the moment, billboards prevailed, and Andy was able to revel in the proliferation of fantastic advertisements for products, motels, diners, gas stations, and attractions that flashed by in rapid succession, just like a high-speed slide show. He found the glorious commercialism of Route 66 to be its crowning achievement, and the sight of it made him feel good about being an American. "I didn't

ever want to live anyplace where you couldn't drive down the road and see drive-ins and giant ice cream cones and walk-in hotdogs and motel signs flashing," he enthused.

Andy and his companions were a little testy after spending twenty-four hours in captivity. Somewhere in Texas, Wynn experienced that inevitable moment on a long drive when the white line in the dark road starts to have a hypnotic effect on the driver. The eyes strain and flutter, the head nods, the body slackens . . . until a close call and a slam on the brakes get the adrenaline pumping. That's exactly what happened to Wynn. Instead of stopping at an intersection, he robotically followed the car ahead of him and went right through it. Luckily, Taylor saw what was happening and yelled for him to pay attention, avoiding a horrible crash. Andy, who was always asking the drivers to turn up the radio as a ploy to help them stay awake, was remarkably cool, considering their narrow escape. Taylor marveled that five or ten minutes passed before Andy calmly asked reproachfully, "Wynn, where were you?"

The incident underscored the fact that the travelers needed a break from their sprint to Los Angeles, and they needed it immediately. The sudden appearance of bright lights in the distance signaled that they were approaching the outskirts of Amarillo, their destination that night. The former cow town ("There ain't nothing between Amarillo and the North Pole but a barbed wire fence, and it's usually fallen down," went the old saying) had been transformed into an oasis of bright lights and activity in the middle of nowhere.

Once the Falcon entered the city limits, Route 66 became Ama-

rillo Boulevard, a main drag that offered a broad selection of flashy motels and restaurants. Cowboys had money to spend, and Amarillo was the only place for miles where they could have a good time. There were many eye-catching signs along the busy strip, calling out to all those tourists and their dollars, but the one that appealed to everyone who had ever fantasized about eating a slab of juicy, homegrown beef stood in front of a steak house known as the Big Texan.

"Howdy," the twenty-five-foot cutout of a cowboy seemed to say as he grinned at the curious folk below. He was a beacon in the night, colorful in his plaid shirt and jeans. And the portions inside the restaurant, including a seventy-two-ounce steak (free for those who could consume it in an hour), were just his size.

A few blocks away from the steak house, the Falcon pulled into the Town House Motel. There was nothing, not even a showy sign, to distinguish this generic, two-story motel from a dozen others on the strip. But it had a vacancy, and the price was right ($7.21 per room, cash only), so it was the perfect place to spend a quick night before resuming the trip. Andy and Gerard checked into one room, and Taylor and Wynn took another.

Being Andy's roommate was a real eye-opener for Gerard. Back in New York, it had taken him a month to realize that his employer's unusual hair was a toupee. "At first I just thought Andy was very strange-looking," he said. But it was the color of his hair, not the hair itself that seemed odd. "When you looked at Andy, you didn't think 'he's wearing a toupee,' you thought, 'My God, look at that guy's hair!'" Gerard explained. Andy, a master of camouflage and deflection, made you see what he wanted you to see.

One hot summer night, Gerard accompanied Andy and some friends to Coney Island, where they rode the roller coaster. He noticed that a strong wind almost—but not quite—blew Andy's toupee off his head. But it wasn't until they shared a room in Amarillo that he understood how it stayed on. Andy had a little kit that he took into the bathroom, and when Gerard peeked inside he saw scissors and Johnson & Johnson medical tape. These were Andy's secret weapons, and if he had his way, no one—not even his closest friends—would ever see him bald.

The next day, the travelers piled into the Falcon and continued west. They passed Jesse's Café in the tiny rest stop of a town called Adrian, Texas. Jesse's claim to fame was that it stood at Route 66's midpoint—exactly 1,139 miles from the road's start and finish. They also passed Glenrio, the last town in Texas for them, the first town in Texas for cars headed east.

Glenrio was a lively little place that offered tourists a store, a gas station, a motel, and a bar. It didn't sound like much, but the area was so desolate that these establishments were always a welcome sight for travelers. The town might have expanded if it had remained a popular Route 66 destination, but the plans for the new interstate did not include an exit leading to Glenrio. Without one, motorists would bypass the town as if it never existed. Other small towns that depended on Route 66 traffic for their livelihood faced a similar fate: slow death. Some businesses (the Big Texan, for one) had the foresight to move closer to the interstate, where they would continue to thrive. But the proprietors who decided to tough it out on 66 ran the risk of losing business from tourists, which meant losing everything.

Meanwhile, Glenrio still had its gas station, and it was time to refuel. The drill was to get gas and see if Taylor's goofy charms worked on the pump boy. Then it was back to the highway. "Come on! We're going to Los Angeles," Andy said repeatedly, his excitement mounting. Only one thousand miles to go.

Gerard Malanga saved the only existing photograph from
the trip—a strip from a photo booth in Albuquerque, New
Mexico. As Taylor Mead, Wynn Chamberlain, Gerard,
and Andy clown for the camera, a young local woman
(*top image*) jumps into the frame and smiles prettily.

Chapter 11

The farther we drove, the more Pop
everything looked on the highways.

—Andy Warhol

The Llano Estacado in New Mexico was, according to an 1849 land survey, "the great Sahara of North America"—a place so dry and threatening that "even the savages dare not venture to pass it." Route 66 had tamed that rough terrain—to an extent. Some parts of the road were narrow, pitted with potholes that could cause cars to lose control, and contained abrupt climbs and descents that challenged even the best drivers, let alone "chronically relaxed" types such as Wynn and Taylor. In this part of the country, locals scared outsiders by saying that there were "six inches and a cigarette paper between you and death on 66." They urged travelers to "carry a spare container of water" and cautioned, "don't turn off on any side roads!"

It was Thursday, September 26—amazingly, only two days since they had left New York. With the variable road conditions and the punishingly high speeds, the poor Falcon had taken a beating in the previous forty-eight hours, but it was holding up nicely. Andy passed the time alternating between daydreaming and worrying. As he stared at the sky and the blur of telephone poles, wires, and signs

speeding past his window, it occurred to him that "Once you 'got' Pop, you could never see a sign the same way again. And once you thought Pop, you could never see America the same way again." Tucumcari, New Mexico, was a perfect case in point.

A tourist town that was two blocks wide and two miles long, Tucumcari boasted an astonishing two thousand motel rooms. "Tucumcari Tonight!" suggested strategically placed billboards on Route 66. After a long day on the road, weary travelers were happy to reach this bedroom community, check in to a motel, and get a good night's sleep. Motel rooms aside, Tucumcari's real attraction was an array of brightly lit and whimsically designed signs that turned this brief yet memorable stretch of Route 66 into a neon wonderland. The signs, which identified local businesses, were surprisingly sophisticated for a town in the middle of nowhere.

The sign for the Flying-M Ranch had white neon wings that appeared to flap when they blinked on and off; Tee-Pee Curios, one of those desert trading posts that sold everything from authentic Native American jewelry to tourist trinkets, advertised itself with a giant neon teepee decorated with multihued patterns; La Cita restaurant signaled its down-home Mexican cuisine with a giant sombrero; and the Buckaroo Motel topped its sign with a cowboy on a bucking bronco. The jewel in Tucumcari's neon crown was the Blue Swallow Motel. Rendered in eye-catching shades of blue that blended with the brilliant New Mexico sky during the day, the sign came to life at night, displaying a gracefully rendered blue swallow perched atop its lettering.

Andy and his companions were impressed by the neon creations that competed for their attention. They never expected to come face-to-face with the real-life antecedents of *their* kind of art on a

road trip across America. As Taylor summarized their reaction, "It was a whole new way of looking at the United States, filled with the bright, primary colors that Warhol or Lichtenstein might have painted. Especially the signs over the motels along Route 66. As we got farther west, all the signs on motels were really Pop Art." He considered Andy's passage through this vibrant landscape a great event. "It was like Pop Art was meeting the great king of Pop Art from the East," he said.

Albuquerque was their next stop, and, in this instance, Andy knew exactly where he wanted to stay, the luxurious Hilton Hotel. A respite from truck stops and "knotty pine" posers, the Hilton—like *all* Hilton Hotels at the time—was a welcome oasis of sophistication and glamour. Conrad Hilton, a native of New Mexico, opened the hotel in 1939 and subsequently honeymooned there in 1942 with his second wife, Zsa Zsa Gabor. He was proud to have built the tallest building in the state. "I never dreamed that the Albuquerque Hilton would stand right there in the middle of it all, tall enough to cast a shadow on the railroad station," he marveled in his autobiography, *Be My Guest*. The building was ten stories high and its lavish interior featured murals by the artist Willard Anderson and the handiwork of New Mexico artisans. The lobby's heavy, carved furniture and old-world touches suggested the opulent home of a Spanish grandee. Thankfully, it did not suggest the interior of a Falcon station wagon, so the travelers were able to enjoy their freedom for a few hours.

They strolled through downtown Albuquerque that evening, stretching their legs and taking in the sights. The weather was pleasant—in the seventies and breezy. When they spotted a photo booth, one of their favorite pastimes in New York, they decided to com-

memorate their trip with a group portrait. Gerard, looking young and irresistible with his slicked-back hair and oxford shirt, started flirting with one of the girls at the arcade. He had been trapped in the car for so long that this was his first opportunity to let his roving eye rove. When it was time for the friends to pile into the booth, Gerard and Taylor took the front row, while Andy and Wynn stood in the back. They stared at the lens, waiting for the light, and on cue, clowned for the camera, smiles wide, eyes open, looking as if they were having an uproarious time. Even Wynn appeared happy, and Andy was positively beaming. Then the girl Gerard was eyeing suddenly jumped into the picture and grinned at the camera.

Outside the booth, Gerard waited for the photo strip to print. When it came out of the slot, he blew on it until it was dry, as was his habit, and tucked it away in his shirt pocket, making a mental note to store it somewhere safe when he got back to the hotel. Gerard liked to save mementos he imagined might be important someday. As for the high-spirited, dark-eyed girl who was immortalized in the picture—she walked away, never to be seen again.

The next morning, Friday, September 27, Andy realized that Los Angeles was only about eleven hours away from Albuquerque, and that somehow they were two days ahead of schedule. Their superhuman sprint across the country left them with enough time to take a side trip, and a relaxing weekend in Palm Springs, California, sounded like a perfect getaway. Andy knew all about the posh resort from his fan magazines. In fact, Troy Donahue's upcoming movie, *Palm Springs Weekend*, had been filmed there. Andy thought it sounded glamorous, and he was eager to visit a place that had attracted so many celebrities.

Palm Springs was a playground for the Hollywood elite because

it offered scenic vistas, a glorious climate, and luxurious hotels with pools, spas, golf courses, nightclubs, and gambling . . . all the ingredients of a first-class vacation. There was another purely practical reason for its popularity. Most stars had a clause in their contracts requiring them to show up within two hours of being summoned by the studio while they were in production on a film. Palm Springs was close enough to Los Angeles to accommodate a quick return should the "two-hour rule" be invoked. "I've been all over the world and this is my favorite spot," said Bob Hope, a Palm Springs homeowner. Gable and Lombard, Bing Crosby, Marilyn Monroe, Tab Hunter, Betty Grable, Lucy and Desi, and Frank Sinatra were just a few of the luminaries who shared Hope's enthusiasm for this desert destination.

Palm Springs was everything Andy imagined it would be. He loved the brilliant blue skies, the boulevards lined with palm trees and bright flowers, and the buildings designed in the cool, indigenous style called Desert Modern. Unlike Route 66, Palm Springs prohibited neon signs because they were too vulgar, and the word "motel," which sounded low-class, was never, ever, used. The desert resort purposely projected an upscale ambiance designed to attract affluent pleasure-seekers instead of run-of-the-mill tourists.

Andy consulted his Carte Blanche guide and decided they would stay at the Palm Springs Sands Hotel. Located in the shadow of the San Jacinto Mountains, the Sands offered impressive landscaping and exotic lighting designed to inspire "a feeling of enchantment," according to its brochure, and it promised its guests "luxury for less," without compromising "the hospitality of the bygone era." It was "a place where you were welcomed not for your money alone," the management insisted, "but for the friendship which we gained

as a result of your being our guest." That particular sales pitch may have been a little over the top, but Palm Springs was full of resorts, and the Sands was eager to impress.

The Falcon pulled onto the hotel's spacious property and parked outside the lobby. The temperature was 111 degrees, and it was expected to climb as high as 116 during the weekend. Palm Springs and Los Angeles were in the throes of a legendary Indian summer heat wave, and everyone seemed to be moving in slow motion. The best way to escape the inferno was to jump into the hotel pool and stay there as long as possible. Equipped with a high diving board and a slide, the pool was the perfect stage for Taylor to perform his goofy imitation of a water sprite. He danced around and flirted with anyone who looked in his direction, finally catching the eye of a sexy construction worker who accompanied him back to his room. Taylor said that his tryst satisfied "everyone's vicarious sex-maniacy." The others loved hearing all the details.

The next day, after some sightseeing in downtown Palm Springs, Andy found a shop called Monroe's for Men, where he bought swim trunks, shorts, and other tropical additions to his wardrobe that would allow him to dress the part of the casual Californian. Afternoon and evening plans on Saturday included a visit to nearby Indian Wells, which was the home of a fabulous new hotel, the Erawan Garden.

Looking like it belonged in Disneyland, this $3 million resort was modeled after a famous hotel in Bangkok, with fourteen two-story bungalows, two pools, the "Cambodia" dining room, the "Moongate" lounge, eleven acres of landscaped gardens decorated with tiki torches, and a main building that looked like an Asian palace. The Erawan proudly described itself as offering "all the luxury

of the Orient." America in the 1950s and 1960s was experiencing a craze for all things "tiki." Technically, the word described wood and stone carvings found in the Polynesian islands, but when soldiers returned from World War II with enthusiastic tales of life in the exotic tropics, the South Seas style became popular, and the terms "tiki" and "Polynesian" were used to describe everything from island-inspired decor to giant cocktails (like the potent mai tai) topped with miniature umbrellas. Andy frequently dined at the ultrachic Trader Vic's in New York City, and the Erawan, while emphasizing its Far East roots, had a similar theatrical, flaming-food approach to cuisine. The travelers headed there for an evening of tropical drinks, sizzling platters, and, hopefully, prime celebrity-spotting.

While they were enjoying their night on the town, the most famous man in the world was only six miles away, on a private estate in nearby Palm Desert. President John F. Kennedy had ended a whirl-wind trip through America's Western states with a stop in the Palm Springs area. "Mr. Kennedy's schedule calls for him to return to Washington Saturday night," the *New York Times* reported. But the newspaper also speculated that he might make a quick stop in Palm Springs on Saturday and Sunday to relax from the strenuous tour.

Kennedy had a history of "relaxing" in Palm Springs, notably doing so in March 1962, when he enjoyed a long-anticipated tryst with Marilyn Monroe. The fireworks on *that* occasion began long before the weekend started. Kennedy planned on staying at the Palm Springs home of his friend and enthusiastic supporter Frank Sinatra. Kennedy's brother-in-law, the actor Peter Lawford, was a member of the Rat Pack, Sinatra's posse of friends and fellow performers, which included Dean Martin, Joey Bishop, and Sammy Davis Jr. Dazzled by the thought of hosting the president of the United States

Deborah Davis

in his home Sinatra prepared for the visitation. He remodeled rooms to make them suitable for the president, installed a state-of-the-art telephone system to accommodate Kennedy's entourage, and commissioned the construction of a helicopter landing pad so the visiting dignitaries could come and go privately

Sinatra was finalizing his painstaking preparations when he received an unexpected call from the first brother-in-law. Lawford had been assigned the thankless job of telling Sinatra that JFK would not be staying with him on this trip, or on any other. Attorney General Robert Kennedy had decided that Sinatra's friendship with the mob boss Sam Giancana made him an unsuitable host for the president. If word got out . . .

Sinatra, whose temper was famous, became so enraged that he personally took a sledgehammer to the helipad. Then he trained his shoot-the-messenger ire on Lawford, whom he banned from the Rat Pack, a spiteful act that had dire consequences for Lawford's career. The situation went from bad to worse when Sinatra learned that Kennedy would instead be staying with actor and crooner Bing Crosby—a *Republican,* no less.

"Der Bingle," as insiders called him, may have been a Republican, but he certainly knew how to have a good time. He owned more than one property in Palm Springs, and the one he offered the president for his first visit was so private that two people as world-famous as JFK and Marilyn Monroe could spend the night together without the danger of exposure. Kennedy returned to Palm Springs a few times to let off steam at raunchy pool parties attended by a curated selection of decorative and extremely willing young women.

And here he was again on September 28, ready to "relax," as the press called it, at Crosby's hideaway. Andy had a much tamer

Palm Springs experience. When the travelers woke up on Sunday, the sky was especially blue, as Gerard later recalled. Tan and relaxed (or, in Andy's case, *pink* and relaxed), they assumed their front seat, backseat positions in the Falcon, turned on the radio, and headed for Hollywood. The party was in a few hours and they did not want to be late.

1712 North Crescent Heights Boulevard, the "well-
loved" house of the Dennis Hoppers, in a photograph
taken by Dennis and featuring Brooke.

Chapter 12

Vacant, vacuous Hollywood was everything
I ever wanted to mold my life into.

—Andy Warhol

Route 66 is a giant chute down which everything loose in this country is sliding into Southern California," one historian observed cynically. But Andy was anything but cynical when he reached his destination. "Oh, this is America," Andy marveled, as the Falcon turned onto storied Sunset Boulevard, the final stretch of Route 66 in Los Angeles. He had been waiting for this moment since childhood, when he first fell in love with little Shirley Temple and all the other stars whose headshots and publicity stills he carefully pasted into his photo albums. Finally Andy was in Hollywood, and on the Sunset Strip, no less, the current capitol of cool for celebrities and fans alike.

"You can get pretty much anything you want, or think you want, on the Strip these days," promised *Esquire* magazine's West Coast guide. Sunset offered everything, from an Alfa Romeo sports car to a cappuccino, from an Italian meal at Dino's Lodge, a restaurant personally endorsed by Dean Martin (whose neon likeness adorned its sign) and the Rat Pack (and popularized by the

hit television show *77 Sunset Strip*), to a soy burger at the Aware Inn, Warren Beatty's favorite health food spot, where he was frequently seen with beautiful young actresses such as Leslie Caron. Andy avidly read about these places in his beloved fan magazines, so he was thrilled to see them in real life.

On his left he passed the Cinerama Dome, LA's newest and most unusual movie theater. Recently completed and not scheduled to open for another two months, the Cinerama was based on a concept by R. Buckminster Fuller, a genuine geodesic dome—easy and inexpensive to build, and roomy enough to hold a seventy-foot screen.

Nearby was Schwab's Pharmacy, no ordinary drugstore but rather the legendary hangout where Hollywood hopefuls waited to be discovered. Gossip columnist Sydney Skolsky sat on a stool at Schwab's to pen his *Photoplay* column, appropriately titled "From a Stool at Schwab's."

Two fabulous, giant-size figures caught Andy's eye near the historic Chateau Marmont hotel, which was a Hollywood monument in its own right. "If you must get in trouble, do it at the Chateau Marmont," Harry Cohn, the head of Columbia Pictures, had urged his rambunctious stars, because the hotel was so discreet that anyone could get away with anything behind its cloistered walls. On the Chateau side of Sunset was a billboard with a revolving, skimpily clad showgirl advertising the Sahara Casino in Las Vegas (an image that would later become the cover of the racy Gore Vidal novel *Myra Breckinridge*). On the opposite side of the street was a similarly posed revolving statue of the popular cartoon characters Rocky and Bullwinkle—a squirrel and a

moose—an obvious homage to the sexy giantess and a clear indication that someone in Hollywood had a sense of humor about billboards.

Andy saw the marquee for Cyrano's coming up on his right, *the* hangout for Hollywood's young movers and shakers. It was a coffeehouse, complete with an espresso machine and a selection of continental pastries. But actors, agents, directors, writers, producers—celebrities and nobodies—did not come to Cyrano's for caffeine or calories. They came to see and be seen, and were constantly glad-handing, table-hopping, deal-making, and, in the case of beautiful young women, entering and exiting multiple times per night to guarantee getting noticed. Cyrano's was like a private club but with an ever-changing membership. "This year's crop of young hopefuls is succeeded by next year's crop of young hopefuls," *Esquire* observed when profiling the hot spot. All the lovelies whose studied entrances failed to break them into show business would eventually have to admit defeat, pack their bags, and head back to Minneapolis, Muncie, Phoenix, and all those other hometowns that were not Hollywood.

Andy was fascinated by the showy assortment of billboards lining Sunset. He was marveling at the colors and bold designs, pointing out one after another to his companions, when suddenly he spotted a sign that stood out as prominently as the eyes of Dr. T. J. Eckleburg in *The Great Gatsby*. There was the word "POP" in giant letters, and it seemed to be sending him a private welcome. In this case, however, Pop had nothing to do with art. POP was pronounced "pee-oh-pee" and referred to Pacific Ocean Park, a popular amusement park located on the beach between Venice and Santa Monica.

POP opened in 1958, and it was designed to be a conveniently located rival to Anaheim's Disneyland. The park's theme was inspired by its backdrop, the Pacific Ocean, and featured twenty-eight acres of sea green-and-white Moderne buildings and state-of-the-art midway attractions, including the Sea Serpent roller coaster, the Ocean Skyway (which carried passengers out over the waves), the Sea Circus, with trained dolphins and sea lions, and King Neptune's Courtyard. Unlike Disneyland, POP (which also stood for "pay one price," was all-inclusive and affordable. The Beach Boys sang about it in "Amusement Parks U.S.A." and television shows such as *Route 66*, *The Man from U.N.C.L.E.*, and *I Spy* filmed episodes there. In 1967, *The Fugitive* shot Dr. Richard Kimble's final confrontation with the elusive one-armed man at POP's Mahi Mahi ride, an episode that won an unprecedented 72 percent of America's television-viewing audience, as well as being great national exposure for the park.

As the Falcon continued west on Sunset, the billboards, clubs, restaurants, liquor stores, and shops were replaced by stately rows of palm trees with Norma Desmond–like mansions hiding behind them. Andy spotted the famous Beverly Hills Hotel and thought longingly about its famous pool and Polo Lounge, a destination for celebrities where deals, reputations, and promises were made and broken daily. "Los Angeles is a large, city-like area surrounding the Beverly Hills Hotel," quipped the writer Fran Lebowitz, acknowledging that the Pink Palace, as the hotel was called, was the city's true center. Only the most inside of insiders stayed there, whether they were boldface names, such as the tabloid mainstay Elizabeth Taylor or the hot newcomer Barbra Streisand, or power brokers

avoiding publicity, such as Howard Hughes, who maintained rooms there for thirty years.

Even if there were an occasional vacancy for a "non-pro" (as *Variety* called people not in show business) like Andy, it was unlikely that he would have found an available room at *this* of all times. "When we arrived, we discovered there was a World Series going on and all the hotels were filled," he lamented. Later in the week, the New York Yankees and the LA Dodgers (formerly the Brooklyn Dodgers before relocating to California in 1958) would go head-to-head for baseball's biggest prize. The first two games were scheduled for October 2 and 3 at Yankee Stadium in New York, but on the fifth, the games would move to Los Angeles. Baseball fans were descending upon the city en masse, making it difficult to find a place to stay.

Luckily, Taylor knew of an out-of-the-way hotel on the beach in Santa Monica. The Surf Rider Inn was not a celebrity hangout, but it was large and modern, and it had a beautiful setting. Actually, it was a fancy "motor inn," meaning that guests could park in front of their "De Luxe unit" and have easy access to the pool, coffee shop, and other facilities. In the evening, there was a restaurant called the Horizon Room that offered a view of the water, ambitious menu items such as "Filet of Sole Bonne Femme," entertainment, and dancing. Fine dining aside, the Surf Rider's best feature was its proximity to the Pacific Ocean—the shore was so close that the pounding waves provided a constant soundtrack, one that was music to the ears of these New York City boys. Andy and Gerard checked into room 106, with Taylor and Wynn next door in 107.

Inviting as it was, the beach would have to wait until tomorrow, because it was time to dress and hurry to the Hoppers' for the long-anticipated "movie star party."

———

The Hoppers and their three children, Jeffrey, Willie, and Marin, had recently moved into a beautiful California Spanish-style house that had been built in 1929. Located at 1712 North Crescent Heights Boulevard, in the scenic hills overlooking the Sunset Strip, their new home offered stunning views and an impressive group of neighbors, including Marlon Brando and the legendary Russian composer Igor Stravinsky. With its multilevel terraces and flamboyant Mediterranean architectural details, including a dramatic two-story turret, the house called to mind old Hollywood, even though its young owners were decidedly contemporary. They set about turning the classic, old-world space into a backdrop for their eclectic, scavenger-hunt-meets-mod aesthetic.

The Hoppers were in a unique position because they had lost everything—their beloved heirlooms, art collection, paintings, and poetry created by Dennis—when their former house burned down in the 1961 Bel Air fire. In a funny way, it was a cleansing experience, Dennis thought. "You can start over in your own world, not the world that was left to you by your parents," he explained. Brooke also saw a positive side to their terrible loss. "It's very important to be able to start over again," she said, suggesting that getting on with life was a mark of character.

After the fire, their insurance agent advised them that silver, paintings, and antiques held their value, which was wonderful to

hear because the Hoppers loved old objects and collectibles at a time when most people wanted things that were new. There wasn't much competition for the unusual pieces they coveted; a shiny white enamel and black leather barber chair, a sewing cabinet stocked with thread, a set of Gothic stained glass windows. "We bought priceless signed Tiffany lamps and magnificent Art Nouveau pieces for nothing," Brooke later recalled, reminiscing about filling the new place with treasures from out-of-the-way shops such as Scavenger's Paradise and Firehouse Antiques. Dennis regularly visited junk shops and salvage yards, buying anything that caught his eye. "I loved some of those pieces just as much as the art I was collecting," he admitted.

In an article for *Vogue*, the writer Terry Southern called the Hoppers' décor "the bizarre and the beautiful and the banal in wild juxtaposition, everything the most of its kind." He described their house as "well loved," and it was. The Hoppers enjoyed home improvement projects. Brooke spent hours patiently installing tiles, and managed to look stunning in a bikini while she worked. Dennis tackled other jobs, determined to make everything perfect for Andy's party. It was going to be the first time they entertained in their new home, and Dennis wanted it to be a night to remember. He found a papier-mâché clown that was too big to stand up and hung it from the ceiling. Warhol's *Mona Lisa*, Ed Kienholz's sculpture *The Quickie*, Roy Lichtenstein's canvas *The Mad Scientist*, and other contemporary works added a touch of Pop to the living room. Then, according to Brooke, Dennis came up with a wild idea for the perfect finishing touch. "He decided that the one thing that would really make the house stand

out fabulously would be billboards," she said. And he meant *inside* the house.

Dennis hurried over to Foster and Kleiser, the preeminent outdoor advertising company on the West Coast. It was responsible for the fabulous array of billboards on display throughout Los Angeles, as well as most of the ones Andy had enjoyed on Route 66. One of their most famous creations was a three-dimensional billboard promoting the Sahara Hotel in Las Vegas. Foster and Kleiser re-created the hotel's "Garden of Allah" swimming pool on the Sunset Strip, complete with water, frolicking bathing beauties, and, on one memorable day, a much-publicized dive into the "pool" by the comic Red Skelton, who was performing at the casino.

The Foster and Kleiser warehouse was a gallery of giant commercial images that radiated Pop. Everywhere Dennis looked he saw commercial paintings that looked just like Rosenquist's, but were the real thing. He selected some to bring home, including a painting of a man and a woman enjoying hot dogs at a barbecue. The mouthwatering sight of that all-American dog and bun may have inspired the menu for Andy's party, because Dennis told Brooke that he wanted to have a classic New York City street stand stocked with chili, dogs, and all the trimmings, food generally not found at a Hollywood soiree. With just a few days until the big event, Dennis unfolded his billboards and tried to figure out how to hang them on the walls in the downstairs bathroom. By the time he was finished, every surface was covered with oddly matched fragments, and the effect was surreal.

Andy could not have been more excited as he got ready for the party. He debated about bringing his Bolex, but decided that he'd be too shy to pull out a camera in the midst of all those actors. "The

only time I hadn't been shy about filming was with *Sleep*," he admitted. And that was because the star hadn't been conscious.

The group got back into the car and headed east until they reached the Chateau Marmont, at which point they turned left to ascend into the Hollywood Hills. The streets were narrow, winding, and tricky to navigate, so they nearly passed the Hopper house before realizing they had reached it. Andy got out of the car and climbed the steep stairs to the entrance. There were celebrities behind that door! When Dennis greeted him and led him inside to meet the guests gathered in his honor, Andy's reaction was everything his host had hoped for.

"OOH! AAH! OOH! AAH!" That's what Dennis remembered Andy saying as he moved through the charmingly eclectic house. "I never heard Andy make a sentence," Dennis claimed. "He was wonderful to be around, but he was always 'OOH! AAH! OOH! AAH!'" Andy was delighted to see the bold mix of folk art, junk ethnic pieces, memorabilia, and, best of all, Pop Art. In fact, the Hoppers' art collection was entirely Pop. "We had Lichtenstein . . . we had Frank Stella . . . we had Kienholz . . . we had Andy Warhol . . . we had Ed Ruscha," Dennis recounted.

Andy marveled at the décor, with its "circus posters and movie props and red lacquered furniture and shellacked collages." He pointed out that "this was before things got bright and colorful everywhere, and it was the first whole house most of us had ever been to that had this kiddie-party atmosphere." Actually, the reason Andy found the environment so appealing was that his New York townhouse was decorated in a similar fashion, with a playful and personal combination of high and low "treasures" on display.

Looking around the room, Andy immediately noticed a few fa-

miliar faces. Irving Blum stepped forward, suave and beautifully dressed, as always, and full of enthusiasm about the opening at the Ferus the following night. He introduced several of the artists from the gallery, including Wallace Berman, the man who had turned the party invitation into the clever collage that Dennis hung on his wall. Andy was happy to reunite with Patty and Claes Oldenburg, who told him all about their upcoming show at the Dwan Gallery on Tuesday.

Though it was great to be in the company of friends and colleagues, Andy couldn't stop staring at the famous faces he spotted among the guests. He recognized Sal Mineo from *Rebel Without a Cause*, and Tony Bill, who costarred with Frank Sinatra in *Come Blow Your Horn*. Dean Stockwell, the former child star who'd recently been one of the leads in *Compulsion*, Richard Fleisher's dramatization of the Leopold and Loeb murder case, was there, as was the handsome John Saxon, who had played the male ingénue opposite Sandra Dee in Vincente Minnelli's *The Reluctant Debutante*. Andy also noticed Robert Walker Jr., an up-and-coming young actor whose father had been a star, and whom he recognized from his appearances on episodes of *Route 66* and *The Defenders*.

The most impressive sighting of the evening was that of the tabloid couple of the moment, Troy Donahue and Suzanne Pleshette, *in the flesh*, looking as if they had stepped out of the pages of the very magazines Andy had read on his way there. He had been following the couple's romantic saga for so long that he felt he knew them (Were they shacking up? Was there an engagement in the works?). The idea that the twosome had come to the Hoppers' to meet *him* was incredibly exciting.

Andy was also intrigued by an attractive young man whom he described as "a preppy mathematician," but who was none other than Peter Fonda, Henry's son, Jane's brother, and Brooke's almost, but not quite, relative. Peter was an actor, and like Dennis, he stayed afloat by working on television shows such as *Naked City, Wagon Train,* and *The Defenders.* Actually, that May, he had made his feature-film debut as the romantic lead opposite Sandra Dee in *Tammy and the Doctor.* Peter told Andy that he hoped to make his own films someday—serious projects that had something to say—not that Andy saw anything wrong with a starring role opposite Sandra Dee.

Conversation became less lucid as the partygoers surrendered to the beat of the loud music coming from the Hoppers' stereo. They danced the latest steps—the Twist, the Monkey, the Mashed Potato—and ones they made up on the spot. "Everyone was dancing to the songs we'd been hearing on the car radio all the way across the country," Andy said. Patty Oldenburg, who loved to dance and was not shy about being the center of attention, was executing some very energetic moves and reminiscing with Andy. Things got a little out of hand when Patty twirled into an antique spool cabinet and sent an Ed Kienholz sculpture crashing to the floor. *The Quickie* was a typical Kienholz assemblage, consisting of a mannequin's head on a roller skate. Of course, the head came off in the fall and went flying, a wild moment Brooke considered the high point of the party.

There were other "highs"—literally. Wynn recalled ducking into a closet with Taylor and another guest, Jenny Hecht (the daughter of the legendary screenwriter Ben Hecht), to sneak a joint.

They were having fun until Brooke opened the door, caught them in the act, and immediately ousted them from the house. "That's how hip they were," Wynn sniffed. But Andy had a completely different recollection of the Hoppers' "hip" factor and made no mention of the closet incident. In fact, he recalled joints being passed around in plain sight all through the evening. This was, after all, Hollywood in the early sixties.

Since this was Andy's first trip to Los Angeles, several guests offered their favorite sightseeing tips. "Venice Beach, man," was a popular recommendation. Venice was like the East Village in New York: edgy, casual in its morality, and the preferred habitat of all who were uninhibited and cool. Several of the Ferus artists maintained studios there, and Taylor knew it well because he used to live there. Pushing a shopping cart outfitted with a transistor radio, he had fit right in with the other bohemians.

The natives also recommended that Andy visit the canyons— Topanga and Laurel—as well as Malibu. Watts was another destination. "What?" Andy asked. No, *Watts,* the Watts Towers, someone said, explaining that it was a Pop Art monument of sorts consisting of hand-built spires located in an out-of-the-way Los Angeles slum. This was all a lot of information for Andy to absorb. However, the suggestion that won his undivided attention came from his hostess. Brooke mentioned that if Andy wanted to stay at the Beverly Hills Hotel, she could ask her father to make his suite available—he maintained one there on a permanent basis. Hayward was out of town at the moment, so his rooms were empty.

Andy was delighted that his "movie star party" had, in fact, led

to movie star accommodations at the hotel of his dreams. The combination of drugs, celebrities, music, and Pop Art was incredibly intoxicating, prompting him to say, "This party was the most exciting thing that had ever happened to me." One day in Hollywood and he already felt like a star.

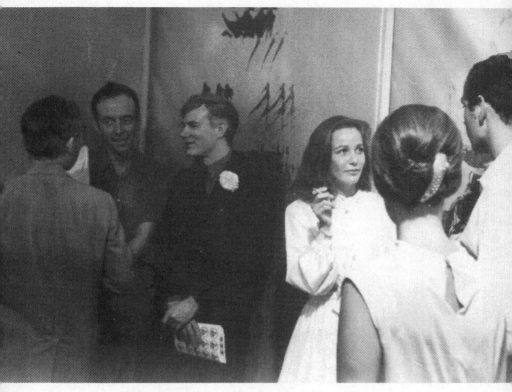

A beaming Andy stands with Taylor Mead and Brooke
Hayward Hopper at the opening of his Elvis and
Liz exhibition at the Ferus Gallery in 1963.

Chapter 13

The old Hollywood was finished and the
New Hollywood hadn't started yet.

—Andy Warhol

On Monday, September 30, Andy woke up to a classic Santa Monica beach day. Finally, Los Angeles's record heat wave came to an end, making way for blue skies, a slight breeze, and temperatures in the low eighties, the kind of balmy weather that convinces people to move to California. Though he had spent under twenty-four hours in the city, Andy decided he loved everything about Hollywood (his generic term for all of LA)—the colors, the light, the landscape, the glamour, the movie stars, even the vulgarity. When he thought about how he might use this setting, and the rush of impressions it generated, one idea prevailed. Painting was out. What Andy *really* wanted to do was direct.

Talking to Dennis, Peter Fonda, and the other young film people at the Hoppers' party made Andy realize that this was actually a good moment to break into show business. The studio system that had produced such extravaganzas as *Cleopatra* wasn't dead, but it was foundering, and it had every reason to be nervous about its future. American moviegoers were becoming more sophisticated, especially when it came to risqué foreign films. They embraced

Deborah Davis

Federico Fellini's *8½*, and they were looking forward to the bawdy British literary romp *Tom Jones*. How much longer could Doris Day's freckles compete with tantalizing, albeit artistic, glimpses of butt and breast in such imports as Roman Polanski's sexy thriller *Knife in the Water*? "It was the French girls who had the new star mystiques," Andy said, pointing to Jeanne Moreau and Catherine Deneuve, not to mention the exquisitely beautiful (and utterly un-inhibited) Brigitte Bardot.

Studio head Jack Warner was well aware of the problem, and tried to deflect attention from the advancing threat of the "New Cinema" when he announced his $17 million production of the hit Broadway show *My Fair Lady* at a June press conference. "Holly-wood is not on the rocks," he said defensively. "It is anything but finished . . . But we are not going to sully ourselves with the dirt of pictures made in Spain, France, or Italy. This industry is flourishing, and we can make just as good atmosphere pictures on the lot here as in Siberia or England."

Warner was shortsighted to think that the only enemies to tra-ditional moviemaking were films from abroad. He should have been *more* concerned about the beast within. Young Americans, including Andy's new friends Dennis and Peter, were talking about alterna-tive approaches to film. And by 1963, some mavericks were actu-ally turning talk into action. Twenty-four-year-old Francis Ford Coppola made his first feature film, *Dementia 13*, for a mere $30,000 by time-sharing the sets of a Roger Corman production in Ireland. These new directors were nimble, resourceful, and adventurous, and they were not afraid to tackle tough topics.

Andy saw an opportunity to make his kind of experimental movie in a brand-new setting. His Bolex was ready, but before he

could start filming, he needed a concept. Here he was at the shore, surrounded by beach bums and bunnies, bikinis, and Coppertone tans—a scene right out of that summer's blockbuster movie *Beach Party,* starring Annette Funicello and Frankie Avalon. American International Pictures, the company that produced *Beach Party,* was best known for churning out low-budget exploitation films about hot rods and horror. But this rock 'n' roll romp about teens having fun in the sun was such a smash hit that it initiated an entire genre of independent surf films. Andy loved the idea, but he realized such a film was too ambitious for a director with no cast and a camera that couldn't record sound.

Improbably, an exit sign on a Los Angeles freeway provided him with the subject of his first Hollywood opus. In 1919, Edgar Rice Burroughs, the creator of Tarzan, the famous jungle hero, bought a large ranch in a Los Angeles suburb. Eventually the area came to be known as "Tarzana," and, after Taylor spotted the sign, a comic idea was born. He suggested that Andy make a Warhol version of a Tarzan film, with Taylor himself—the classic ninety-eight-pound weakling—playing the title role. Everyone knew how Tarzan was *supposed* to look—Burroughs's books had sold twenty-five million copies in fifty-six languages and had inspired thirty-six movies— and he in no way resembled Taylor Mead. The more Andy thought about it, the more he loved the idea. He decided to start shooting immediately after his opening at the Ferus.

Andy went to the gallery, eager to see how Blum had installed his paintings. He brought his Bolex with him, hoping to get some footage under his belt. Blum, who was always a bit of a ham in the presence of a camera, posed obligingly outside the Ferus, as did John Coplans, the editor of *Artforum,* whose offices were in the same

building. Inside, Andy was relieved to see that his paintings looked good. He filmed a few panoramic shots, spinning so quickly that the paintings appeared to flicker. Eventually it was time to put away the Bolex and focus on being Andy Warhol, Pop artist.

A nervous Andy had dressed up for the occasion, donning a dark jacket, a tie, and a festive white boutonniere, but he soon discovered that there was nothing formal or starchy about the opening. LA's Monday night Art Walks were fun and attracted all kinds of people. Shirley Neilsen Blum recalled that "Anywhere there were a group of people involved in the contemporary art scene it was always very mixed . . . of every stripe and appearance." In the midst of so many strangers, Andy was happy to see the Hoppers, Brooke looking demure yet glamorous in a high-necked white dress. Dennis clowned for his friend and fellow photographer William Claxton by pretending to nuzzle one of the Liz portraits.

Taylor, Wynn, and Gerard had arrived with Andy, looking like an oddball entourage. But Gerard never made it inside the gallery. He was distracted by the sight of someone he knew from New York, Gene Frumkin, a fellow poet and one of the editors of the literary magazine *Coastlines*. The thought of mingling with movie stars and collectors held no appeal for him compared with the opportunity to visit with Frumkin, whose writing he revered. The two poets went off together to a quiet coffee shop, and that was the last anyone saw of Gerard all evening.

The Art Walk regulars were joined by some of the Ferus artists, including Billy Al Bengston, the epitome of California casual in a motorcycle T-shirt that emphasized his bronzed surfer's body. Even the artists in Los Angeles looked like movie stars, Andy thought, especially devilishly handsome Ed Ruscha. The Ferus men traded on

their machismo by playfully referring to themselves as "the studs." Andy was hardly in *that* category, but no one seemed to hold his pale, toupeed appearance against him. "Andy seemed no more (well maybe a little more), nor less, [strange] than all the other strange folks one might meet," Shirley Nielsen Blum said. Hollywood was, after all, a place filled with eccentrics.

Andy's unusual looks aside, the California artists were fascinated by what he had to say. For example, he insisted on calling his silkscreens "paintings." When they challenged him by arguing, "It isn't a painting, it's a print," he countered, "No, no, no, not at all. It's a painting." Irving Blum suggested that Andy's conviction about his manufactured work being fine art "opened the door to artists' using mechanical means to make an image," noting that Wallace Berman's "Verifax technique (whereby the artist used an early version of a Kodak copy machine to create collages) was a direct result of his having been exposed to Andy's screened images."

The overall reaction at the Ferus was one of quiet enthusiasm. The emblematic images of Elvis and Liz, two of Hollywood's biggest stars—popped off the walls. With their silver backgrounds, they almost looked as if they were being projected on a movie screen. People were looking—and even admiring—but, unfortunately, they were *not* buying. This crowd lived with Elvis and Liz every day. In their world, celebrity images were too familiar to be considered art. Ultimately, only one painting—a Silver Liz—sold.

Irving Blum recounted the story of the lone buyer, an elegantly dressed woman who came into the gallery and badgered him with questions about the paintings on display. "This must be some kind of joke," she said, refusing to believe that *these* pictures were considered art. But after listening to Blum's passionate appraisal of An-

dy's creations, she actually agreed to take one. Two weeks later she came back, utterly distraught. "My husband hates the painting, my children hate the painting, my friends hate the painting," she said. Blum tried to persuade her to reconsider, but she was intractable. In the end, he took back her Silver Liz and gave her a refund.

Despite the fact that the opening was not financially remunerative, Andy appeared to enjoy himself and actually found the tepid response to his work amusing. "I always have to laugh, though, when I think of how Hollywood called Pop Art a put-on. *Hollywood??* I mean, when you look at the kind of movies they were making then—those were supposed to be *real??*" Honestly, his expectations were not very high, especially following the Hopper soiree. "After a dazzling party like that, my art opening was bound to seem tame," he rationalized. But tomorrow was another day. If Andy had his way, he would go to bed a slightly disappointed artist—and wake up a Hollywood director.

Tuesday morning he was all business. He had breakfast at the hotel coffee shop and then hit the phones, making one call after another. Andy gallantly ordered flowers for the Hoppers to thank his hosts for their hospitality. He spoke personally to Betty Allan, florist to the stars, requesting blooms of "every color" arranged in the shape of a heart and displayed on an easel. And, adding that sly touch of Pop, he told her to wrap it up with a ribbon that said "Good Luck." When Betty Allan asked where he was staying, he proudly answered, "the Beverly Hills Hotel." As promised, Brooke had obtained her father's permission to use his suite, and although Andy was not moving in until the next day, he sensed that the posh hotel was a better address for a would-be mogul than the Surf Rider.

Andy made some long-distance calls, probably to his mother

The Trip

(who was on the phone constantly with Gerard's mother in the Bronx, worrying about what their "boys" were up to on the road), and to Henry Geldzahler, to share every little detail of his Hollywood adventure. Then he called local friends to make plans. He would see the Oldenburgs at Claes's opening that night, where it would be a relief to be a guest instead of the guest of honor. He also reached out to Cecil Beaton, who was living in Los Angeles while working as production designer, art director, and costume designer on Warner's *My Fair Lady*. The film was shooting on the Warner Bros. backlot, so Beaton was furiously busy, but he invited Andy and his friends to come to his suite at the Bel Air Hotel for tea later in the week. Andy had admired Beaton for years and considered the appointment a great coup.

He was also looking forward to seeing Lewis Beach Marvin III, a friend who was building what sounded like a spectacular home overlooking the ocean on a remote summit in Topanga. The New York sculptor John Chamberlain was also living in Topanga at the time, and he was enjoying life in the canyon.

In true Judy Garland/Mickey Rooney fashion, Andy excitedly told everyone that he was gathering all the "kids" together to "put on a show"—in this case, a film about Tarzan, but with a big twist. As with Andy's soup cans, his dollar bills, and his celebrity portraits, he would take a familiar subject—Tarzan, the beloved jungle hero—and portray him in a fresh and irreverent way. Unlike past Tarzans such as Johnny Weissmuller and Lex Barker, who were prime physical specimens (and gay icons), Taylor was small, droopy-eyed, comical, and without an ounce of muscle. The very idea of *Taylor* as Tarzan was so amusing that when people heard it they laughed out loud.

To make the production official, Andy visited Hollywood Camera and paid $7.03 for a clapboard, the traditional marker directors used at the start of every shot. Then he stopped in at Shaeffer Photo to pick up 16-millimeter film for the Bolex, which cost him about $29.00. Back at the Surf Rider, Andy and the others walked down to the beach for some sightseeing and location-scouting. They found wall-to-wall tourists and sunbathers on the expanse of sand. To the right was the famed Santa Monica Pier, home of a beautiful European-style carousel that was often used as a movie location. To the left was the gleaming outline of POP in the distance. Directly in front of them—in living, sun-kissed color—was Muscle Beach, the original home of California's world-famous bodybuilders, a stunning display of sweaty, sexy male pulchritude.

In the 1930s, the Works Progress Administration had installed a wooden platform and exercise equipment on Santa Monica beach, just a few hundred feet south of the pier. Young men who were interested in physical culture gravitated to the area and used the free equipment to work out. The presence of all those muscles pumping iron inspired the name "Muscle Beach," and spectators gathered to watch the bodybuilders go through their daily routines and perform in flexing and lifting exhibitions. Some of the men—Jack LaLanne, Steve Reeves, and Joe Gold, for example—became famous for their sculpted physiques.

The bodybuilders established a real community in Santa Monica. Several of them lived up the street at a place called "Muscle House," where they rented cheap rooms from a kindly landlady (who also cooked their meals). On inclement days, when the beach was inhospitable, they worked out in a garage-like building on the grounds of the Surf Rider. Nearby, Honest John's, a popular ham-

burger stand run by a professional wrestler, was their preferred hangout during breaks.

The sight of the bodybuilders and their equipment gave Andy an idea. Muscle Beach would be Tarzan's jungle. As for his other locations, Andy decided to combine sightseeing with filmmaking. Many of the places that had been recommended to him as "must-sees"— Venice, Topanga Canyon, even the Beverly Hills Hotel—would be scenic backgrounds for the "action," whatever that might be. Taylor was famous for improvising, the more outrageous the better.

They gave the film the working title *Tarzan Returns . . . Sort Of.* "Sort of" were the two most important words in the title, because Andy's "sort of" movie was defined by how it differed from conventional Hollywood productions. For starters, it was low— or more accurately, *no*—budget, nonunion, 16-millimeter, and silent. It was a movie without stars, script, sets, lighting, or costumes. Somehow, Andy had to figure out how to make a Tarzan movie with a droopy-eyed prankster as his leading man and crazy, contemporary Los Angeles as his backdrop.

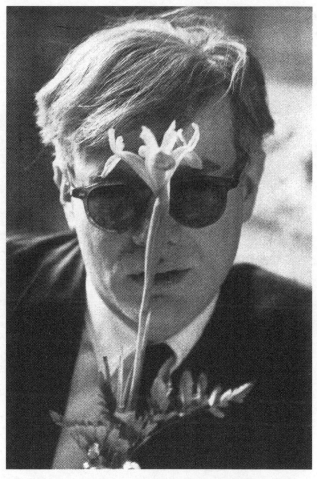

Dennis Hopper captures Andy in a celebratory
mood at a Hollywood dinner.

Chapter 14

Anybody can make a good movie, but if you consciously try
to do a bad movie, that's like making a good bad movie.

—Andy Warhol

According to the date he scribbled on his brand-new clapboard, Andy started shooting *Tarzan Returns . . . Sort Of,* on Wednesday, October 2. The first location was Muscle Beach, where Taylor offered a highly personal interpretation of the famous character. He climbed the monkey bars, hung from the swings, and played games with young children who looked as if they were trying to decide if he were a big kid or a demented grown-up. Just to make sure everyone knew he was Tarzan, the puny star repeatedly beat his chest and bellowed. At some point during the filming, he took off his shirt in front of Honest John's, the bodybuilders' hangout, emphasizing the fact that his scrawny body had absolutely nothing in common with their chiseled physiques.

From Santa Monica, Andy and his crew headed down the road to a fresh location, a community of bohemians, artists, poets, and derelicts known as Venice Beach. Taylor had spent time there a few years earlier and regaled his companions with stories about living out of a shopping cart and giving poetry readings at the Gas House, a counterculture café famous for bongos and beat writers such as

Allen Ginsberg. These days, Venice was so shabby that it was called "the slum beside the sea," but in 1904, the colorful little city had proudly entered the world as a showplace.

That year, the American tobacco king and conservationist Abbot Kinney had returned from a European tour convinced that provincial Southern California needed a touch of Venice, Italy, to make it more cosmopolitan. At great expense, he turned a worthless parcel of saltwater marshlands bordering Santa Monica into the Venice of America, complete with canals, bridges, gondolas, gondoliers, and a beachside reproduction of the Piazza San Marco. A trolley connected the floating city to greater Los Angeles, but once visitors arrived in Venice they could walk—or sail on a gondola—to wherever they wanted to go.

Kinney was a high-minded international traveler who hoped his European replica would attract people who were curious about world culture—he even envisioned offering classes to enhance the experience. Unfortunately, most tourists were not interested in self-improvement. They came to the storybook setting because they wanted to have fun at the amusement park and on the midway. Thrill rides, arcade games, and sideshows trumped culture, and Venice became the Coney Island of the Pacific.

By 1920, the picturesque canals that had been such a popular attraction were perceived as a liability. The automobile was taking over Los Angeles, and a city that was restricted to pedestrian traffic was an impediment to progress. Worse still, Venice's once scenic waterways and Italianate buildings were deteriorating. They looked authentic in their prime, but they had been built with ersatz materials that had succumbed to the corrosive salt air and the passage of time. In 1929, the city of Los Angeles filled most of Kin-

ney's beloved canals and turned them into paved roads. His majestic colonnades survived, but they sheltered the kinds of honky-tonk establishments that could be found on most boardwalks.

That same year, Venice began a new—and unlikely—chapter in its history. Speculators struck oil on a plot of land two blocks from the beach, and experts determined that the city was sitting atop a rich oil field. By 1932, 340 wells were up and running, pumping gallons of oil and buckets of money into the local economy. Residents were ecstatic about their newfound prosperity, until they opened their eyes to the ugly realities of living in a place that was blighted by unsightly derricks and pollution. Eventually the oil dried up, as did the cash, leaving a depressed community plagued by toxic waste and plunging property values.

Ironically, the city's decline was good news for one group: struggling artists—painters, writers, poets, and other creative types who gravitated to Venice because they could now find cheap housing in a beachside setting. They, in turn, attracted hangers-on who may not have been artistic, but who enjoyed the permissive lifestyle (sex, and even drugs) that could be found wherever bohemians congregated. Venice developed a reputation as the place to go for an illicit good time.

In 1959, the author and Venice resident Lawrence Lipton captured this fringe world in titillating detail in his book *The Holy Barbarians*, an opportunistic exposé that purported to tell the true story about "the rebellious, the nonconformist, the bohemian, the deviant . . . all the misfits of the world . . . the lost, the seekers, the beat, the disaffiliated, the educated, diseducated, re-educated," who called Venice home. The book was a runaway bestseller because, in the name of sociology, it dealt with subjects that were taboo and,

frankly, more than a little thrilling in the fifties. Lipton openly discussed orgasm (a word that rarely came up in public), drug use, free love, sexually explicit poetry and prose, and jazz, suggesting that his fellow Venetians had no known inhibitions and lived happily and unconventionally in their seaside Sodom.

Filmmakers liked the fact that the streets of Venice were edgy and authentically atmospheric, unlike the sanitized backlots at the studios. When Orson Welles filmed the famous opening of his 1958 noir drama *Touch of Evil*, he used the city's once-beautiful plaza as a stand-in for a sleazy Mexican border town. Venice became a popular destination for low-budget horror films because its stucco walls, desolate alleys, and abandoned buildings were the perfect backdrop for sinister behavior and dark deeds.

Courtesy of the Oldenburgs, Venice was about to become one of the locations in Andy's *Tarʒan*. Affordable rent and the presence of other artists had convinced Claes and Patty to settle in Venice when they moved to LA that summer. Their apartment, half a duplex bungalow at 438 Linnie Canal, was small and nondescript, but it had a courtyard and a small strip of garden filled with the extravagant blooms—lilies and hibiscus—that made even the poor parts of Los Angeles so seductive. Patty loved the climate and enjoyed sitting outside (with or without a bikini—the pink cement walls were high enough to provide absolute privacy) while she hand-stitched Claes's oversized soft sculptures, his shirts, toothpaste tubes, and the like. Claes, meanwhile, worked out of a studio he rented in the old Plaza area at the beach. "L.A. was full of inspiration for Claes," Patty noted. He loved that buildings looked just like his creations, particularly Tail o' the Pup, a hot dog stand shaped like a wiener and bun. And Mickey Mouse was everywhere. The seamless juxtaposi-

tion of the playful and the prosaic made people look twice, which was exactly what Claes wanted to achieve with his art.

When Andy visited the Oldenburgs, he discovered that Linnie Canal was *actually* a canal, one of the originals built by Abbot Kinney. A small pocket of residential waterways had survived the wrecking ball and was tucked away in the middle of Venice, a hidden enclave still boasting picturesque old bridges and walking paths. The site bore little resemblance to the fabled showplace of the past. "The canal looked prettiest at night," Patty admitted. By day, however, all its flaws were exposed. The water had become a dumping ground for garbage and old appliances. A man with a motorboat patrolled once a week, attempting to remove the debris that floated on the surface. But abandoned refrigerators, shopping carts, and other detritus remained planted in the ugly (and unhealthy) green sludge.

Like Orson Welles, Andy found Venice's quaint seediness the perfect location for his revisionist Tarzan. In one scene set in the Oldenburg's tiny backyard, Claes, who could be convincingly menacing, battled Taylor for control of a garden hose, until the pint-size hero escaped by climbing over the pink wall and jumping into the fetid canal. There he performed the film's first act of heroism by rescuing a dirty old doll that appeared to be drowning in the muck.

In just a few shots, Andy overturned decades of Tarzan tropes. Taylor was no hero, the "jungle" consisted of drab and barren concrete instead of lush foliage, and the shooting style couldn't have been further from the polish of the MGM originals. Instead, with his Bolex, Andy was doing his own version of cinema verité, the term used to describe the groundbreaking work of documentarians and such maverick fiction filmmakers as John Cassavetes, who were

experimenting with handheld cameras and improvisation. Andy did all of that, but with touches of irony and humor.

After dropping off the first day's film at a lab for processing, Andy and the others drove to the Beverly Hills Hotel to check in to the Hayward suite. With its towering palm trees, sweeping drive-way, candy-pink facade, and white-glove service, the Spanish Mission–style landmark was the antithesis of the Surf Rider. Andy was thrilled to walk under the famous green-and-white striped portico and into the arched lobby, a gathering place for celebrities. Even Taylor found the place impressive. "It was all very glamorous with 1930s movie stars and Howard Hughes in this little compound," he reported. Hughes had been staying there for over twenty years and felt so at home that he kept a telephone booth in his bungalow and had a standing late-night room service order of roast beef sand-wiches, which, per his specifications, were delivered to the branch of a nearby tree so he could go outside and hunt for his snack.

The hotel took its guests very seriously and maintained a card system to flag VIPs. The occasional nobodies who got in were filed on white cards as "commoners." Regulars—people who were not movie star famous, but who stayed often enough to warrant better treatment—were placed on blue cards (Lyndon Johnson was con-sidered "blue"). The megawatt Lizes and Dicks of this world—the real stars—were assigned special cards tinted the hotel's signature pink. One glance at a card would tell a clerk everything he needed to know about the person checking in. Andy was definitely in the white card category since, outside of art circles, few people had ever heard of him.

In this instance, anonymity worked in his favor. After touring the grounds, Andy selected two bodies of water to use in *Tarzan*—

the hotel's famous pool and the spacious bathtub in his suite. Many films had been shot at the Beverly Hills Hotel, starting with early silent comedy classics by Charlie Chaplin and Harold Lloyd. In 1957, Vincente Minnelli filmed *Designing Woman* there, and, most recently, the hotel figured prominently in the contemporary comedies *Move Over, Darling* with Doris Day and *Who's Been Sleeping in My Bed?* with Dean Martin. The hotel welcomed such productions because they generated great PR, but it was unlikely that any sane Beverly Hills Hotel executive would authorize a project directed by Andy Warhol and starring Taylor Mead. The underground filmmakers kept their movie underground and plotted to shoot surreptitiously.

The pool was their first location and was a clever choice. Johnny Weissmuller, the actor and Olympic gold medalist who played Tarzan in twelve films, was cast in the role after having been "discovered" while rescuing a drowning girl in that very pool. Andy picked a time of day —either very early or very late—when the area was almost empty, except for a few diehard sunbathers. The lounge chairs had been folded and their cushions put away by a fleet of white-clad cabana boys who worked under the supervision of the pool manager, Svend Petersen. Taylor looked normal—sort of— in short black swim trunks, and the Bolex was so small that Andy could pass as a tourist making a home movie should Petersen or a security guard happen to notice them. Taylor strutted by the deep end of the pool, where the Beverly Hills Hotel logo was visible, and mugged for the camera on the diving board. "I was Tarzan in one of his shark-infested lagoons," Taylor joked, referring to the show business "sharks" who congregated there daily.

Hayward's suite, rooms 271 and 272, was small, comfortable,

and pricey. The hotel charged $14.50 a night for each member of the Warhol party, although technically they were Hayward's guests. Taylor was particularly impressed by the lavish breakfasts they enjoyed, finding the rolls and orange juice especially delicious. Andy continued to pay for everything . . . well, *almost* everything. Taylor said that someone had supplied them with the top telephone number for young men. "I was too shy to call," Taylor admitted, "and Andy—the cheap bastard—was not sure if he wanted to spend the money." So no distracting hustlers were delivered to their rooms. Andy and the "boys" concentrated on making *Tarzan* instead.

Just as they were determining how to film a scene in the suite's oversized bathtub, there was a surprise knock at the door, and it opened on Naomi Levine. As promised, she had flown to Los Angeles, and her arrival inspired a dramatic, last-minute casting development. She insisted she had to be in Andy's movie. After all, every Tarzan needed his Jane. "No way," was Taylor's quick retort. "What nerve—to have taken a plane and followed us to L.A.— how pushy!" he thought. Typically, Naomi stood her ground and got what she wanted. Hoping to get rid of her, Taylor joined her in the tub for a test shot. Andy filmed "Tarzan" and "Jane" playing with a rubber duck and having good, clean fun with soap and water. Everyone assumed Naomi would be terrible, but an amazed Taylor was the first to admit that she was the perfect Jane, photogenic and spirited.

They stayed in that tub for a long time, and several calls to room service were required to keep their energy high. Short of occasionally saying, "Naomi, look over here for a minute," Andy didn't offer much direction. Like Taylor, Naomi was at her best when she was free to improvise. She prided herself on being completely un-

inhibited, and enjoyed when people seemed shocked—or, at least, surprised—by her unpredictable behavior.

Naomi and the boys became a quintet. Like an enthusiastic puppy, she was happy to go anywhere as long as she was in Andy's company. She was staying with the sculptor John Chamberlain and his wife, Elaine, in Topanga Canyon, but she spent very little time with them because it was more fun hanging out with Andy.

One of the social highlights of the trip was tea with Cecil Beaton at the Bel Air Hotel. His bungalow was one of the most beautiful properties in all of Hollywood. Initially, Beaton was reluctant to move in because he found the hotel's decorative swans, recorded cricket and frog sounds, ersatz storybook setting, and obsequious service a little over the top. However, after spending a few weeks in the trenches at Warner Bros., he realized that pampering was exactly what he needed.

On Friday, October 4—Beaton's only break from his brutal work schedule that week—he invited Andy and his entourage to visit. Some of them were impressed by their renowned host and the hotel's posh atmosphere. But Taylor found him snooty and raised his eyebrow when the Brit served tomato juice in little cans. He decided that Beaton was either witty or charming for coming up with a clever homage to Andy's Campbell's Soup can, or he was just plain lazy.

Gerard found the eminent photographer fascinating, and he was especially interested in a series of shots he had just done for *Vogue*. Beaton had a way of adding "clang and excitement," as the fashion editor Diana Vreeland liked to say, to every image he shot. The September issue featured profiles of the poets W. H. Auden and T. S. Eliot, and the actresses Anna Magnani and Greta Garbo, with

text by Christopher Isherwood and portraits by Beaton. The photographs were unusual because Beaton played with superimpositions that made his subjects look surreal. Coincidentally, Andy and Gerard had used the same technique when silkscreening some of the Elvis prints for the Ferus exhibition.

During their visit, Andy tried to explain Popism to Beaton, who found the new art incomprehensible. Nor could he wrap his head around the notion that Taylor and Naomi were stars, or "superstars," as Andy called them. The only stars Beaton knew looked like Audrey Hepburn and Rex Harrison. Surprisingly, Andy and Beaton were aligned in some of their thoughts about film. Earlier in the week, Beaton had dined with the great French director Jean Renoir, and one of their topics of conversation was the death of old Hollywood. Movies had gotten too big, too important, they agreed, invoking the observation of their friend Christopher Isherwood that "Hollywood is reduced to making masterpieces." All agreed that it was time for something different, though maybe not as different as what Andy was doing.

Beaton seemed very proper and "up there," as Andy liked to say, but as soon as the troop left the Bel Air that myth was dispelled with a choice bit of gossip. According to Taylor, Andy confided to his companions that *he* had heard Beaton's preferred form of sex was pretending to be a corpse and having a male hustler tease him back to life. "And he thought *we* were strange," Taylor observed wryly.

Another social highlight of the trip was dinner with Dennis Hopper—ever the serious host—at a Hollywood hot spot. That evening made a particular impression on Naomi because Andy, who was seated next her, suddenly opened a packet of sugar and poured

it on her arm. It was a gesture she found strangely endearing. "Gee, he's so sweet," she thought, interpreting his act as an indication of interest, which she hoped was romantic.

Andy was animated as he discussed his upcoming plans. There was more shooting to be done on *Tarzan* at a number of fabulous locations, he had people to meet, parties to attend, and he was eagerly looking forward to the opening of the Pasadena Art Museum's Marcel Duchamp show, curated by the former Ferus gallerist Walter Hopps. Andy was like a debutante in high season, his dance card completely full. His Ferus paintings may not have sold, but everyone was buying Andy himself.

Dennis was sitting opposite Andy that night and raised his camera to snap a few shots from across the table. Andy, stylishly decked out in jacket, tie, and movie star sunglasses, offered a slight, knowing smile, his face partly obscured by a flower from the centerpiece. Unlike the Raggedy Andy of the past, *this* Andy, the one who socialized with celebrities and was directing a film in Hollywood, looked cool, confident—even glamorous. This was the moment Andy had been dreaming of his whole life. Finally, he was ready for his close-up.

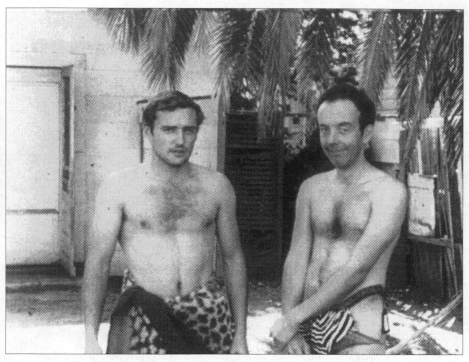

Two very different Tarzans, handsome Dennis Hopper
and goofy Taylor Mead, pose for Andy during the
filming of *Tarzan and Jane Regained . . . Sort Of.*

Chapter 15

That's one of my favorite things to say. "So what."

—Andy Warhol

Andy was in such high spirits that he decided to host a party for all his LA friends, both old and new. Not a conventional cocktails-and-canapés affair, but an evening even the most jaded Angelenos would remember. James Elliott, a curator at the Los Angeles County Museum, told Andy about the Looff Hippodrome on the Santa Monica Pier. The twenty-thousand-square-foot building, which housed a beautiful, old-fashioned carousel, had a few apartments overlooking the ocean, and Elliott was one of the lucky residents who lived on the Hippodrome's second floor. The setting was magnificent, although the booming organ music was annoying when the ride was up and running.

Elliott told Andy that the Looff could be rented for events. In fact, Walter Hopps had staged a groundbreaking art exhibition there in 1955. Andy remembered seeing the carousel and its antique wooden horses in the Hopper film, *Night Tide*, and decided it would be the perfect setting for his party. He scheduled the soirée for Saturday night, October 5, which coincided with his departure from the Beverly Hills Hotel. Taylor explained that "after

a few days there, it was just so dull that we moved out." Andy was happy to have experienced the landmark's old-Hollywood atmosphere, but he was discovering that Los Angeles's west side— Venice, Santa Monica, Malibu, Topanga—had hipper horizons to offer. The "boys" returned to the Surf Rider, eager to get back to the beach for the sun, sand, and surfboard experiences that attracted *young* Hollywood.

The Hippodrome was big enough to accommodate a large and eclectic guest list and Andy invited everyone he knew—Irving Blum, the Oldenburgs, the Hoppers, and all the friends of friends of friends he'd met on the trip. He even invited Cecil Beaton, who, not surprisingly, sent his regrets. When Taylor saw who Andy was inviting, he decided to step in as cohost to liven up what he saw as a staid Beverly Hills crowd. Reaching into his past, he came up with old acquaintances from Venice Beach. "I invited my 'best' friends from Venice, blacks and whites, and Andy invited his black-and-white tuxedoed friends from the Beverly Hills crowd," Taylor quipped, observing that their party may have been one of the first to meld those two practically exclusive social scenes.

Taylor also took charge of the food for the evening. He was sick and tired of liquor-fueled parties and wanted to make sure there would be plenty to eat. The one catch was that he was a vegetarian. He and Andy went to Norm's Market, which was right across the street from their motel, to stock up on alcohol and bar snacks. They bought six quarts of vodka, six bottles of Scotch, and three gallons of wine—enough spirits to guarantee a good time— and also ordered bountiful cheese and vegetable platters to round out the menu.

The brightly colored carousel and gay music unleashed the child in everyone. Andy's guests hopped up on horses and rode round and round, up and down, reaching for the gold ring. The more they drank—and partook of whatever drugs were available—the harder it was to stay in the saddle. The sight of Irving Blum and Claes Oldenburg balancing on wooden ponies was too good to pass up. Andy pulled out his Bolex and started filming. The lighting was terrible, and the carousel moved so quickly, the images were blurred, but he managed to capture quick flashes of happy faces, which would somehow make their way into *Tarzan*.

Taylor knew it was a good party when the guests had gotten so high they started crawling on the wooden floor, oblivious to the splinters, spilled drinks, and puddles of melted cheese spilling from the platters. "It was hot weather and the cheese was smelly and it ran all over everything," Andy complained. Cecil Beaton heard through the grapevine that the evening turned into "a fantastic orgy with people making love on the revolving horses and being photographed for an advanced movie," but that may have been a bit of an exaggeration. At some point, however, the police did come because the party had become too noisy for even the rowdy crowd at the Santa Monica Pier.

Before that happened, Gerard had locked eyes with a cute California girl named Andrea. She was a petite brunette, one of those friends of a friend who came because the party promised to be a wild and crazy night at the beach. She found the intense young New York poet irresistible because he was so dangerously handsome and dramatically different from the bland, blond beach boys she knew.

Ready to take their flirtation one step further, Andrea and Gerard walked over to his room at the Surf Rider to escape the crowd. They locked the door and started making out, thinking that they had time—and privacy—while everyone else was caught up in the party scene. After about forty minutes, the doorknob started rattling and they heard loud, insistent knocking. Gerard threw on his clothes opened the door, and found Andy—a very jealous Andy—outraged that Gerard had brought a girl to *their* room. Thinking quickly, Gerard announced that he and Andrea were going to spend the night at her house. They rushed out, leaving an indignant Andy in their wake.

Andrea lived in Beverly Hills, where her father was a successful dentist with movie star patients. Weirdly, he was also a famous mathematician who specialized in the esoteric study of flat geometry. Given the late hour, the young lovers bypassed the house and tiptoed to the finished room over the garage, where they spent the night together. This was the first time in twelve days that Gerard had been separated from Andy and the others and, as much as he liked Andrea, he *loved* these few hours of freedom.

Early the next morning, he made his way back to Santa Monica via public transportation. The desk clerk at the Surf Rider told him that Andy was at the beach, where Gerard found him sitting by himself, reading reviews of the Ferus show. Andy assiduously avoided mentioning his heated outburst from the night before. Instead, he concentrated on the reviews. Henry Seldis, the art critic at the *Los Angeles Times* and a self-proclaimed enemy of Pop, was predictably dismissive of the Elvis pieces (he didn't even mention Liz). He referred to Andy's celebrity subject as "Sir

Swivel," a derogatory name for Elvis (and his swiveling hips) in newspaper circles, and called any would-be fans of the exhibition "worshipers of pop art banality." Andy took Seldis's barbed comments in stride, but it was hard to forget Gerard's behavior the night before.

Andy saw himself as being "gregarious and looking for bosom friendships," so it puzzled him that true intimacy seemed to elude him. Perhaps it was better to accept being a loner, he thought, to stop campaigning for relationships, to stop caring if they didn't happen, and to act cool and detached, as if none of it mattered. "Sometimes people let the same problems make them miserable for years when they could just say, 'So what? My mother didn't love me. So what? . . . I'm a success but I'm still alone. So what?'" Embracing this philosophy, Andy practiced studied nonchalance on Gerard. *Tarzan* seemed to be a safe topic of conversation.

Andy had very ambitious plans for the movie and only five days left to finish filming. To use the time efficiently, he planned on bringing his cast and camera wherever he went, so that socializing, sightseeing, and shooting could happen simultaneously. "It was like a diary almost," Gerard said in describing the making of *Tarzan*. Andy used the movie as a visual record of his activities in Los Angeles

One day he spent in scenic Malibu was a perfect example. Wynn had introduced Andy to an amiable young man named Denis Deegan, who was friendly with John Houseman and his wife, Joan. Houseman was best known for his producing partnership with Orson Welles, which yielded such collaborations as *Citizen Kane* and *The War of the Worlds*. These days, Houseman was produc-

ing the kinds of heady, high-profile Hollywood movies that Andy loved, including Kirk Douglas's *The Bad and the Beautiful*. Thanks to Deegan, Andy and his friends were invited to spend the day at the Housemans' beach house, where they could film *Tarzan* and get a taste of the exclusive Malibu scene.

Andy was thrilled that day because there was an exciting new addition to his cast. Dennis Hopper had agreed to appear in the movie. Unlike Taylor, Dennis was a *real* star who had a sculpted physique much better suited to the title character. Andy cast him as Taylor's stunt double, and the juxtaposition of the handsome, well-built movie star with the scrawny Taylor made a big comic statement. When Taylor was supposed to climb a palm tree to pick a coconut, Dennis obligingly stepped in and did it for him. The two actors seemed to enjoy improvising their scenes, and Taylor was shocked by how natural Dennis seemed. He usually found the brooding actor to be a little rigid. "This is the most relaxed on camera I've ever seen him," he noted, adding that only *one* day in a Warhol film had changed him forever.

Dennis definitely added star power to *Tarzan*, but the big revelation that day was Naomi Levine. It was still very hot in Los Angeles, and, to stay cool, Naomi wore as little as possible—mostly a large, diaphanous purple scarf that she wrapped around her naked body. At one point during the filming at the Housemans', Naomi brazenly stripped off the scarf, leaving nothing to the imagination, and jumped into the pool, smiling unashamedly at the camera.

When she lay on her back in the water, her bare breasts in full view, she was challenging Andy to notice. Interestingly, he realized that the more he withdrew into himself, and the less he reacted to

her antics, the more she acted. This was proving true of the other performers, as well; sooner or later, they were bound to go too far and do something shocking just to elicit a response from him. Andy came to understand that his greatest talent was to stand by impassively and inscrutably, letting his subjects reveal themselves. Naomi's flirtatious nudity and Taylor's puckish hamming were their responses to Andy's maddening detachment. Thus, a directorial technique was born.

Each time he picked up the Bolex, Andy became more sophisticated and technically adept with it. He experimented with color film at the Housemans', the deep blue of the pool offsetting Naomi's glistening, tanned body. And he added a few Brechtian touches to his jungle adventure by placing himself inside the narrative. In one scene, Andy is showing Taylor the script and spanks him with a palm frond for refusing to take direction.

Andy put his color film to even better use at his next location, the remarkable Watts Towers. Not the buildings their name connoted, they were instead a collection of immense sculptures improbably located in a backyard in South Central Los Angeles. Andy packed up his cast and crew, along with a few masks and a giant lollipop, and drove to the site of the seventeen structures that New York's Museum of Modern Art had called "works of great beauty and imagination," and which the art historian William Seitz had described as "a unique creation of inspiring power and beauty."

The Watts Towers were built by Sabato "Simon" Rodia, an Italian immigrant who moved to the United States at the turn of the twentieth century. In 1921, he settled in Watts, a small blue-collar community set between Los Angeles and Long Beach. Rodia was a

cement finisher and tile maker by profession, but in his free time he used his skills to design and construct an array of edifices with different shapes—several lofty spires, a gazebo, a fishpond, a ship, and connecting serpentine pathways—which came to be known collectively as the Watts Towers. He started the project when he was forty-two, and he spent the next thirty-four years creating his magnum opus on a small triangular lot on a dead-end street in an impoverished urban neighborhood.

The towers looked as if they had required extensive planning and resources, but Rodia's process was really very simple. He covered steel wire mesh with thin layers of cement, then decorated the mortar with found objects, including "11,000 pieces of whole and broken pottery; 15,000 glazed tiles; 6000 pieces of colored bottle glass,; dozens of mirrors; 10,000 sea shells, abalone shells, and clamshells; hundreds of rocks, large and small; pieces of marble, linoleum, and telephone line insulators," among other materials. On closer inspection, shiny bits of glass turned out to be fragments from green 7 UP bottles and blue milk of magnesia containers. He picked up refuse wherever he could find it and used it in his sculpture. The art historian Cecile Whiting credited Rodia with transforming "the copious waste of an industrial society into a structure of soaring magnificence"—which was very close to what Andy and his fellow artists were doing with Pop.

Rodia's neighbors observed him working late into the night. Inch by inch, and with painstaking effort, he gradually added height and detail to his constructions, until the main towers were almost a hundred feet tall. "I did it all by myself," he boasted. "I never had a single helper." Nor, for that matter, did he have sophisticated tools,

or money. Rodia's assemblages were handcrafted, without the benefit of bolts, rivets, welds, or even scaffolding. Yet they were strong and remarkably beautiful. His masterful shapes, patterns, and color combinations confirmed that he had the eye, the instincts, the touch, and the soul of a true artist.

He was also a man of mystery. After completing his towers in 1954, Rodia suddenly deeded his property to a neighbor and inexplicably abandoned his life's work. He moved to Martinez, California, where he died ten years later. The vacant property became a dumping ground and a target for vandals, but it also developed staunch fans. Walter Hopps and Shirley Neilsen, who were art students at the time, were married there in 1955. Subsequently, two concerned individuals purchased the lot (which was in danger of becoming a taco stand) with the idea of turning the towers into a monument. They were surprised to discover that city officials considered the sculptures a safety hazard and were planning on demolishing them before they might collapse and hurt someone. Safety issues aside, the chief inspector of the City Building and Safety Department also weighed in as an art critic, calling the Watts Towers "the biggest pile of junk I've ever seen . . . it's an eye-sore and should be pulled down."

These were fighting words to members of Los Angeles's artistic community—including the famous architects Philip Johnson and Buckminster Fuller—who believed Rodia's naive works were masterpieces. A committee was formed to save the Watts Towers, and a battle ensued that culminated in a dramatic "load test" administered on-site. In one corner, Rodia's tallest spire; in the other, an apparatus designed to deliver ten thousand pounds of stress. Hundreds

of supporters watched, praying that the towers would pass the test. After a minute and a half of the full load, the beam supporting the test cable started to bend, but Rodia's tower stood strong. The property and its sculptures were rescued and restored, instantly becoming a destination for artists and art students.

Andy was enchanted by Rodia's colorful structures. Through the lens of his camera he zoomed in closer and closer to observe the intricate variety of materials and all the fabulous details. At certain angles, the coils of wire and concrete looked like jungle vines—a perfect setting for his reimagined *Tarzan*. Andy's cast that day, including Naomi, Taylor, and some new friends—the actor Jack Larson (who played Jimmy Olsen on *Adventures of Superman*) and the young director Jim Bridges (who would later make *Urban Cowboy* and *The China Syndrome*)—wore masks as they posed on the structures, while Naomi sucked seductively on that oversized lollipop.

Andy's little movie was turning into quite the travelogue, one that explored alternative Los Angeles and went beyond the Hollywood most tourists experienced. Perhaps the most alternative setting (and lifestyle) of all belonged to Andy's friend Lewis Beach Marvin III, whom Andy liked to call "the eccentric Green Stamps heir." Marvin came from money—his father was the chairman of the board of the Sperry Hutchinson Corporation, progenitors of the exceedingly popular S&H Green Stamps, which consumers would get as bonuses when they shopped, paste into books, and redeem for gifts when they had collected the requisite amount (just like the "points" awarded by banks and credit card companies today).

Though raised in luxury, Marvin was someone who always

blazed his own trail. After studying at Oxford, he moved to California in 1957 to pursue a healthier, more individualistic lifestyle. He paid $15,000 for the ultimate retreat—a sixty-acre parcel of land at the very top of Tuna Canyon in Topanga—and named it "Moonfire." A journalist who saw the spectacular spread quipped, "For a trading stamp heir, it has to be the ultimate redemption center."

Fifteen hundred feet above sea level, the property offered a lofty view of the Pacific Ocean and the LA coastline from Santa Barbara to Palos Verdes. The land was completely unspoiled, and Marvin intended to keep it that way. Without the benefit of running water or electricity he started building a residential compound with his own two hands. He was "Thoreauly in love with nature," wrote the *Los Angeles Times* in an early profile of the iconoclast. Marvin was a vegetarian and an animal-rights activist who, like a modern-day Noah, surrounded himself with many exotic pets, including a monkey named "Mr. President," fourteen German shepherds, sheep, goats, hundreds of birds (from chickens to peacocks), and, ultimately, a camel named "Boney Bananas." He believed in maintaining a pure body in an environment that was at one with nature, refusing to ingest animals or harm them. He wouldn't even swat a fly, though swarms of them followed his animals wherever they went.

Marvin invited Andy to visit Moonfire, suggesting that it would be an interesting location for *Tarzan*. Andy accepted, having no idea that he was embarking on the riskiest and most hair-raising stretch of his trip thus far. The two-mile road leading up to Moonfire was little more than a narrow dirt scar winding around

the mountain—there were no shoulders whatsoever, and a sheer drop. The bulky Falcon took up its entire width, and the unlucky passenger who found himself sitting behind the driver on the way up experienced a stomach-turning cliffside view for the duration of the steep ascent. However, once the car passed through Moonfire's antique gates, a magical place awaited. Marvin was in the process of building a concrete temple overlooking the ocean. The outdoor pavilion was outfitted with a ceremonial fire pit and a grand piano on pulleys, so it could be raised and lowered to prevent it from blocking the view. Marvin was also building an outdoor bedroom that consisted of a mattress balanced on steel pylons that could be lifted forty feet into the air—spectacular, but potentially danger-ous for a restless sleeper.

Andy took advantage of the quirky setting by filming Taylor cavorting on the property, and he persuaded Marvin and Mr. Pres-ident to appear with him. Despite his wealth, Marvin lived simply, in a manner that would later be described as "back to the land." "While he was building this incredible house," Andy noted with amusement, "he lived on the grounds in a trailer filled with dirty laundry." In one scene, Taylor jumped out from that very trailer, which was decorated with a giant eye and the words "Uno Mundo," and danced a crazy little jig while Marvin played the drums. In an-other scene, he pretended to play the outdoor piano.

There was a visiting dignitary on set that day. When Marvin called for a break and served cucumber sandwiches to his guests in his weed-filled garden, Aldous Huxley, the author of the dysto-pian classic *Brave New World*, appeared from nowhere. Tripping on LSD, he fit in perfectly with Andy's band of outsiders. After shoot-

ing wrapped, the bizarre, through-the-looking-glass experience at Moonfire culminated with a slippery and tense drive down the mountain, which was even more unnerving than the trip up, since Taylor or Wynn, whichever was at the wheel, was undoubtedly higher than the proverbial kite.

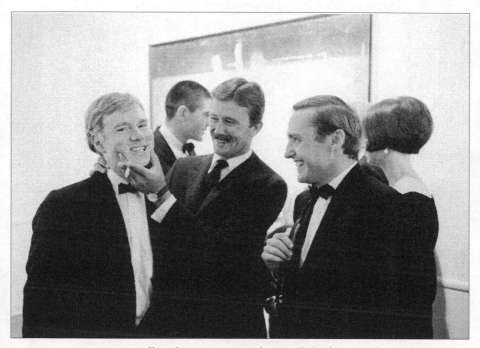

Painter Billy Al Bengston pinches Andy's cheek at the
Marcel Duchamp opening while Dennis Hopper watches.
The Ferus Gallery's Irving Blum stands behind them.
© 1963 Julian Wasser. All rights reserved.

Chapter 16

I'm really afraid to feel happy because it never lasts.

—Andy Warhol

The centerpiece of Andy's extraordinarily crowded calendar was a party honoring Marcel Duchamp, one of the most controversial artists of the twentieth century, at the Pasadena Art Museum on Monday, October 7. Duchamp pioneered the revolutionary philosophy that the act of calling something art *made* it art. Perhaps the best-known example of this is the urinal he bought in 1917, which he titled *Fountain* and submitted to an art show. He wanted to challenge staid preconceptions about art by shifting the focus from the object to the viewer's interpretation of that object. The debate surrounding Duchamp's work (was it art, or was it a joke?) was similar to the one surrounding Andy's contentious creations.

Posh, prim Pasadena, with its manicured gardens and elevated social scene, seemed to be the least likely community to pay tribute to an avant-garde artist, but it was the home of a preeminent modern art museum that housed a million-dollar collection of German Expressionist art and work by other contemporary artists. Recently, the museum had recruited Walter Hopps to be its new acting director and to curate Duchamp's first retrospective show, *By or of Marcel Duchamp or Rrose Sélavy*. Hopps was introduced

to Duchamp's work in the 1940s when he was a student. He had visited the home of Walter and Louise Arensberg, two Duchamp collectors, and developed a lifelong interest in the controversial artist. Now Hopps was dedicated to pulling off this groundbreaking show, which could make the little Pasadena Art Museum famous in international circles.

Society matrons and museum patrons put their heads (and wallets) together to stage an invitational premiere and gala reception for the famed Frenchman, starting with an exclusive viewing of such Duchamp classics as *Nude Descending a Staircase* (a painting so extreme that it caused a critical storm when it was shown at the New York Armory Show in 1913), followed by a party at the historic Hotel Green. Most of the people on the guest list were lenders to the show, Pasadena aristocrats, or French diplomats. But the Hoppers, Irving Blum, and some artists—Billy Al Bengston, Wallace Berman, Claes Oldenburg, Ed Ruscha, and Andy, among others—also made the cut.

Andy was excited to meet the man who was considered the godfather of Pop Art (although he joked that Pop Art had more fathers than Shirley Temple in her movies), and decided to bring Gerard, Taylor, and Wynn with him. He dressed in a tuxedo for the occasion, but Taylor bemoaned the fact that he had nothing to wear to the ball. At the last minute, he borrowed an expensive white cardigan from Wynn, but the sweater was so large on Taylor's diminutive body that Andy said the rolled-up sleeves looked "life preservers." Even Taylor had to admit that he was dressed more like an "informal golfer" or a "beach-lounger" than someone on his way to mingle with a roomful of "L.A. society swells."

When they arrived in Pasadena, Andy and Gerard had a chance

encounter with Duchamp himself at a cocktail party in the garden outside the museum, which got the evening off to an auspicious start. "Andy and I were like two little giddy kids jumping up and down around Marcel Duchamp," Gerard recalled. Everyone was charmed by Duchamp, whom the *Los Angeles Times* described as "a slight, soft-spoken French gentleman with an enchanting sense of humor." Andy had a good time at the exhibition, and, after a week of shooting *Tarzan*, he was much less inhibited about using his Bolex, so he filmed various friends at the opening. Brooke Hayward and Irving Blum posed playfully, although Brooke put an end to Andy's insistent close-ups by raising her hand to block his lens. Julian Wasser, a photographer covering the evening for *Time*, photographed Bengston pinching the cheek of a beaming Andy while Dennis Hopper looked on. It was a happy, celebratory crowd.

Wallace Berman, who was a fiercely independent-minded artist and parent, brought his eight-year-old son, Tosh, to the historic Duchamp event. It was Tosh's first big art opening. "I had not the foggiest idea who this Frenchman was," he said when recalling the experience, but he remembered loving the artist's iconic bicycle sculpture. Adults had to think about "theory, humor, and the concept what is and what isn't art" when they viewed Duchamp's baffling creations, especially the urinal, but Tosh was just a kid who liked looking at a bicycle wheel. When Andy met Tosh that night he knew that he had found the perfect person to play "Boy," Tarzan and Jane's son, rounding out his cast. He arranged to shoot at Berman's home in Beverly Glen later in the week.

After the opening, the festivities moved to the Hotel Green, where Dennis indulged in a little Duchampian mischief by stealing a sign pointing the way to the party and then asking Duchamp to

sign it. Later, he hung the artifact in his living room (along with the exhibition poster) as part of his treasured collection.

There was hell to pay when Taylor discovered that his name was not on the guest list. Channeling his inner superstar, he tried to talk his way into the party by insisting that he was *the* Taylor Mead, although no one in Pasadena social circles seemed to know who that was. The ever-gracious Marcel Duchamp came to his rescue. He had heard of the underground star and insisted that he be seated at his table, which made Taylor feel more self-important than usual. Wynn suspected that Andy was annoyed by the amount of attention Taylor received from the guest of honor, but Andy was enjoying himself too much to care.

Duchamp was a gentleman to everyone that night. Gerard came over to him to discuss poetry and received advice he would never forget. Duchamp pointed out that poems, like works of art, did not have to be original: they could be reworkings—or "readymades"—of existing material, filtered through a new point of view. He said, "write me a poem that's not a poem," presenting Gerard with a challenge. This idea had not occurred to Gerard before their conversation, and it was an experiment he was eager to try. "He sort of threw me the ball and I had to run with it," Gerard mused.

On a less aesthetic note, Taylor and Patty Oldenburg brazenly moved to the center of the ballroom and started dancing up a storm. Their crazy moves attracted so much attention that Taylor boasted "I was the star of the party! Everybody was talking about me." Andy found the evening so exciting that he drank too much pink champagne and got sick on the way home. He later joked that "In California, in the cool night air, you even felt healthy when you puked."

There was no time to feel unhealthy because Andy was think-

ing about leaving Los Angeles on Friday. He had only three days to finish *Tarzan* and accomplish all the sightseeing and socializing he had planned. He also had some business to take care of relating to the Ferus exhibition, most importantly an interview with Ruth Hirschman, the arts director at the radio station KPFK. Andy brought Taylor with him to the studio and was surprised to see that Hirschman was accompanied by her five-year-old daughter, who was too sick to go to school that day. Hirschman saw the look on their faces. "They were not pleased, to say the least," she recounted. "It was clear they were going to be interviewed by this suburban mom . . ." But she forged ahead with her questions, pretending not to notice that Andy and Taylor were not taking her seriously.

Andy opened with the blatant lie that he was from Youngstown, Ohio, and answered most of her questions tersely, alternating between "Yes" and "Uh, no" responses. He was trying on his inscrutable sphinx personality, withholding information and blurring the line between truth and fiction in an attempt to package himself as being enigmatic. But Hirschman was a seasoned professional who worked very hard to keep the conversation going. Then loquacious Taylor stepped in—which is what Andy was counting on when he persuaded him to come– and did enough talking for everyone. He discussed everything from the new cinema to their cross-country trip, and how everything looked Pop. "Both of us would say, 'Oh what a great Coca-Cola sign or what a great restaurant sign . . . as a result of Pop Art," he told listeners.

Eventually, Andy realized that Hirschman was actually smart and engaging and he started warming up to her questions. When asked if each can of Campbell's Soup held a different meaning for him, he reflected and said, "No, I just think people do the same thing

every day and that's what life is. Whatever you do is just the same thing." Andy was experiencing an internal tug of war: as much as he wanted to be inscrutable, there were moments when he could not help being genuine.

Thanks to Billy Al Bengston, Andy paid a visit to Ascot Park, a dirt racetrack that was not far from Watts. Bengston, in addition to being a talented artist and crackerjack surfer, was a motorcycle enthusiast who had raced professionally for a few years, until he was in a serious accident at Ascot and started contemplating his own mortality. Bengston still loved bikes and racing, and he encouraged Andy to spend an evening at the track. Naturally, the Bolex came with him and he shot dimly lit footage of speeding vehicles that somehow made it into *Tarzan* even though race cars had nothing to do with the plot.

Andy and his friends also got around to visiting POP, which was a lot closer than Disneyland. Naomi tagged along, annoying Andy by constantly trying to start "something" between them. She had been flirting with him throughout the shoot and was growing bolder every day. He was cordial and considerate, but never remotely intimate. If Naomi was trying to force him into a display of affection, she picked the worst way to do it. While they were enjoying one of the rides à deux at POP, she committed the ultimate sin by playfully pretending to pull off his toupee. Andy was not amused and reacted badly, turning on Naomi in anger.

When Naomi went home to the Chamberlains' that night she had a lot to say about Andy. Spending time with him had led her to certain unpleasant conclusions. "I started seeing how, with his passiveness, he provoked people into becoming sort of freaky," she said. Chamberlain found Naomi's observations both interesting and

timely because he was in the process of constructing an "Andy" sculpture that he called *Andy Candy*. His creation consisted of twisted red, white, and blue metal, an inescapably American color scheme. The piece's underlying message seemed to be that Andy— who was fascinated by celebrity, death, and consumerism— and America were one.

More anthropomorphic than Chamberlain's other works, *Andy Candy* had powerful "arms" that looked ready to deliver a super-hero punch, suggesting that Andy's oversized fist was delivering a knockout blow to conventional art. The figure also had a head with a "face" rendered in shiny metal. Instead of seeing "Andy's" features, the viewer saw his own reflection. Andy, in this work of art and in life, was a mirror—a reflective surface, giving no hint of what, if anything, might lie beneath.

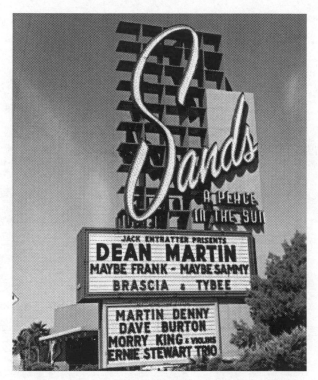

Las Vegas at its most glamorous was one of the
"places in the sun" Andy visited on his way home.

Chapter 17

We took the Easy Rider route back, through
Vegas, then down through the southern states.

—Andy Warhol

After Andy and Naomi's Tunnel of Love squabble, there was tension between them, and the friction became infectious. The four road-trippers began to spat as well. Taylor was in a snit because he accused Andy and Wynn of trying to bully him into giving them blow jobs (something Wynn denied vehemently after the trip) while he was preparing for a poetry reading in Venice—although it was difficult to imagine Taylor being offended by *any* sexual overture. Gerard was still smarting after Andy's fit of jealousy the night of the party at the carousel. And Wynn was wondering why the hell he signed on for this interminable trip in the first place. It was time to go home.

On Thursday, October 10, Andy wrapped *Tarzan* at Wallace Berman's house. As promised, young Tosh played the part of Boy, and the Bolex loved his soulful little face. Tosh had very definite memories of Taylor, who joked and played cards with him. But he had no recollection of Andy, who was already perfecting his laissez-faire, invisible-man style of directing. The movie's final scenes depicted Jane being kidnapped and knocked out by hunters (includ-

ing Berman wearing a white hat) and Tarzan reviving her with a jar of Gold's Mustard. They celebrated their happy ending at a classic Hollywood hot dog stand.

Tarzan and Jane Regained . . . Sort Of, as the film was now called, was finished . . . sort of . . . and Andy had decided to let Mead edit it in New York. That was one reason to think about heading home. Another was that Andy had to find a new studio because he was being forced to vacate the Firehouse. Most important, after two weeks on the road, Andy was ready for a change of scenery and a new cast of characters. It was time to pack up the Falcon and say good-bye to Hollywood.

On Friday morning, Andy made some telephone calls, ate breakfast in the Surf Rider coffee shop, and paid the motel bill with his Carte Blanche card—$223.27 covered the cost of two rooms, miscellaneous meals, and calls for six days. It was unlikely that a lengthy car ride would improve the travelers' deteriorating relations, so it was best to get started. The one bright note was that they decided to make a quick stop in Las Vegas—a first for Andy—before taking the Southern route home.

In 1963, Las Vegas was the epitome of cool. After filming the popular movie *Ocean's 11* there in 1960, Frank Sinatra and his Rat Pack—Dean Martin, Sammy Davis Jr., Joey Bishop, and Peter Lawford—had made the city their personal playground. Whenever one of them headlined at the Sands or another top casino, the rest of the gang would show up for an impromptu performance. "DEAN MARTIN—MAYBE FRANK—MAYBE SAMMY," the marquees teased, prompting sellout business.

Vegas regulars knew the drill. In the Copa Room at the Sands, if waiters rolled a drink cart onto the stage, it signaled the arrival of

Frank and friends (now minus Lawford after the JFK Palm Springs debacle). The stars helped themselves to cocktails and immediately started telling jokes, volleying barbs, and performing musical numbers. The act seemed improvised, but was generally orchestrated by Joey Bishop, who was quietly clever. No subject was off-limits. Dean Martin celebrated the joys of alcohol, while Sammy Davis good-humoredly participated in (and sometimes initiated) jokes that made fun of racism. One night, Martin held the diminutive Davis in his arms and said that he'd like to "thank the NAACP for giving me this trophy."

Andy and his companions drove the 265 miles and swaggered into Vegas to enjoy their own rat pack experience. They may or may not have known that they were there at the exact same time as Marcel Duchamp. The artist's old friend Bill Copley knew of his interest in chess, gambling, and the casinos of Monte Carlo, so he arranged for a private jet to transport Duchamp, his wife, Teeny, Walter Hopps, and some LA collectors to Las Vegas for the weekend.

The party stayed at the Stardust Hotel, where they saw the show *Le Lido de Paris,* a Folies Bergère–themed feather-and-sequin extravaganza. Duchamp would have been amused to know that Vegas was in the throes of what insiders were calling the "French wars." Somehow, the notion persisted that French entertainments were racier (doubtless the legacy of the bum-baring cancan) than American fare. Top nightclubs tried to out "ooo-la-la" each other by importing shows and beautiful women from the Continent. The Tropicana had the authentic Folies Bergère; the Hacienda featured *Les Poupées de Paris,* an adult puppet show; the Silver Slipper offered a "French" stripper named Lili St. Cyr (at least, the Minnesota-born burlesque queen *sounded* as if she could be French); and the New Frontier pre-

sented the eye-popping "Paree! Ooo LA LA!" One of Duchamp's companions observed that he (an *authentic* Frenchman) looked a little stunned during the show.

Late that evening, Duchamp toured downtown to see the lights (which he pronounced a "wonderland"), and stopped in at the Golden Nugget Casino to gamble. According to Hopps, Duchamp used his "readymade" philosophy to develop a system at the roulette table. "He touched no equipment nor engaged directly into any game during the entire 48 hours," Hopps explained. Instead, Duchamp gave him seemingly random and spontaneous pieces of advice on how to play: "Place some chips on that table and see what happens," he said. Or, "Why don't you try seven chips on corners of the high numbers?" And sometimes he suggested that they just "stop and chat." The "system" did not make much sense to Hopps, but apparently Duchamp knew what he was doing because, by the end of the trip, an initial investment of twenty dollars had increased "100-fold." Duchamp presented Hopps with a signed reproduction of a roulette wheel to commemorate their success. He also posed with his friends for a group photo, just like a proper tourist.

Andy elected to stay at the Blair House Hotel Apartments, a motel with ninety-two self-described "luxurious" apartments and a heated pool. It was about a mile and a half from the Strip, which made it more affordable than the big resorts. And it seemed to be a popular place with the transient showbiz crowd who came to work in Las Vegas. The hotel advertised in *Billboard*, the music industry's bible, boasting that "to Entertainers everywhere, the Blair House is known as home away from home."

Andy may have economized on their rooms, but he spared no expense in planning the evening's recreation. Las Vegas attracted

the hottest talent, and the fans followed, happy to be entertained while they gambled. Elvis was a regular (he and Ann-Margret had just finished shooting *Viva Las Vegas* in September), as were Patti Page, Robert Goulet, Bobby Darin, Liberace, and Barbra Streisand, to name just a few others. The *Las Vegas Show Sheet*—the weekly schedule of headliners at the top venues—listed this week's performers, including Eddie Fisher at the Desert Inn, Ella Fitzgerald at the Flamingo, Harry Belafonte at the Riviera, Bob Newhart and Sergio Franchi at the Sahara, and, at the Sands, Sinatra's hangout, Bobby Rydell. Andy loved Rydell, the popular teen idol whose recording of "Volare" had climbed to the top of the charts and who recently starred as Ann-Margret's dreamy boyfriend, Hugo, in the hit movie musical *Bye Bye, Birdie*. Rydell's opening act that night was Alan King, the acerbic, wisecracking, quintessentially New York comedian. Nightclubbers at the Sands always held out hope that there would be a surprise last-minute performance by Frank and his friends. Andy and the others enjoyed a great show even though there was no sign of the famous drinks cart or the Rat Pack, and they spent the rest of the night exploring Vegas.

Like Duchamp, Andy was stunned by what he saw. If he liked the signs on Route 66, he *loved* the neon skyline on the Strip. Tom Wolfe visited Las Vegas at roughly the same time in 1963—seeing exactly what Andy saw—and wrote a rapturous description of the city's signature illuminations. "One can look at Las Vegas from a mile away on Route 91 and see no buildings, no trees, only signs. But such signs! They tower. They revolve, they oscillate, they soar in shapes before which the existing vocabulary of art history is helpless," he marveled. Nondescript two-story buildings were topped by sixteen-story signs, and an entire Las Vegas sign-making indus-

try, led by the Young Electric Sign Company, was developing to support it.

Andy saw a giant silver slipper (looking very much like one of his shoe illustrations) rotating high above the casino of the same name. A bucking bronco stood guard over the Hacienda. An oversized martini glass welcomed visitors to the Red Barn. The Sands had its own towering, eye-catching logo. And the Stardust sign was a masterpiece, featuring a neon solar system that looked like an enormous space-age chandelier. Las Vegas signage, a hybrid of light-infused advertising and way-out architecture, was as much of draw for tourists as the gambling was. Andy thought of Vegas as one fabulous Pop Art museum.

On their way out of town, the boys made a quick sightseeing stop at the Hoover Dam. Then their plan was to drop down through Arizona on Route 93, which cut straight through the Sonora Desert, and head east by way of Texas. The land surrounding the highway was so undeveloped that it was called "the loneliest road in America." There were dramatic views of mountains, cliffs, Saguaro cacti, creosote bush, scrub, flowering bear grass, and other desert plants, and, at one point, gnarly Joshua Trees appeared on the horizon. They decided to stop in the old mining town of Wickenburg and eat at the Rancho Bar 7, a classic Western bar and restaurant where they could get a drink and a taste of the local cuisine. Even the bartender, "Uncle Wes" Bodiroga, was a local treasure. He started working at the Rancho Bar 7 in 1942, when he was twenty-two years old. Uncle Wes might have raised an eyebrow when Andy, Taylor, Gerard, and Wynn walked in and sat in a booth in the back. Then again, he had seen everything during his two decades behind the bar.

After dinner, they drove to Phoenix to spend the night. Four

The Trip

highways—Routes 60, 70, 80, and 89—intersected there, so the city had become a "motel alley" for weary travelers in need of last-minute accommodations. Van Buren Street was home to over a hundred nondescript motor hotels, and Andy chose Newton's Inn, which had a pool and coffee shop and, most important, accepted his Carte Blanche card. The next morning, the "boys" grabbed a quick breakfast and got back into the car. On went the radio and out came the magazines, as the foursome wrestled with the inescapable boredom that came with a lengthy car trip—especially if one were on one's way home.

They drove across the southern end of New Mexico. Somewhere in Texas, the travelers began to notice some unusual bumper stickers and billboards, the antithesis of the playful ones they had seen on the way to Los Angeles. "KO the Kennedys," was their ominous message, expressing the mounting animosity toward JFK and his younger brother, Robert, in this conservative part of the country. In fact, a popular parlor game at the time was "Which Kennedy do you hate most?" In Texas, there were so many reasons to hate the Kennedys, especially JFK. The president was Catholic; he had too much money; he was soft on Communists; he showed favoritism to African Americans—in short, he was running this good ol' country into the ground, and some people wanted to voice their disapproval. Privately, JFK called the Lone Star state "nut country."

Just as Andy and his companions were passing through Dallas, a twenty-four-year-old ex-Marine and Communist sympathizer was moving into a rooming house, following a lead he'd been given about a job opening at the Texas School Book Depository. Lee Harvey Oswald had recently returned to the United States after living in the Soviet Union, and he claimed he wanted to settle down in

Dallas with his Russian bride and infant daughter. He got the job and began working at the depository immediately.

After Dallas, Wynn and Taylor pushed the Falcon to the limit. Having covered nearly five thousand miles, the exhausted car, no longer the little engine that could, choked, smoked, and finally broke down in Meridian, Mississippi. Luckily, D. L. Kelley's Texaco Service was able to diagnose the problem. A mechanic replaced the battery, fuel pump, and muffler, and filled the tank, all for $30.35.

In the Appalachian town of Sylva, North Carolina—a place so far from the highway that it was a mystery how they got there—the car once again sputtered to a halt and had to be handed over to a service station. Andy checked everyone into a motel room to await the second round of repairs and, out of curiosity—or boredom—made a halfhearted pass at Gerard, who immediately pushed him away and dismissed the idea of fooling around with his boss.

The rest of the trip passed quickly. Andy was stretched out on his mattress, reading magazines and daydreaming about movie stars, neon lights, billboards, beaches, and all the amazing sights he had seen during his Pop odyssey. The Falcon raced through Pennsylvania and New Jersey, the landscape became pleasantly familiar, and, at long last, the Manhattan skyline was within sight. They were home.

ALL SET

Taylor Mead and Naomi Levine appear on the
cover of *Moviegoer*, whose reviewer sort of
liked *Tarzan and Jane Regained ... Sort Of.*

Chapter 18

Well, you might say I have a fondness for silver . . .
<div align="right">—Andy Warhol</div>

T he terror began immediately in New York," said Taylor, describing Andy's behavior once the Falcon turned onto Lexington Avenue and pulled up in front of the townhouse. Gerard's suitcase seemed to have gotten bigger while they were on the road and he had to somehow transport it all the way home to the Bronx. Taylor watched him struggle as he carried it down the street to the subway, shocked that Andy didn't offer him money for a cab. "Don't tell me Gerard is going to take the subway with that thing," he said to Andy accusingly. But there was no response. Gerard's comfort seemed to be the last thing on Andy's mind.

It was business as usual the next day for everyone. Gerard got over Andy's petty snub and was back at the Firehouse immediately after their homecoming. In addition to working on Andy's art projects, he was scouring the city for a new studio. After hours, he squired Andy to poetry readings at places like Café Le Metro in the East Village. There was always something interesting to see, and Andy wanted to keep up with new ideas. He said he went because he "liked to listen for new ways to say old things and old ways to say new things."

Thanks to Gerard's encounter with Marcel Duchamp, the young poet felt newly invigorated about his writing, and he was trying to figure out how to compose a poem that wasn't a poem. "Duchamp's influence, which was a very concrete influence, had to do with discovery. Recognizing the poetry in something even if it doesn't have to do with words," he explained. Suddenly, Gerard saw the possibility of poetry everywhere, from the descriptive copy in fashion magazines to the lessons in his science books. Eventually, he wrote (and published) poems based on these unlikely source materials—his versions of Duchamp's readymades.

Taylor immediately immersed himself in the herculean (and some would say impossible) feat of editing *Tarzan* into a cohesive film. "Editing" might have been the wrong term to describe what he was doing, because Taylor barely left anything out. In fact, he included footage that had nothing to do with the ape man's story, including a shot of Brooke Hopper and Irving Blum at the Duchamp opening. He said he was attempting to turn their wacky California travelogue into "a more or less flowing sequence," but this underground *Tarzan* was still odd and chaotic.

The movie was silent, until Taylor, who rarely went anywhere without his transistor radio and considered himself a connoisseur of pop music, laid on a primitive soundtrack of songs he deemed appropriate, including "You'll Never Get to Heaven if You Break My Heart" and "South Street." He also added bits of narration here and there, commenting not so wittily on the action.

Taylor was shocked when Naomi—the same Naomi who eschewed underwear, took off her clothes at the drop of a hat, and was rumored to be the flagrantly sexual star of *Christmas on Earth*—suddenly turned prudish after she saw the footage of *Tarzan*'s extended

bathtub scene. "Naomi couldn't wait to take off her clothes the whole time we were in L.A. She blamed it on the heat, but she liked making people look at her," Taylor explained. "It changed once we were back in New York. She didn't mind showing her tits and a bit of leg, but anything else was taboo because she was afraid Daddy might see it and get upset. When she tried to rip the film from the editing machine, I slugged her," Taylor said unapologetically, describing a knock-down, drag-out fight. He stood by his decision not to cut any nudity, and Naomi was furious.

Now that Taylor was a "superstar," his talents as an actor were suddenly more in demand. The poets Frank O'Hara and LeRoi Jones tapped him to star in their upcoming plays, which would be performed on a double bill at the Writers' Stage Theater in March. In O'Hara's *The General Returns from One Place to Another,* Taylor was cast as a campy version of General Douglas MacArthur, once again playing against type (and he won an Obie for his performance), while in Jones's *The Baptism,* he was convincingly cast as "the Homosexual."

Wynn came back from the trip ready to try a different style of painting. He found himself thinking about some interesting magazines he had seen in California that celebrated "nudie" physical culture, especially one called *Teenage Nudist.* The debut issue showed wholesome young people at play, clean-cut all-Americans who might be found at a country club or at a ball game. He described them as "ordinary people in ordinary surroundings without clothes."

Wynn was trying to figure out how to incorporate the magazine's fresh, naive aesthetic in his work, as he said, "to move figure painting out of its academic past to a bright new level." It was a challenge be-

cause, in the art world, there was a longstanding distinction between "nude" and "naked." According to the art historian Kenneth Clark, nudes were highly idealized, while naked figures were more realistic and usually inspired shame. "To be naked is to be deprived of our clothes, and the word implies some of the embarrassment most of us feel in that condition," he wrote. Wynn wanted to combine the two and create "Naked Nude" figures that were realistic, yet unashamed, just like the playful photographs in *Teenage Nude*.

He decided to ask some friends to pose for him, and, not surprisingly, one of the first people he called was Naomi Levine. She had been so comfortable without clothes in front of the camera (and in front of friends *and* strangers, for that matter), that he thought she might say yes. Despite her sudden prudishness about *Tarzan*, Naomi was enthusiastic about posing nude (or naked) for Wynn. He also asked Andy's friend and the star of *Sleep*, John Giorno, the artist Ruth Kligman, and the beat poets Allen Ginsberg and Peter Orlovsky, among others. The series of paintings, which he titled "The Naked Nude," were as bright and as vibrant as the California sunshine, capturing the innocence and casual exuberance of the new sexuality.

For Andy, coming home meant a reunion with his doting mother, who had missed him terribly while he was gone, and a pile of work. There were paintings to finish and a giant mural to create for the 1964 New York World's Fair (he was thinking about covering the side of the New York Pavilion with thirteen oversized mug shots of men from the 1962 most wanted list, an idea inspired by Duchamp's *Wanted 1923*). He had at least two films to edit—*Tarzan and Jane Regained, Sort Of,* with Taylor, and *Sleep*—and more films to shoot, including additional segments of *Kiss*.

The Trip

After Taylor put the finishing touches on *Tarzan*, Andy arranged a showing at the Film-Makers' Cooperative. Celebrating the experimental spirit of the film, *Tarzan* was projected out of order, with the ending shown first. Taylor was supremely insulted when one of Andy's disparaging friends stood up to leave the room. But Jonas Mekas was supportive, writing in his column, "A new entertainment cinema is developing. Andy Warhol's *Tarzan and Jane Regained . . . Sort Of*, is one example. Uneven, sometimes good, sometimes bad, it is as good an entertainment as any half-successful Hollywood movie." He also praised Naomi as "the voluptuous star of Andy Warhol's *Tarzan and Jane*, in which she took her 'famous' soap bubble bath and outdid Hedy Lamarr in the swimming scene, in a Hollywood pool."

A critic in *Moviegoer* also weighed in favorably in a review entitled "New American Cinema . . . Sort Of." James Stoller wrote that Taylor "and Warhol have given us an hour of Arcadian comedy, sweet and incalculably beguiling." He *liked* Taylor Mead, he said, even if the actor "looked about as innocent as Mae West's ass."

And speaking of asses, one irate filmmaker had plenty to say about Taylor's overexposed derriere in a letter to the *Village Voice*. Who wants to watch "films focusing on Taylor Mead's ass for two hours?" the man queried, prompting Taylor to fire back, "Andy Warhol and I have searched the archives of the Warhol colossus and find no 'two hour film of Taylor Mead's ass." However, he promised, "We are rectifying this undersight with the unlimited resources at our command." Soon after, Andy filmed the seventy-minute *Taylor Mead's Ass*, featuring beautifully lit scenes of a naked Taylor performing comic "sleight-of-hand" tricks with his shapely buttocks, seemingly removing from his derriere such significant artifacts as a

program from the New York Film Festival and a photo of Elizabeth Taylor from *The V.I.P.s.*

When Andy wasn't working, he was networking, and after his experiences in Hollywood he was trading up socially. His new friends seemed to come from everywhere. "Jet-setting" was the popular term used to describe the ease with which travelers moved from one part of the world to another in the sixties, especially between America and Europe. "Everyone was either just coming back or just about to go or trying to get to go or trying to explain why they weren't already there," Andy marveled. Nicky Haslam, the great-grandson of an English earl, was one of those peripatetic, jet-setting Brits, a lively combination of aristocrat and mod. He came to New York with his friends David Bailey and Jean Shrimpton, England's hottest young photographer and model, and decided to stay after being offered a job in the art department at *Vogue*.

Haslam met Andy at the magazine (Andy was still doing the occasional illustration) and gave him his first taste of the mod revolution that, along with the Beatles, would soon invade America. Ruffled shirts, Andy learned, could be simulated by stuffing curtain lace up a sleeve. Haslam also introduced Andy to a beautiful New York socialite named Jane Holzer. With her voluminous mane of blond hair (usually described as "leonine"), lithe body, and sizable bank account, Jane was the most unusual "housewife" on Park Avenue. Both she and her husband, Leonard, came from money, so the spirited twenty-two-year-old had plenty of time to devote to the pursuit of pleasure.

Andy, using the oldest line in any studio mogul's book, asked Jane if she would like to be in his new movie. "Sure," agreed the young woman whom Tom Wolfe later described as "the living em-

bodiment of almost pure 'pop' sensation," and "the girl of the year."
"Anything beats being a Park Avenue housewife," she told Andy.
Not only was Jane Holzer wealthy and well connected—she was
fun! Looking both passionate and polished, she smooched with Ge-
rard in one of the later *Kiss* films. Jane was a glamorous golden girl,
a style icon, and, in Andy's words, a true superstar.

Andy borrowed the term "superstar" from the filmmaker Jack
Smith, but he gave it a meaning all his own. He believed real super-
stars could turn themselves on in front of the camera, and they were
not that way when the camera was off, he pointed out. After watch-
ing Naomi come to life onscreen during the filming of *Tarzan*, Andy
always looked for that quality in his leading ladies—that ability to
be spontaneous, uninhibited, even outrageous on command, with-
out benefit of a script.

Andy was still working out of the Firehouse when, on Novem-
ber 22, he heard the shocking news of JFK's assassination in Dallas,
a death presaged by those ominous "KO the Kennedys" billboards
and bumper stickers he had seen in Texas. In the weeks that fol-
lowed, Andy studied the stills from Abraham Zapruder's horrifying
film footage of the shooting that had been printed in a recent issue
of *Life* (the film itself would not be shown for eleven years). Where
others saw tragedy, Andy saw art. He was inspired to create a col-
lage of Jacqueline Kennedy silkscreens, similar to his photo booth
portrait of Ethel Scull, but different in that the sequential images in
the painting paid homage to Zapruder by suggesting the almost im-
perceptible movement of successive film frames.

After the assassination, the country would never be the same,
and after the autumn of 1963, neither would Andy. What he had in
mind was nothing less than a total transformation. Raggedy Andy

was banished forever, replaced by a slim hipster wearing tight jeans, a black leather jacket, and cool, dark shades. To complement his bold new look, Andy perfected a provocative way of speaking. The old Andy used to finish his sentences; now, he was more likely to whisper monosyllables with a breathiness that rivaled Jackie Kennedy's sexy/schoolgirl delivery. "Uh, yes" and "Uh, no," he said constantly, with a knowing smile.

David Dalton, a British teenager who was a friend and neighbor of Andy's, and who worked closely with him on various projects, saw that he was changing. "I noticed Andy consciously shutting down, becoming more elusive and secretive, developing his social catechism—those exasperating responses: 'Oh, I love everything.' 'Uh, I dunno.'" According to Dalton, "This was a new and improved Andy, the Andy with eyes permanently sealed behind shade, the fingers to the lip, the pregnant silences, the Andytic—and at the same time fatuous—utterances."

When Andy did speak, he offered perfect sound bites long before the term was coined. "The reason I'm painting this way is because I want to be a machine" was a provocative Andyism he told the journalist Gene Swanson in an interview published in *ARTnews* that November. He was all about the "surface," he said unapologetically in another interview. Truman Capote, who was a master of self-invention, saw Andy—the same Andy he had described as "hopeless"—beating him at his own game, and he ultimately dismissed the new media darling by quoting Oscar Wilde, calling Andy "a sphinx without a secret." Of course, Andy was the first to admit he was "deeply superficial." "If you want to know all about Andy Warhol, just look at the surface of my paintings and films and me, and there I am. There's nothing behind it," he said unapologetically in another interview.

The Trip

Like Garbo, Andy cultivated an air of mystery: the more with-holding he was, the more interesting and desirable he seemed. But he did it playfully in a black-and-white television interview from 1964, when he was perfecting his new image. Andy (wearing dark glasses) and Ivan Karp stand in front of a backdrop of giant Brillo boxes, while a pedantic journalist fires off questions about the future of Pop. Andy's face is impassive, his answers monosyllabic, until he is asked if he thinks Pop Art has become repetitive. He listens, looks at Karp, and for a moment his cool expression dissolves into the mischievous smile of an eight-year-old. Andy is not pretentious—he's a prankster, he's Puck. "He's playing dumb, just as his paintings do," said Henry Geldzahler, "but neither deceive us."

Andy celebrated his self-described "deeply superficial" surface in his first official self-portrait, which he created at the end of 1963. Florence Barron, a noted Detroit collector, met with Andy to discuss having her portrait painted. At some point in the conversation, she decided that it would be more interesting to commission Andy to do a portrait of himself. "Nobody knows me," she said. "They want to see *you*." Andy loved the idea and came up with a plan.

Paying homage to the charismatic stars of the New European Cinema—Alain Delon, Jean-Paul Belmondo, and Marcello Mastroianni—he dressed in a fashionably rumpled trench coat, a loosened necktie, and dark sunglasses. Then, as he had done with Ethel Scull, he went to a photo booth in Times Square, fed the machine quarters, and posed behind the curtain. The resulting photographs fell somewhere between a movie publicity still and a mug shot. In the best ones, Andy was part celebrity, part outlaw, and all superstar.

Back at the Firehouse, he selected four different shots and silk-screened the individual panels in varying shades of blue. Just as

young Andy's early self-portrait, *The Broad Gave Me My Face, But I Can Pick My Own Nose*, had been a declaration of independence, this painting was designed to communicate his official transition from "out" to "in." "I can control my own image," it seemed to say. Everything about the portrait, from Andy's pose, to his fashionable trench and sunglasses, to the painting's icy coloring, portrayed him as the epitome of cool.

Andy's new persona needed a new setting. Inspired by his stay in LA, he wanted his own version of a Hollywood studio. Gerard's exhaustive search for a new place led him to 231 East Forty-Seventh Street, between Second and Third Avenues, a large loft recently vacated by a hat manufacturer. Unlike SoHo or the East Village, this neighborhood was bland—there was a YMCA across the street and a few photography labs and modeling agencies scattered through the area. The nearest New York City landmarks were the United Nations and Grand Central Terminal.

The building was unremarkable: an industrial-looking brick box with a gunmetal gray lobby and a freight elevator. Upstairs on the fourth floor, the loft had a long row of windows overlooking Forty-Seventh Street—a nice feature, except that the bright, unforgiving light exposed the crumbling walls. Defects aside, there was plenty of room for Andy's painting equipment and giant-size artworks, a movie camera, lights, and the occasional secondhand couch.

Fortunately, Andy had a vision of how to turn the broken-down space into a work of art. His friend Billy Linich (who called himself Billy Name) was a lighting designer incredibly handy with tools and materials. He had cleverly used foil to fashion his unremarkable apartment into a silver jewel box. Andy, who had spent time there and loved the shiny look, asked Billy to transform the loft in the same

way. "It was the perfect time to think silver," Andy said. "Silver was the future, it was spacey—the astronauts wore silver suits . . . And silver was also the past—the Silver Screen—Hollywood actresses photographed in silver sets . . . maybe more than anything, silver was narcissism—mirrors were backed in silver."

Billy painstakingly foiled the walls and painted the other surfaces. When he was finished, somehow the word "studio," which called to mind images of canvases on easels and pots of paint, sounded too old-fashioned to describe this shimmering foundry of creativity. Since Andy had already announced that he wanted to be a machine, the best name for his new workplace would be "the Factory," the *Silver* Factory. "Factory is as good a name as any," Andy explained. "A factory is where you build things. This is where I make or build my work. In my art work, hand painting would take much too long and anyway that's not the age we live in. Mechanical means are today, and using them I can get more art to more people. Art should be for everyone."

Andy and Gerard moved in January and settled into a new routine. Since they were no longer around the corner from the townhouse, Andy did less back-and-forthing between work and home. Gradually, he started spending longer hours at the new place, leaving Julia alone in the empty house. She missed having him around for impromptu lunches and spent most of her time in church or in her little kitchen, either praying for her boy or waiting for him. As Julia's world got smaller and smaller, Andy's exploded.

One of the legendary parties at Andy's silver factory, a gathering place for New York insiders at the time, includes voluptuous Naomi Levine, who can be seen dancing (*lower left corner*).

Chapter 19

One day you just wake up and you're a new person again.

—Andy Warhol

East Forty-Seventh Street may have seemed out of the way when Gerard first proposed the location, but after its "coming-out" party on April 21, 1964, the Factory quickly became the polestar of the newly chic underground. The impetus for the celebration was Andy's second show at the Stable Gallery, an exhibition of Warhol-made grocery boxes. The cartons, painted with the names Brillo, Kellogg's Corn Flakes, and Mott's Apple Juice, looked as if they had been manufactured in a *real* factory. Robert Scull, who always had a keen eye for new art, immediately placed an advance order, and he and Ethel, along with their friend Marguerite Littman, offered to pay for a party at the Factory the night of the opening.

The hostesses sent out proper invitations to their socialite friends and to such luminaries as Senator and Mrs. Jacob Javits, Philip Johnson, Tennessee Williams, Allen Ginsberg, and the ubiquitous Henry Geldzahler. After summoning all the right people, they stationed Pinkerton guards at the door to keep the *wrong* people out. Many of Andy's edgier friends were left off the list, but Ray Johnson, a downtown collagist, cleverly solved that problem by telling

the guards he was Norman Mailer (who was on everyone's guest list that spring) and was allowed to enter.

After riding upstairs on the dilapidated elevator, guests stepped into an explosion of silver. "Reynolds wrap is what hits you," reported a journalist on the scene, who marveled that even the toilet bowl had a silver lining. Fred McDarrah, a photographer for the *Village Voice*, snapped a picture of Andy—looking happy, slim, and fashionably outfitted in black—posing with the Pop artists Tom Wesselmann, Roy Lichtenstein, James Rosenquist, and Claes Oldenburg, in front of one of his *Ten Most Wanted* mug shots for the World's Fair. But most of the night, Andy stood off to the side with Emile de Antonio, watching. "I took the action in from a corner," he recalled, describing the party as if it were a movie.

Ethel and Marguerite had arranged for amusing Coney Island food—hot dogs served from carts (just like at the Hopper party), hamburgers, and corn on the cob. As usual with this group, the cocktails were the first to go. When Robert Scull noticed they needed alcohol, he tried to slip a young man fifty dollars to run out for more. That "gofer" turned out to be a major young painter—a highly *insulted* major young painter—who huffily refused the cash.

Scull was in a bit of a huff himself because the photographers were ignoring his wife. They were more interested in younger fringe types who had managed to talk—or sneak—their way past the Pinkertons. Soon Ethel and Marguerite started fighting about who should pay for what. According to Andy, they were "adding up hot dogs, tallying bottles, practically dragging paper cups out of the garbage to count them—and they wound up hating each other." Andy loved the drama and pronounced the event "a great party."

The next morning, he was bombarded with calls from irate friends demanding to know why they were not included. Suddenly, the Factory was the hottest—and coolest—destination in town. Andy was at the center of this social circus, usually working with Gerard, sometimes filming, and always watching. "A lot of people thought that . . . I was some kind of big attraction that everyone came to see," he said. Instead, he insisted, "it was me who was hanging around everyone else . . . People weren't particularly interested in seeing me, they were interested in seeing each other. They came to see who came."

Who came? Everyone. The Factory became a compulsory scene for artists, actors, rock stars, the rich, the nouveaux riches, celebrities of all stripes, and the inevitable hangers-on who followed celebrities. Even the drug addicts (mostly amphetamine users, or A-Heads, as Andy called them) who were friends of Billy Name viewed the Factory as their late-night haven.

The man Truman Capote once called "the loneliest, most friendless person I'd ever seen in my life" had a large and ever-expanding following, a development that prompted Andy to observe, "As soon as you stop wanting something you get it." No longer "Andy the Red-Nosed Warhola," "Raggedy Andy," the Andy who had "gone around the world with a boy and not even received one kiss," or the misfit who contented himself with being "exactly wrong," Andy Warhol was, for the first time, *exactly right*.

In 1964, Andy Warhol could do no wrong. With the Silver Factory as his launching pad, he was going up, up, up. Professionally and socially, the name "Andy Warhol" signified what was *in*, what was happening *now*. He was on the cover of *Artforum* in December, looking very much like a superstar in Dennis Hopper's beguiling

sunglasses-and-flower photograph. And whether people were condemning *Thirteen Most Wanted Men*, the mug shot mural he created for the New York World's Fair (which officials deemed too controversial for a public building and ordered painted over), arguing about *Empire*, his provocative eight-hour film of the Empire State Building, or praising his sellout exhibition of *Flowers* at Castelli (his new gallery), Andy was considered a legend of Pop Art, the artist of the moment.

That "moment" showed no sign of ending. In 1965, Andy's first solo museum show at the Institute of Contemporary Art in Philadelphia drew the kind of crowd that usually lines up for rock shows. The enthusiastic throng was so out of control that museum officials had to pull the paintings from the walls to protect them, while Andy and his equally famous companion, Edie Sedgwick, were forced to sneak out via an escape route on the roof.

Following in the shapely footsteps of Naomi and Jane, Edie was the latest addition to Andy's lustrous collection of superstar muses and, like her predecessors, she had a personality and look all her own. Her silvered hair, heavily made-up eyes, short skirts, and legs that went on *forever* quickly established her as a style icon, or "youthquaker," as "it girls" were called at the time. To top it off, Edie was a bona fide blue blood (her ancestors dated all the way back to the American Revolution), with access to a family fortune. And she was a little crazy, having been in and out of rehabilitation hospitals for an eating disorder.

Andy was enchanted. Edie was everything—uninhibited and unpredictable like Naomi, yet golden and aristocratic like Jane. She became his constant companion and, some said, his alter ego. "Andy

Warhol would like to have been a charming, well-born debutante from Boston," Truman Capote quipped.

Filmmaking, not painting, became Andy's real passion. "I'm retiring from painting," he announced at an exhibition in Paris. One exciting new film project was inspired by the photo booth. A movie camera was set up at the Factory, and friends and guests were invited to sit for impromptu portraits called "screen tests." Positioned in front of bright lights, the sitter stayed in place for three minutes, showing a range of facial expressions (or no expression at all). The result was a living, breathing portrait, reflecting the inner life of the subject at that moment in time.

Between 1964 and 1966, Andy and Gerard shot over 472 screen tests, from Bob Dylan to Salvador Dalí. Some people (predictably, Dennis Hopper), looked completely at home in front of the camera, while others seemed nervous, or struggled to appear composed. The poet Ann Buchanan was a standout. She became known as "the Girl Who Cried a Tear" when, in the course of her screen test, a single, decorous teardrop fell gracefully down her face.

Inspired by his trip to Hollywood, Andy turned the Factory into a counterculture MGM, complete with "contract players" (Taylor, the socialites Jane Holzer and Edie Sedgwick, the drag queens Candy Darling and Holly Woodlawn, and an assortment of drug addicts, hustlers, and other underground personalities), a "backlot" (expanses of raw space and a seedy secondhand couch); and a "stable" of technicians (usually Gerard and Billy Name). He spent more and more time making movies—he shot sixty between 1963 and 1968—including *My Hustler*, *Vinyl* (his interpretation of Anthony Burgess's *A Clockwork Orange*), *Poor Little Rich Girl*, *Lonesome Cow-*

boys, and *Chelsea Girls*, the first underground film exhibited in a commercial theater. In 1968, Andy returned to Hollywood as an established filmmaker and shot *San Diego Surf*, his skewed version of a California beach party movie.

One of Andy's films starred his mother. Shot at home, in the kitchen of their Lexington Avenue townhouse, *Mrs. Warhol* presents the seventy-four-year-old Julia as an aging movie star—a former bathing beauty who has been married twenty-five times. Julia's peppy character irons clothes, scrambles eggs, cleans, and speaks heavily-accented English, just as Julia did in real life. While Andy's mother was not much of an actress, she was a very good sport, and she clearly enjoyed being the center of her son's attention, especially since he was spending so much time at the Factory.

In addition to directing, Andy managed the Velvet Underground, the rock band formed by Lou Reed and Jon Cale, and was a busy and increasingly famous man-about-town. "He wanted to be a big nova that would eclipse everything. . . . That was the only thing that would satisfy Andy," observed his friend and Factory mate Billy Name. Andy had a remarkable ability to socialize high or low, "in" or "out," classic or cool, and turned up on every important guest list, including the one for Truman Capote's iconic Black and White Ball honoring publisher Katharine Graham.

Andy's companion that night was Henry Geldzahler. Though they went to the ball together, their friendship had cooled over the past few months, ever since Andy learned from an article in the *New York Times* that Henry had been invited to select the artists for the American pavilion at the upcoming Venice Biennale, a prestigious international art show. "I was so hurt he'd kept the news from me," said Andy. Henry's choices were Roy Lichtenstein, Ellsworth Kelly,

Helen Frankenthaler, and Jules Olitski . . . not Andy Warhol. Henry said there were artistic reasons for his picks, but privately he admitted that he did not want the whole Warhol entourage—the Velvets and the oddball Factory hangers-on—turning up in Venice.

The fact that he was invited to the Black and White Ball, an event that defined "in" and "out" lists for decades to come, should have assured Andy that he was one of the chosen. Instead, the evening underscored his insecurities. "It was so strange," he observed, "you get to the point in life where you're actually invited to the party of parties . . . and it *still* didn't guarantee that you wouldn't feel like a complete dud." Andy said that if he had his way, he'd "sit home and watch every party that I'm invited to on a monitor in my bedroom"—a way to be there without being there.

Andy experienced the dark side of celebrity in June 1968, when Valerie Solanas, a disgruntled writer who believed the artist was trying to steal her work, came to the new Factory at 33 Union Square West. Armed with a grudge and a gun, she shot him point-blank. Andy was rushed to Columbus Hospital, where doctors gave him a "50-50 chance to live," prompting the *New York Post* to run the giant headline, "ANDY WARHOL FIGHTS FOR LIFE."

Andy beat the odds, survived his gunshot wounds, and became more famous than he was before. In the coming decades, he would perfect his complex and seemingly contradictory Warholian image. He was the flighty Studio 54 party animal who claimed "I have a social disease. I have to go out every night," and the successful entrepreneur who built an art and publishing empire and insisted, "Being good in business is the most fascinating kind of art." He was the devoted son who lived with his mother and mourned her passing in 1972, but kept the news so private that most people didn't realize

Deborah Davis

Julia Warhola was dead (he memorialized her with one of his signa-
ture portraits in 1974). There was the playful Andy who walked the
runway, endorsed any products willing to pay, and appeared on *The
Love Boat*—and the serious Andy who produced films, wrote (or at
least inspired) books, and painted masterful portraits of celebrities,
society matrons, and world leaders.

The flamboyant portraits Andy created in the seventies and
eighties reinvented the art of portraiture, combining elements of
painting and photography to come up with an ultramodern hybrid.
His technique usually involved snapping a Polaroid, then sculpt-
ing the subject's face and neck with his scissors—artfully cutting
away nature's imperfections. Then he would transfer the image to a
screenprint, enhancing the best features with vibrant colors. Andy
was a genius at turning sitters into superstars because he had trans-
formed himself in the same way.

On February 20, 1987, Andy checked in to New York Hospital
for gallbladder surgery. He was uneasy because he had a premoni-
tion about dying in a hospital. He told himself there was no reason
to worry: the procedure was routine. It was, and the operation was
a success. But twenty-four hours later, Andy died, the unfortunate
victim of postoperative mishaps.

Art critics and cultural observers seized the opportunity to prof-
fer big statements about Andy's life and work, often comingling the
two. The *New York Times* suggested his "keenest talents were for
attracting publicity, for uttering the unforgettable quote and for
finding the single visual image that would most shock and endure,"
which seemed to be faint praise and refer only to his most superficial
accomplishments. Hilton Kramer, a critic who had called Pop Art "a
very great disaster" back in the sixties, came back at Andy with box-

ing gloves, condemning his approach to art as "a permanent, and permanently disabling, component of cultural life."

The fact that Andy's obituaries turned into an ongoing debate about his legacy would have thrilled the man who had once quipped, "Don't pay any attention to what they write about you. Just measure it in inches."

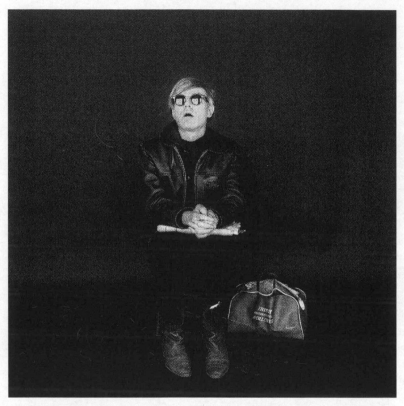

The famed photographer Jerry Schatzberg portrays the newly transformed Andy as the cool, sphinxlike figure he became after his road trip.

Chapter 20

The idea is not to live forever. It is to
create something that will.

—Andy Warhol

A ndy's companions on the 1963 trip had less dramatic,
but sometimes equally surprising, destinies. After his
cross-country adventure, Gerard decided against returning
to Wagner College. Instead, he settled into an all-consuming rou-
tine at the Factory, assisting Andy with his screenprints, sculptures,
films, and other projects. Gerard was a remarkably versatile young
man. He starred in Andy's movies, performed onstage with the Vel-
vet Underground during the groundbreaking "Exploding Plastic
Inevitable" media show, and, in 1969, was one of the cofounders
of Andy's *Interview* magazine. According to Gerard, the magazine
came into existence for two practical reasons: "Andy wanted to give
me something to do, and also we needed to get passes for the New
York Film Festival—press passes which we were denied originally."

In addition to being multitalented, Gerard also had a big heart.
When Valerie Solanas shot Andy in 1968, Gerard was the one who
rushed to Julia Warhola's side to protect her from the media. He
gently broke the news of her son's brush with death and escorted
her to the hospital to see Andy, mindful of her fragile state.

Through these frenetic Andy years, Gerard continued to work on his poetry—writing, staging readings, and publishing his work. In 1970, after adding photographer and filmmaker to his list of credentials, he decided to leave the Factory to concentrate on his own projects. He described his time with Andy as "a summer job that lasted seven years." Forty-four years later, he is a respected archivist, the award-winning author of nineteen volumes of poetry, and an internationally acclaimed photographer. And the former "Factory foreman" has not lost any of his charm. He speaks eloquently and affectionately about the past, never denigrating Andy, probably because their time together did not define him; it was just one of the many chapters in his storied life. At poetry readings, Gerard still exudes the dreaminess—the "sort of permanent reverie"—Andy referenced the first time he described his new assistant.

Taylor and Wynn, who were bickering like the Odd Couple by the end of the road trip, seemed to be fed up with each other, yet they were linked professionally for years to come. In 1967, Wynn produced *Conquest of the Universe* by the avant-garde playwright Charles Ludlam (a play described as a "humorous tale of unbridled space queens"), starring Taylor and a cast of Factory regulars. The production's chief fan was none other than Marcel Duchamp, who came to the theater nearly every night to see the outrageous "Theater of the Ridiculous" comedy. In 1969, Wynn produced *Brand X*, a film about the banality of television. Taylor played a number of unlikely roles, including the president of the United States.

In 1970, Wynn grew unhappy with life in America and packed up his wife and two young children to move—first to India, later to Morocco—to concentrate on writing books, including the well-reviewed Indian epic *Gates of Fire*. Presumably, his battered Falcon

station wagon was long gone. Ford stopped producing the once popular "little engine that could" that very year.

Wynn, who had seemed so quiet and detached on the trip, was someone who actually became *more* interesting with the passage of time. His paintings, movies, and books were always edgy and challenging. He and Taylor had a brief reunion in 2012, when *Brand X* was screened for appreciative audiences in New York and London. But most of the time, Wynn continued to live his rugged individualist existence in faraway places with his wife, Sally, until he passed away in November 2014.

Taylor spent some time in Europe in the late sixties, but ultimately returned to New York, where he became a familiar figure on Manhattan's Lower East Side. His last movie for Andy was *San Diego Surf,* although he continued to act for other directors, including Jim Jarmusch, who cast him in *Coffee and Cigarettes* in 2003. Taylor could also be found at the Bowery Poetry Club, where he performed once a week as the opening act for "hipster bingo" on Monday nights. His "act" consisted of delivering rants and reading his poetry with musical accompaniment from his cassette player.

Taylor had an ongoing love/hate relationship with Andy. Although he titled his memoir *Son of Andy Warhol,* when it came to Andy, Taylor's sore spot was always money: he complained that Andy had plenty of it, but refused to share. Taylor believed that he had helped build the Warhol empire and was entitled to a cut—or at least a little cash—every now and again, and it irked him that Andy disagreed.

In success and in failure, Taylor always considered himself a superstar and was happy to tell anyone how incredibly famous he was. At a screening of *San Diego Surf* at MoMA, he channeled Norma

Desmond in *Sunset Boulevard* when he placed his hands in front of his face and told well-wishers, "No interviews tonight!"

In his final year, he watched his neighborhood, once the habitat of artists and experimental filmmakers, turn into a Gold Coast for real estate developers. Taylor fought to remain in his decrepit, rent-controlled apartment, and won . . . sort of, in that he received a settlement and moved to Denver to stay with his beloved niece. Taylor died in 2013, but remains a downtown legend.

Naomi Levine and Andy remained friends after their fight in Los Angeles, but her days as a Warhol superstar were numbered. Her earthy, ethnic look was on the way out while thin, leggy, blond beauties—Jane and, later, Edie—moved into the spotlight. Naomi's behavior was so unpredictable that she was prescribed medication that caused weight gain and depression, which made her even crazier. One day, while in the throes of a manic fit, she lashed out at Andy, calling him a "fag." He was furious and immediately told Gerard to throw her out of the Factory . . . and keep her out.

Naomi was in and out of psychiatric institutions. She fought with her family and friends, and tried to remain close to Andy by writing him long and increasingly incoherent letters about the wonderful projects they might do together. Despite the fact that she was getting older, she persisted in playing the part of the seductive ingénue, and ended up being a pathetic caricature of her former self.

Most people forgot about Naomi, but she still had delusions of being an insider in the art world. She once showed up at James Rosenquist's studio demanding $300. When he refused to see her, and his assistant asked her to leave, she threatened, "Don't touch me, you fuck. I have a gun." Ultimately Rosenquist gave her the money because it was the only way to get rid of her. Many of her

former friends felt the same way. One intimate from the early six-
ties said she was out of her head, and dangerously so. She was "un-
questionably talented," he explained, but was "a big baby with the
expressive freedom of a child."

In the 1990s, Naomi turned up on a cable access show in Ver-
mont. Calling herself "The Dictionary Lady," she read words and
their definitions on camera. Her viewers had no idea that they were
watching a former Warhol superstar. Ironically, it was exactly the
kind of show Andy would have loved. Eventually Naomi stopped
coming to the studio, left her old, oversized dictionary there, and
retreated into a world of her own. Some people speculated that she
moved to Florida, others said she passed away. Records were incon-
clusive because the name "Naomi Levine" turned up so many times
it might as well have been "John Doe." In the end, Naomi was so
lost that she couldn't be found.

The Sculls, who, according to *People* magazine, went "Pop to
the top" in the 1960s, found themselves at the center of a Jacobean
revenge drama a decade later. In 1973, Robert and Ethel sold one-
fifth of their famous art collection at auction, making $2.2 million on
works that had cost them $150,000. However, this seeming stroke of
good fortune marked the beginning of a long, slow descent for the
couple. Ethel broke her back in a freak accident and needed constant
therapy, while Robert, in the throes of a classic midlife crisis, grew
his hair, took up with a younger woman, and started hiding his art
assets, which he moved to a secret storage facility. In 1974, he peti-
tioned for divorce.

The Scull settlement, which was pre–community property laws,
denied Ethel coownership of their fabulous art—a collection she
had helped to build and, according to Ethel, her father's taxi money

had paid for. The exes entered into a bitter legal battle that consumed them for the rest of their lives and was not fully resolved until after Bob's death in 1986, when Ethel finally was awarded a significant share of the collection. More important, with a single toss of a coin, she won the right to pick the first painting—she chose Jasper Johns's *Out the Window*, the most valuable piece in the collection, which subsequently sold for $3.63 million.

As for Andy's *Ethel Scull Thirty-Five Times*, in a typically divisive move, Bob left it to the Metropolitan Museum of Art, while Ethel left it to the Whitney. Wisely, the two institutions agreed to share ownership of the spectacular work, and, with the addition of one more photograph to even off the piece, it became *Ethel Scull Thirty-Six Times*.

Dennis Hopper, just like his friend Peter Fonda, longed to work on a film that was meaningful to him. In fact, Peter had a project for them to do together. It would tell the story of two antiheroes and their adventures during a counterculture road-trip across America—a biker version of the *Odyssey*. Unlike a studio film, and influenced by the shaggy, improvisational aesthetic of Andy's recent Factory films, it would be a movie without stars, script, sets, lighting, or costumes. It took them a few years to get it off the ground, but in 1968 they made *Easy Rider*. Dennis was so consumed by the production that it cost him his marriage—he and Brooke separated while he was off making the movie, and they divorced in 1969.

Despite its low budget and lack of production values, *Easy Rider* turned the indie actor Jack Nicholson into a star, pulled in $19 million at the box office, was nominated for two Academy Awards, and completely revolutionized the movie industry in

ways that Jack Warner had never imagined. Hollywood changed Andy, but in a roundabout way, Andy, with his "sort of" films, also changed Hollywood.

Lewis Marvin's Moonfire is still a Topanga landmark with an air of mystery. According to family folklore, something terrible happened a few years after Andy's visit. While Lewis was away visiting his father, his remote hideaway was vandalized by Charles Manson and his disciples. For Lewis, a fervent animal activist, the Manson Family's greatest crime was that they sacrificed animals in his outdoor temple, which was meant to be a sanctuary for all living creatures. The char marks from Manson's ritual fires remain an eerie reminder of evil in a place of beauty *and* the dark side of the peace-and-love sixties.

Andy's vivid descriptions of the Pop-like landscapes he witnessed on his trip turned out to be a eulogy. Soon after he drove cross-country, the National Interstate and Defense Highways Act moved full speed ahead, building freeway bypasses that rendered the old highways obsolete. Route 66 was one of them. "America's Main Street" was superseded in so many places that what formerly constituted a vital road culture turned into a series of ghost towns. Some locations proudly display Route 66 signs in prominent places, while others keep the hipster's highway a deep secret. Travelers constantly get lost, hitting dead ends and fragments of roads that lead to nowhere. Yet the thriving interstate is usually nearby, a parallel universe that is close, but worlds away.

Glenrio, Texas, one of the towns that was abandoned so quickly after the freeway was built, houses a small cluster of broken-down buildings—including a motel and a store—with their doors left

Deborah Davis

wide open, as if their owners had fled a few moments earlier. The fact that the town is still (barely) standing suggests that it is not important enough to tear down.

Ironically, "America's Main Street" is rarely visited by Americans. The buses and cars that travel Route 66 are filled with European and Asian tourists who view it as a place to experience the America they have seen memorialized on television and in films. There are some diehard US Route 66 enthusiasts and reenactors, many inspired by *Cars,* the blockbuster animated feature about an imaginary Route 66 location, but they celebrate the route's glorious past, not its present.

The billboards Andy regarded with such enthusiasm in 1963 became an endangered species. Billboard lobbyists could ignore the "scenic sisters" who carried on about blight and "landscape leprosy," until one of them turned out to be the First Lady of the United States. Lady Bird Johnson wanted to improve America inside out, and she considered the Highway Beautification Act the place to start.

President Johnson may or may not have felt as strongly as his wife about the issue, but he stood by her when the Outdoor Advertising Association of America objected. "You know I love that woman and she wants that Highway Beautification Act . . . by God, we're going to get it for her," he insisted, signing it on October 22, 1965. Although billboards did not disappear overnight, Americans would soon see more amber waves of grain and purple mountains majesty than Pop Art–style advertising.

The art Andy created in 1963, the year now considered his annus mirabilis, enjoyed the most remarkable destiny of all. In 2010, *Eight Elvises,* a work that failed to sell at the Ferus, went to a private buyer

for a record-breaking $100 million. The woman who demanded a refund because her family hated the Silver Liz she bought from Irving Blum made a very big mistake, because in 2011, one of those paintings sold for $24 million. That same year, Andy's cool blue self-portrait sold for $38.4 million. At the end of 2013, Andy Warhol was the top-selling artist at auction, with sales of $427.1 million. *Silver Car Crash (Double Disaster)*, a Death and Disaster painting that was considered resoundingly uncommercial in its day, sold at auction for $105 million, the highest amount paid for a Warhol—yet.

He's been called the "colossus of the art world," the "god of contemporary art," the "American Picasso," and "the art market's one-man Dow Jones." Today, Andy is also famous for being a philanthropist. In his will, he bequeathed most of his artwork and fortune to the Andy Warhol Foundation, an entity established to advance the visual arts. In his name, the foundation awards grants to support experimental art, artists, and evolving technologies, among other activities, in the hope of creating future Andys.

Since Andy's death in 1987, the foundation has given away more than fifty-two thousand of Warhol's works, ranging from Polaroids to paintings, to various museums and universities. Its first major gift of one thousand works served as the foundation for the Andy Warhol Museum in Pittsburgh, which opened in 1994. According to the *Los Angeles Times*, a recent two-year (2013–2015) "art giving spree" of 14,847 pieces will spark "the largest wave of exhibitions ever dedicated to a single artist," suggesting that 2015 promises to be Andy's best year ever.

Eulogizing Andy in *Art in America*, Peter Schjeldahl captured his true significance: "One was forever catching on to Warhol's genius at the instants when it shrugged and went elsewhere. *How can*

he be so right?" In September of 1963, Andy truly went "elsewhere," taking a trip that bridged the staid, sleepy '50s to the swinging '60s—and beyond—and bringing the country along for the ride. That was him, speeding to embrace a new idea, mastering it, and then moving on to the next, with America in hot pursuit, trying to keep up with him.

Acknowledgments

Writing *The Trip* has been a trip, and I offer my deepest gratitude to the many people who came along for the ride.

My thanks to Eric Shiner, Matt Wrbican, and Greg Burchard at the Warhol Museum, the expert caretakers of an amazing collection; Claudia Defendi at the Warhol Foundation for the Visual Arts; Alexandra Schwartz and Gail Stavitsky at the Montclair Art Museum; Claire Henry at the Whitney Museum; and Esperanza Sobrino at Acquavella Galleries. Thanks as well to the individuals who generously shared their memories and their expertise, including the late Taylor Mead, Shirley Neilsen Blum, Tosh Berman, Barbara Marvin, Patty Mucha, Pat Hackett, Thomas Kiedrowski, Tony Scherman, James Warhola, Amy Taubin, Charley Plymell, Jim Ross, and the late Tommy Clanton. I did a great deal of research at the Montclair State University Library and the Montclair Public Library, two institutions that are a gift to every scholar.

Every book has its muse, and Gerard Malanga has been the guiding spirit behind *The Trip*. His recollections, his writing, and his photographs have inspired me throughout the project and I am thrilled to have this incredible poet in my life.

Thank you, Jerry Schatzberg, for your generosity and for making the past come to life with your beautiful photographs.

As always, I want to extoll the virtues of my agent, Scott Wax-

man, the magician who turns dreams into reality—and to the lovely Julianna Wojcik at the Waxman-Leavell Literary Agency.

At Atria Books, I am grateful to Peter Borland for his vision, sagacity, and unfailing charm, and to the ever-clever Rakesh Satyal for making this book Pop! Thanks also to Rosemary Ahern for her extraordinary guidance.

Personal thanks to Mary MacDonald Dana for thoughtfully outfitting us with everything we needed on our cross-country road trip, including two outrageous Andy Warhol wigs, and to Carol and Terry Wall for providing spectacular retreats where I was able to do some of my best writing.

At home, I am indebted to my family. My wonderful mother, Jean Gatto, whose love and enthusiasm for all things "Deborah" is always deeply appreciated by her grateful daughter.

My day begins and ends with thoughts of my remarkable children, Oliver and Cleo, who are my greatest creations and a constant source of pride and delight. And thank you, Beau, Minnie, Ike, and Alfie (and Scarlet and Bianca), the family dogs who have taught me so much about love.

Finally, my heartfelt thanks to my dear husband, Mark Urman—my partner on the road and in life. Every adventure is better with him at my side.

Notes

SEPTEMBER 24, 1963

8 *"I wanted to see":* Andy Warhol and Pat Hackett, *POPism* (New York: Harcourt, 1980), 44.

CHAPTER 1

16 *Her older boys:* Bob Colacello, *Holy Terror* (New York: Cooper Square Press, 2000) 15.

18 *"I don't want to know":* Kenneth Goldsmith, ed. *I'll Be Your Mirror: The Selected Andy Warhol Interviews* (New York: Carroll & Graf, 2004), 13.

18 *"Being born is like being kidnapped":* Andy Warhol, *The Philosophy of Andy Warhol* (New York: Harcourt, 1975), 96.

19 *"What writing presents:* Epistle to Bishop Serenus of Marseilles, *Nicene and Post-Nicene Fathers 2,* Vol. XIII, p. 53.

19 *Dr. Thomas Sydenham:* http://archneur.jamanetwork.com/article .aspx?articleid=778437 (accessed November 10, 2013).

20 *He seemed even paler:* Warhol, *The Philosophy of Andy Warhol*, 63.

21 *Yet when classes started:* Colacello, *Holy Terror*, 17.

22 *"Uptown":* One of Andy's famous sayings that is oft-repeated, but difficult to trace.

22 *Born in Stockholm:* Claes Oldenburg et al., *Writing on the Side 1956–1969* (New York: Museum of Modern Art, 2013), 127.

22 *"I am for art":* Ibid.

23 *When times were good:* Ibid.

24 *According to Allan Kaprow:* Jason Geiger, ed., *Framework for Modern Art* (New Haven: Yale, 2003), 36.

25 *On one occasion:* Warhol, Hackett, *POPism*, 4.

26 *"Poor Andy":* Frederick N. Rasmussen, "Baltimore Artist Recalls Andy Warhol," *The Baltimore Sun*, October 9, 2010.

26 *According to Gretchen Schmertz:* Tony Scherman and David Dalton, *Pop: The Genius of Andy Warhol* (New York: Harper Collins, 2009), 9.

27 *"If anyone had asked me at the time":* Victor Bockris, *Warhol: The Biography* (New York: Da Capo, 2003), 59.

27 *"You do it the way you see it":* Patrick Smith, *Conversations About the Artist* (Ann Arbor, MI: UMI Research Press, 1988), 14.

28 *"Artist Huckster Sketches Customers":* Colacello, *Holy Terror*, 18.

28 *I like to be the right thing":* Andy Warhol, *The Philosophy of Andy Warhol (From A to B and Back Again)* (New York: Harcourt, 1975), 158.

28 *"He had a stylistic integrity":* Smith, *Conversations About the Artist*, 22.

29 *"When you think of it, department stores":* Another famous Warhol saying that is difficult to trace.

30 *"He was a kind of genius":* Scherman, Dalton, *Pop: The Genius of Andy Warhol*, 12.

30 *"Like an angel in the sky":* Bockris, *Warhol: The Biography*, 65.

30 *"Jack Smith, another veteran":* Smith, *Conversations About the Artist*, 8.

CHAPTER 2

33 *"His ink lines":* Jesse Kornbluth, *Pre-Pop Warhol* (New York: Panache, 1988), 11.

35 *According to Pearlstein:* Philip Pearlstein. "Andy Warhol 1928–87." *Art in America*. May 1987, 138.

35 *"I just planted some birdseed":* Smith, *Conversations about the Artist*, 68.

37 *"Hello Mr. Lynes":* Andy Warhol letter to Russell Lynes, 1949. *Harper's Magazine* records kept by managing editor Russell Lynes, Archives of American Art, Smithsonian Institution.

39 *Andy joked:* Warhol, Hackett, *POPism*, 5.

Notes

39 *"New York life was heavy"*: Dan Wakefield, *New York in the Fifties* (Boston: Houghton Mifflin, 1992), 196.

40 *"He seemed one of those hopeless"*: Jean Stein and George Plimpton, *Edie: An American Biography* (New York: Knopf, 1982), 196.

40 *"The work has an air of preciosity"*: Gavin Butt, *Between You and Me: Queer Disclosures in the New York Art World* (Durham, NC: Duke University Press, 2005), 111.

42 *Willers immediately recognized:* David Bourdon, *Warhol* (New York: Abrams, 1989), 38.

42 *To this end:* Ibid., 39.

45 *"I'd tell them"*: Kirk Varnedoe and Roberta Bernstein, *Jasper Johns: A Retrospective* (New York: Museum of Modern Art, 1996), 126.

46 *And when he managed to exhibit:* Scherman and Dalton, *Pop: The Genius of Andy Warhol*, 34.

48 *Andy had "gone"*: Bockris, *Warhol: The Biography*, 122.

CHAPTER 3

53 *"In the end I had"*: George Frei and Neil Prinz, eds., *Warhol Painting and Sculptures, 1961–1963* (London: Phaidon, 2002), 469.

56 *"Ohhh, I'm doing work"*: Bourdon, *Andy Warhol*, 80.

58 *"These blunt, straightforward works"*: Warhol and Hackett, *POPism*, 9.

58 *"You can't do"*: Smith, *Conversations About the Artist*, 212.

58 *"One of these"*: Warhol and Hackett, *POPism*, 6.

60 *He should paint something:* Gary Indiana, *Andy Warhol and the Can That Sold the World* (New York: Basic, 2010), 83.

62 *According to a character:* Frederic Wakeman, *The Hucksters* (New York: Rinehart & Company, 1946), 24.

63 *Multiple images:* David Halberstam, *The Fifties* (New York: Villard, 1993). Halberstam offers a lively and comprehensive analysis of the postwar boom in America.

64 *"Why don't Bob and Jap"*: Warhol and Hackett, *POPism*, 14.

Notes

65 *Karp suspected:* Bourdon, *Andy Warhol,* 84.

66 *"I just felt":* Bockris, *Warhol: The Biography,* 141.

67 *Geldzahler compared it:* Warhol and Hackett, *POPism,* 3.

67 *This generation of artists:* Henry Geldzahler, *Making It New: Essays, Interviews, and Talks* (New York: Turtle Point, 1994) 263.

68 *There was an instant rapport:* Calvin Tomkins, *Off the Wall: Robert Rauschenberg and the Art World of Our Time* (Garden City, NY: Doubleday, 1980) 87.

68 *"I could actually see him":* Warhol and Hackett, *POPism,* 21.

CHAPTER 4

72 *Stepping over piles:* Joanna Weinberg, "Art: It Happened One Night" (*Vogue,* September 1, 2002), 492–499.

73 *He aspired to transform the Ferus:* Oral history interview with Irving Blum, May 31–June 23, 1977, Archives of American Art, Smithsonian Institution, Washington, DC.

73 *With exquisite timing:* Hunter Drohojowska-Philp, *Art Dealer Irving Blum on Andy Warhol and the 1960s L.A. Art Scene* (Q&A) (*Hollywood Reporter,* November 4, 2013).

74 *The art world in Los Angeles:* "Monday Night on La Cienega," *Time,* July 26, 1963.

74 *"Not many people came":* Interview with Shirley Neilsen Blum, October 18, 2013.

76 *When he came home to his wife:* "Once Upon a Time in Los Angeles," *Vanity Fair,* April 2000.

77 *As Andy explained:* Warhol and Hackett, *POPism,* 28.

77 *The new process was working:* Ibid.

78 *Acute observers:* "Pop Art," *Time,* May 3 1963.

79 *"This is instant history":* Henry Geldzahler, *New York Painting and Sculpture: 1940–1970* (New York: E. P. Dutton, 1969), 35.

Notes

80 *Geldzahler noted that:* Ibid.

80 *"Pick it up":* Alice Goldfarb Marquis, *Art Czar: The Rise and Fall of Clement Greenberg* (Boston: MFA Publications), 180.

80 *"The Pop artists":* Arthur C. Danto, *Andy Warhol* (Boston: MFA Publications, 2009), 58.

CHAPTER 5

84 *"It's enough life":* John Wilcock, *The Autobiography and Sex Life of Andy Warhol* (New York: Trela Media), 67.

85 Unlike *Andy:* Paul Katz, "Gerard Malanga Famous Before His Time," *Archives Malanga I* (Dagon James: Key Press), 22.

86 *Maas and Menken:* Warhol and Hackett, *POPism*, 32.

86 *He was considered so handsome:* Katz, "Gerard Malanga Famous Before His Time," 22.

87 *Andy saw Gerard:* Warhol and Hackett, *POPism*, 33.

88 *When they weren't working:* Ibid., 34.

88 *"Some days":* Ibid., 41.

89 *He felt incredibly energetic:* Ibid., 42.

92 *"I don't believe":* Emile de Antonio, *Painters Painting* (documentary, 1973).

93 *"I'd rather use art to climb":* *Newsweek*; November 17, 1986, Vol. 108 Issue 21, 97.

93 *In his article:* Tom Wolfe, *The Pump House Gang* (New York: Bantam, 1968), 142, 144, 145.

94 *As his editor:* Emile de Antonio, *Painters Painting* (New York: Abbeville Press, 1984), 123.

96 *"Now start smiling":* Boudon, *Warhol*, 158.

96 *"It was a portrait":* De Antonio, *Painters Painting*, 124.

97 *So storied:* Patrick S. Smith, *Andy Warhol's Art and Films* (Ann Arbor, MI: UMI Research Press, 1986), 121.

98 *"Ohhhh. She's so glamorous":* Kenneth Goldsmith et al., *I'll Be*

Your Mirror: The Selected Andy Warhol Interviews (New York: Carroll & Graf, 2004), 26.

99 *Andy watched the show:* Warhol and Hackett, *POPism*, 53.

CHAPTER 6

106 *Taylor's parents:* Interview with Taylor Mead, May 21, 2012.

106 *Taylor's head was oversized:* Sissi Tax, "Interview with Taylor Mead," *Brooklyn Rail,* May 1, 2004.

107 *"The source of his art":* Susan Sontag, *Against Interpretation: And Other Essays* (New York: Picador, 2001), 158.

108 *"You are the Voltaire":* Warhol and Hackett, *POPism*, 45.

108 *"I frankly couldn't believe":* Ibid.

108 *"I mean he looked like":* Ibid.

109 *His parents had separated:* Interview with Gerard Malanga, July 12, 2012.

110 *Patty was pleased:* Postcard courtesy of Andy Warhol Museum.

111 *"We don't want false":* Raymond Habeski, *Freedom to Offend: How New York Remade Movie Culture* (Lexington: University Press of Kentucky, 2007), 127.

112 *"They're so terrible":* John Giorno, *You Got to Burn to Shine* (New York: High Risk/Serpent's Tail, 1994), 129.

113 *"People were up all night":* Warhol and Hackett, *POPism*, 42.

114 *Andy had seen:* Calvin Tomkins, "All Pockets Open," *New Yorker,* January 6, 1973.

115 *He noticed that Smith:* Warhol and Hackett, *POPism*, 40.

116 *"No man would be able":* Jonas Mekas, "Movie Journal," *Village Voice,* July 25, 1963.

118 *Naomi expressed her softer side:* Jonas Mekas, *Movie Journal: The Rise of the New American Cinema 1959–1971* (New York: Collier, 1972), 168.

118 *At the same time":* P. Adams Sitney, ed., *Film Culture Reader* (New York: Praeger, 1970), 320.

118 *She also thought:* Wilcock, *The Autobiography and Sex Life of Andy Warhol,* 106.

119 *Naomi looked at Andy:* John Gruen and Fred MacDarrah, *The New Bohemia: The Combine Generation* (New York: Grosset & Dunlap, 1966), 10.

120 *"When I kiss":* Alison Nastasi, "Fifty Underground Filmmakers Everyone Should Know," *Flavorwire.* 24 September, 2014. http:// www.flavorwire.com/478486/50-underground-filmmakers ... know/view-all.htm (accessed March 15, 2015).

120 *"She was crazy":* Wilcock, *The Autobiography and Sex Life of Andy Warhol,* 115.

122 *"A borrowed camera":* "Cinema: A Religion of Film," *Time,* September 20, 1963. http:/www.content.time.com/time/magazine/article /0,9171,870556,00.html.

122 *Mekas wrote in his column:* Jonas Mekas, "Movie Journal," *Village Voice,* 19 September, 1963.

123 *He assured Andy:* David McCarthy, "Andy Warhol's Silver Elvises: Meaning Through Context at the Ferus Gallery in 1963," *The Art Bulletin,* Vol 88, No 2 (June, 2006).

123 *"He couldn't be bothered":* Scherman and Dalton, *Pop: The Genius of Andy Warhol,* 175.

CHAPTER 7

126 *These civilian soldiers:* Charles R. Shrader, *History of Operations Research in the United States Army* (Government Printing Office: V. 2: 1961–1973), 17.

127 *McNamara was credited:* Aaron Severson, "The Salesman and the Statistician: Robert McNamara, Lee Iacocca, and the Ford Falcon," Ate Up with Motor, 2 November, 2008. http.www.ateup withmotor.com/model-histories/american-ford-falcon-history (accessed May 2, 2012).

128 *What Ford needed:* "Cheap and Cheerful" (*SIA Auto Magazine* #199, February 2004), 48.

131 *Andy described:* Warol and Hackett, *POPism,* 47.

Notes

132 *Echoing Andy's own sentiments:* Rebecca Leung, "Dylan Looks Back," CBS News, June 12, 2005), www.cbsnews.com/news/dylan-looks-back/ (January 2, 2013).

132 *His voice was so unusual:* Benjamin Hedin, *Studio A: The Bob Dylan Reader* (New York: W.W. Norton, 2005), 261.

132 *He looked:* Interview with Taylor Mead, May 21, 2012.

132 *"And now, now":* Warhol and Hackett, *POPism*, 48.

134 *Alfred Bloomingdale:* Herbert Brean, "Credit Card Spree" (*Life*, June 1, 1959), 128.

135 *"This is where":* Scherman and Dalton, *Pop*, 173.

CHAPTER 8

139 *"I'd brought about fifty magazines":* Warhol and Hackett, *POPism*, 51.

141 *"How could an American debutante":* Ibid.

CHAPTER 9

150 *Prospective travelers:* Arthur Krim, *Route 66: Iconography of the American Highway* (Center for American Places, 2005), 81.

151 *"That's a darling title":* Ibid.,119.

153 *Kerouac was inspired:* Gerard Nicosia, *Memory Babe: A Critical Biography of Jack Kerouac* (Berkeley: University of Californias Press, 1994), 144.

152 *"Maharis and his companion":* Paul Gardener, "Maharis, From Albee to Route 66" (*New York Times*, November 24, 1963), X23.

153 *There were great:* Wilcock, *The Autobiography and Sex Life of Andy Warhol*, 134.

154 *He conducted his research:* Jack D. Rittenhouse, *A Guide Book to Highway 66* (Albuquerque: University of New Mexico, 1989), 2.

154 *"I'm leaving this tour":* Warhol and Hackett, *POPism*, 147.

155 *Taylor described:* Interview with Taylor Mead, May 21, 2012.

Notes

155 *"I don't know what":* Warhol and Hackett, *POPism*, 50.

155 *Back home:* Warhol and Hackett, *POPism*, 36.

CHAPTER 10

159 *"It is a region":* A. G. Mojtaba, *Blessed Assurance: At Home with the Bomb in Amarillo, Texas* (Syracuse, NY: Syracuse University Press, 1997), 15.

163 *Persuasive messages:* Catherine Gudis, *Buyways: Billboards, Automobiles, and the American Landscape* (Oxford: Routledge, Psychology Press, 2004), 65.

164 *Whatever the subject:* Ibid., 153.

165 *"I didn't ever want":* Warhol and Hackett, *POPism*, 51.

167 *"When you looked at Andy":* Scherman and Dalton, *Pop*, 175.

169 *"Come on!":* Steven Watson, *Factory Made* (New York: Pantheon, 2003), 111.

CHAPTER 11

171 *The Llano Estacado:* Michael Wallis, *Route 66: the Mother Road* (New York: St. Martin's, 2001), 142.

171 *As he stared:* Warhol and Hackett, *POPism*, 50.

173 *As Taylor:* Watson, *Factory Made*, 111.

173 *"It was like Pop art":* Taylor Mead Interview, http://planet groupentertainment.squarespace.com/the-taylor-mead-inter view/.

173 *"I never dreamed":* Conrad Hilton, *Be My Guest* (New York: Simon & Schuster, 1957), 11.

176 *Taylor said:* Interview with Taylor Mead, May 21, 2012.

CHAPTER 12

181 *"Route 66 is a giant chute":* Dan McNichol, *The Roads That Built America* (New York: Sterling, 2006), 75.

181 *"Oh, this is America":* Watson, *Factory Made*, 111.

181　*"You can get"*: "Manners and Morals on the Sunset Strip." *Esquire*, August 1961, 49.

183　*"This year's crop"*: Ibid.

185　*"When we arrived"*: Warhol and Hackett, *POPism*, 52.

186　*The Hoppers:* Brooke Hayward, "Once Upon a Time in L.A." (*Vanity Fair*: April 2000)

187　*"We bought priceless"*: Ibid.

187　*"I loved some of those pieces"*: Ibid.

187　*In an article:* Terry Southern, "The Loved House of the Dennis Hoppers," *Vogue*, April 1, 1965, 138.

187　*"He decided"*: Hayward, "Once Upon a Time in L.A."

187　*The mouthwatering:* Ibid.

188　*"The only time I hadn't been shy"*: Warhol and Hackett, *POPism*, 53.

189　*"OOH! AHH!"*: Hayward, "Once Upon a Time in L.A."

189　*"We had Lichtenstein"*: Ibid.

189　*He pointed out:* Warhol and Hackett, *POPism*, 52.

191　*"Everyone was dancing"*: Warhol and Hackett, *POPism*, 53.

191　*Of course:* Brooke Hayward, "Once Upon a Time in L.A."

192　*"That's how hip"*: Scherman and Dalton, *Pop*, 174.

192　*In fact:* Warhol and Hackett, *POPism*, 53.

193　*"This party"*: Ibid.

CHAPTER 13

196　*"It was the French girls"*: Ibid., 51.

196　*"Hollywood is not"*: Cecil Beaton, *Cecil Beaton's Fair Lady* (New York: Holt, Rinehart and Winston, 1964), 53.

198　*"Anywhere there were"*: Interview with Shirley Neilsen Blum, October 18, 2013.

198　*The two poets:* Interview with Gerard Malanga, July 12, 2012.

199　*"Andy seemed no more"*: Interview with Shirley Neilsen Blum, October 18, 2013.

Notes

199 *Irving Blum suggested:* Gagosian Gallery, *Ferus* (New York: Rizzoli, 2002), 30.

199 *Irving Blum recounted the story:* Ibid., 28.

200 *"I always have to laugh":* Warhol and Hackett, *POPism*, 54.

200 *"After a dazzling party":* Ibid., 53.

CHAPTER 14

207 *In 1959:* Lawrence Lipton, *The Holy Barbarians* (New York: Messner, 1959), 17.

208 *"L.A. was full of":* Patty Mucha, "Sewing in the Sixties," *Art in America*, November 2002, 85.

209 *"The canal looked prettiest":* Ibid.

209 *A man:* Ibid.

210 *"It was all very glamorous":* Wilcock, *The Autobiography and Sex Life of Andy Warhol*, 134.

211 *"I was Tarzan":* Interview with Taylor Mead, May 21, 2012.

212 *"I was too shy":* Ibid.

212 *"No way":* Ibid.

213 *But Taylor:* Interview with Taylor Mead, May 21, 2012.

214 *"Movies had gotten too big":* Beaton, *Cecil Beaton's Fair Lady*, 97.

214 *"And he thought":* Interview with Taylor Mead, May 21, 2012.

215 *"Gee, he's so sweet":* Wilcock, *The Autobiography and Sex Life of Andy Warhol*, 108.

CHAPTER 15

217 *Taylor explained:* Wilcock, *The Autobiography and Sex Life of Andy Warhol*, 134.

218 *"I invited":* Interview with Taylor Mead, May 21, 2012.

219 *"It was hot":* Warhol and Hackett, *POPism*, 57.

219 *Cecil Beaton heard:* Fred Lawrence Guiles, *Loner at the Ball: The Life of Andy Warhol* (Great Britain: Black Swan, 1990), 71.

220 *This was the first time:* Interview with Gerard Malanga, July 12, 2012.

221 *Andy saw himself:* Warhol, *The Philosophy of Andy Warhol*, 23.

221 *"Sometimes people":* Ibid., 112.

221 *"It was like a diary":* Wilcock, *The Autobiography and Sex Life of Andy Warhol*, 115.

224 *He covered steel wire mesh:* Bud Goldstone and Arloa Pacquin Goldstone, *The Los Angeles Watts Towers* (Los Angeles: Getty Conservation Institute, 1997), 56.

224 *He picked up:* Cecile Whiting, *POP L.A.: Art and the City in the 1960s* (Berkeley: University of California, 2006), 151.

227 *"For a trading stamp heir":* Art Seidenbaum, "Moonfire's Marvin—Head in the Clouds, Feet on the Ground" (*Los Angeles Times*, September 19, 1965, B3.

228 *"While he was building":* Warhol and Hackett, *POPism*, 58.

CHAPTER 16

233 *"Andy and I":* Interview with Gerard Malanga, July 12, 2012.

233 *Adults had to think:* Interview with Tosh Berman, January 31, 2013.

234 *"He sort of threw me":* Interview with Gerard Malanga, July 12, 2012.

234 *Their crazy moves:* Interview with Taylor Mead, May 21, 2012.

234 *He later joked:* Warhol and Hackett, *POPism*, 55.

235 *Hirschman saw:* Kenneth Goldsmith, ed., *I'll Be Your Mirror: The Selected Andy Warhol Interviews* (New York: Carroll & Graf Publishers, 2004), 28.

235 *"Both of us would say":* Ibid., 34.

235 *"No, I just think":* Ibid., 43.

CHAPTER 17

242 *"He touched no equipment":* www.dgp.toronto.edu/~stam/suomi/stam/duchamp.html (accessed October 5, 2014).

243 *"One can look at Las Vegas":* Tom Wolfe, *The Kandy-Kolored Tangerine Flake Streamline Baby* (New York: Bantam, 1999), 7.

245 *"KO the Kennedys":* Watson, *Factory Made*, 114.

246 A*ndy checked everyone:* Scherman and Dalton, *Pop: The Genius of Andy Warhol*, 178.

<p style="text-align:center">CHAPTER 18</p>

249 *He said he went: POPism*, 65.

250 *Duchamp's influence:* http://www.raintaxi.com/the-poetry-in-something-an-interview-with-gerard-malanga/.

251 *"Naomi couldn't wait":* Interview with Taylor Mead, May 21, 2012.

251 *Wynn was trying:* This Long Century: www.thislongcentury.com /?p=5731.

252 *According to the art historian:* Kenneth Clark, *The Nude* (New York: Pantheon 1956), 3.

253 *A new entertainment:* Jonas Mekas, *Village Voice* (February 1964).

253 *He also praised:* Jonas Mekas, *Village Voice* (December 24, 1964).

253 *James Stoller wrote:* James Stoller, "Tarzan and Jane Regained—Sort Of," *Moviegoer*, Summer/Autumn, 1964. 66.

253 *However, he promised:* Kelly M. Cresap, *Pop Trickster Fool: Warhol Performs Naivete* (Urbana: University of Illinois, 2004), 196.

254 *"Everyone was":* Warhol and Hackett, *POPism*, 76.

254 *"Sure":* Wolfe, *The Kandy-Kolored Tangerine-Flake Streamline Baby*, xvi.

255 *"Anything beats":* Warhol and Hackett, *POPism*, 76.

255 *After watching Naomi:* Goldsmith, *I'll Be Your Mirror*, 187.

256 *"I noticed":* David McCabe and David Dalton. *A Year in the Life of Andy Warhol* (London: Phaidon, 2003), 5.

256 *According to Dalton:* Ibid., 7.

256 *"The reason I'm painting":* G. R. Swenson, "What Is Pop Art?," *ARTnews*, 1963, November 26.

256 *He was all about:* Eva Meyer-Hermann, ed. *Andy Warhol: A Guide*

to *706 Items in 2 Hours 56 Minutes* (Rotterdam: NAi Publishers, 2007) 57.

257 *"He's playing dumb"*: Geldzahler, *Making it New*, 39.

259 *"It was the perfect time"*: Warhol and Hackett, *POPism*, 83.

260 *"Factory is as good a name as any"*: Annette Michelson, ed., *Andy Warhol: October Files 2* (Cambridge: MIT Press, 2001), 5.

CHAPTER 19

262 *"Reynolds wrap"*: Bockris, *Warhol: The Biography*, 198.

262 *"I took the action"*: Warhol and Hackett, *POPism*, 87.

262 *According to Andy:* Ibid., 111.

263 *"A lot of people thought"*: Ibid., 93.

263 *The man Truman Capote:* Warhol, *The Philosophy of Andy Warhol*, 23.

264 *And whether:* Mark Rosenthal et al., *Regarding Warhol: Sixty Artists, Fifty Years* (New York: Metropolitan Museum of Art, 2012), 253.

264 *"Andy Warhol would like"*: Stein and Plimpton, *Edie: An American Biography*, 183.

265 *"I'm retiring from painting"*: Don Bacigalupi and Scott Atkinson, San Diego Museum of Art: Selected Works, 2003), 242.

266 *"He wanted to be"*: Bob Colacello, "Why Are We Still Talking About Andy Warhol?" The Daily Beast, http://thebea.st/1t-Y2Hmv, March 9, 2014.

266 *"I was so hurt"*: Warhol and Hackett, *POPism*, 195.

267 *"It was so strange"*: Ibid., 196.

267 *Andy said:* Peter Jennings, *The Wit and Wisdom of Andy Warhol* (Amazon Digital Services: 2014).

267 *"I have a social disease"*: Andy Warhol, *Andy Warhol's Exposures* (New York: Grosset & Dunlap, 1980) 1.

267 *"Being good in business"*: *Philosophy of Andy Warhol*, 92.

Notes

268 *The* New York Times *suggested:* Douglas C. McGill, "Andy Warhol, Pop Artist, Dies," *New York Times*, February 23, 1987.

268 *Hilton Kramer:* Rosenthal, *Regarding Warhol: Sixty Artists, Fifty Years*, 269.

CHAPTER 20

271 *"Andy wanted":* Stephen Rea, "Poet Looks Back to Time with Warhol," philly.com, September 28, 1995.

274 *Ultimately, Rosenquist:* James Rosenquist, *Painting Below Zero: Notes on a Life in Art* (New York: Knopf, 209) 131.

Bibliography

ORIGINAL DOCUMENTS

The Andy Warhol Museum Archives

ARTICLES AND PERIODICALS

Numerous issues of the *New York Times, Los Angeles Times, Time, Life, Look, The New Yorker, Art in America, Village Voice, Newsweek*, and other periodicals provided information about Warhol and his times.

BOOKS AND ARTICLES

Alexander, Paul. *Death and Disaster: The Rise of the Warhol Empire and the Race for Andy's Millions*. New York: Villard, 1994. Print.

Amaya, Mario. *Pop Art and After*. New York: Viking, 1966. Print.

"Andy Warhol 1928 Amaya, Mario. *Pop Art . . . and after* 87." *Art in America*, May 1987: n.p. Print.

Andy Warhol and His World. Katrine Molstrom. Louisiana Museum of Modern Art, 2001. Print.

Angell, Callie. *Andy Warhol Screen Tests: The Films of Andy Warhol: Catalogue Raisonné*. New York: Abrams, 2006. Print.

Aquin, Stéphane. *Warhol Live*. Montreal, Quebec: Prestel, 2008. Print.

Atkinson, D. Scott. *San Diego Museum of Art: Selected Works*. San Diego: San Diego Museum of Art, 2003. Print.

Banes, Sally. *Greenwich Village 1963: Avant-garde Performance and the Effervescent Body*. Durham, NC: Duke University Press, 1993. Print.

Bibliography

Basten, Fred E. *Great American Billboards: 100 Years of History by the Side of the Road*. Berkeley, CA: Ten Speed, 2007. Print.

Beaton, Cecil. *Cecil Beaton's Fair Lady*. New York: Holt, Rinehart and Winston, 1964. Print.

Beaton, Cecil, and Hugo Vickers. *Beaton in the Sixties: The Cecil Beaton Diaries as He Wrote Them, 1965–1969*. New York: Alfred A. Knopf, 2004. Print.

Bernstein, Roberta, and Kirk Varnedoe. *Ferus*. New York: Rizzoli, 2009. Print.

Bockris, Victor. *Warhol: The Biography*. New York: Da Capo, 2003. Print.

Bourdon, David. *Warhol*. New York: Abrams, 1989. Print.

Butt, Gavin. *Between You and Me: Queer Disclosures in the New York Art World, 1948–1963*. Durham, NC: Duke UP, 2005. Print.

Chidester, Brian, and Domenic Priore. *Pop Surf Culture: Music, Design, Film, and Fashion from the Bohemian Surf Boom*. Santa Monica, CA: Santa Monica Press, 2008. Print.

"Cinema: A Religion of Film." Editorial. *Time*, September 20, 1963: n.p. Web.

Clark, Kenneth. *The Nude*. New York: Pantheon, 1956. Print.

Colacello, Bob. *Holy Terror: Andy Warhol Close Up*. New York, NY: HarperCollins, 1990. Print.

Coplans, John, Jonas Mekas, and Calvin Tomkins. *Andy Warhol*. Greenwich, CT: New York Graphic Society, 1970. Print.

"Credit Card Spree." *Life* ,June 1, 1959: 128. Web.

Cresap, Kelly M. *Pop Trickster Fool: Warhol Performs Naivete*. Urbana: University of Illinois, 2004. Print.

Crone, Rainer. *Andy Warhol*. New York: Praeger, 1970. Print.

Crow, Thomas E. *The Rise of the Sixties: American and European Art in the Era of Dissent*. New York, NY: Harry N. Abrams, 1996. Print.

Curtis, Charlotte. *The Rich and Other Atrocities*. New York: Harper & Row, 1976. Print.

Bibliography

Danto, Arthur C. *Andy Warhol.* New Haven, CT: Yale University Press, 2009. Print.

Donovan, Molly, Andy Warhol, and John J. Curley. *Warhol: Headlines.* Washington, DC: National Gallery of Art, 2011. Print.

Drohojowska-Philp, Hunter. "Art Dealer Irving Blum on Andy Warhol and the 1960s L.A. Art Scene (Q&A)." *The Hollywood Reporter:* n.p. Web. March 26, 2014. Print.

Esquire Fashions for Men. New York: Harper & Row, 1966. Print.

Farber, David R. *The Sixties: From Memory to History.* Chapel Hill: University of North Carolina, 1994. Print.

Foster, Hal. *The First Pop Age: Painting and Subjectivity in the Art of Hamilton, Lichtenstein, Warhol, Richter, and Ruscha.* Princeton: Princeton University Press, 2014. Print.

Francis, Mark, Margery King, Andy Warhol, and Hilton Als. *The Warhol Look: Glamour, Style, Fashion.* Boston: Little, Brown, 1997. Print.

Galella, Ron. *Warhol by Galella: That's Great!* New York: Monacelli, 2008. Print.

Geldzahler, Henry. *Making It New: Essays, Interviews, and Talks.* New York: Turtle Point, 1994. Print.

Giorno, John. *You Got to Burn to Shine.* New York: High Risk/Serpent's Tail, 1994. Print.

Glenn, Constance W., Linda Albright, Dorothy Lichtenstein, and Karen L. Kleinfelder. *The Great American Pop Art Store: Multiples of the Sixties.* Santa Monica, CA: Smart Art, 1997. Print.

Glueck, Grace. "Robert Scull, Prominent Collector of Pop Art." *New York Times,* January 3, 1986: n.p. Web.

Goldman, Judith. *Robert & Ethel Scull: Portrait of a Collection.* New York: Acquavella Galleries, 2010. Print.

Goldsmith, Kenneth, Reva Wolf, and Wayne Koestenbaum. *I'll Be Your Mirror: The Selected Andy Warhol Interviews: 1962–1987.* New York: Carroll & Graf, 2004. Print.

Bibliography

Goldstone, Bud, and Arloa Paquin Goldstone. *The Los Angeles Watts Towers*. Los Angeles: Getty Conservation Institute, 1997. Print.

Gruen, John, and Fred W. MacDarrah. *The New Bohemia: The Combine Generation*. New York, NY: Grosset & Dunlap, 1966. Print.

Gudis, Catherine. *Buyways: Billboards, Automobiles, and the American Landscape*. New York: Routledge, 2004. Print.

Guiles, Fred Lawrence. *Loner at the Ball: The Life of Andy Warhol*. London: Bantam, 1989. Print.

Haberski, Raymond J. *Freedom to Offend: How New York Remade Movie Culture*. Lexington: University of Kentucky, 2007. Print.

Halberstam, David. *The Fifties*. New York: Villard, 1993. Print.

Haslam, Nicholas. *Redeeming Features: A Memoir*. New York: Alfred A. Knopf, 2009. Print.

Hayward, Brooke. "Once Upon a Time in L.A." *Vanity Fair* Apr. 2000: n.p. Web.

Hedin, Benjamin. *Studio A: The Bob Dylan Reader*. New York: W. W. Norton, 2004. Print.

Hilton, Conrad N. *Be My Guest*. New York: Popular Library, 1957. Print.

Honnef, Klaus. *Andy Warhol, 1928–1987: Commerce into Art*. Germany: Benedikt Taschen Verlag, 1990. Print.

Hopper, Dennis, Petra Giloy-Hirtz, and Brooke Hayward. *Dennis Hopper: The Lost Album: Vintage Prints from the Sixties*. Munich: Prestel, 2012. Print.

Howard, Gerald. *The Sixties*. New York: Washington Square Press, 1982. Print.

Indiana, Gary, and Andy Warhol. *Andy Warhol and the Can That Sold the World*. New York: Basic, 2010. Print.

Johnson, Catherine, and Andy Warhol. *Thank You Andy Warhol*. New York: Glitterati Incorporated, 2012. Print.

Kaiser, Charles. *The Gay Metropolis: The Landmark History of Gay Life in America*. New York: Grove, 2007. Print.

Bibliography

Kaplan, Fred M. *1959: The Year Everything Changed*. Hoboken, NJ: John Wiley & Sons, 2009. Print.

Kerouac, Jack. *On the Road*. New York: New American Library, 1957. Print.

Kiedrowski, Thomas, and Vito Giallo. *Andy Warhol's New York City: Four Walks, Uptown to Downtown*. New York: Little Bookroom, 2011. Print.

Kirwin, Liza, and Joan Lord. *Artists in Their Studios: Images from the Smithsonian's Archives of American Art*. New York: Collins Design, 2007. Print.

Knowles, Drew. *Route 66 Adventure Handbook*. Solana Beach, CA: Santa Monica Press, 2011. Print.

Koch, Stephen. *Stargazer: Andy Warhol's World and His Films*. New York: M. Boyars, 1985. Print.

Kornbluth, Jesse. *Pre-Pop Warhol*. New York: Panache at Random House, 1988. Print.

Krim, Arthur J., and Denis Wood. *Route 66: Iconography of the American Highway*. Santa Fe, NM: Center for American Places, 2005. Print.

Latow, Roberta. *Cheyney Fox*. London: Headline, 1990. Print.

Leland, John. *Why Kerouac Matters: The Lessons of On the Road (They're Not What You Think)*. New York: Viking, 2007. Print.

Lipton, Lawrence. *The Holy Barbarians*. New York: Messner, 1959. Print.

Lurie, Alison. *The Nowhere City*. New York: Coward-McCann, 1966. Print.

MacCabe, Colin, Mark Francis, and Peter Wollen. *Who Is Andy Warhol?* London: British Film Institute, 1997. Print.

MacNeil, Robert. *The Way We Were: 1963, the Year Kennedy Was Shot*. New York: Carroll & Graf, 1988. Print.

Malanga, Gerard. *AM: Archives Malanga*. Vol. 1: Dagon James/Key, 2011. Print.

———. *Archiving Warhol: An Illustrated History*. London: Creation, 2002. Print.

————. *Mythologies of the Heart.* Santa Rosa, CA: Black Sparrow, 1996. Print.

————. *No Respect: New & Selected Poems, 1964–2000.* Santa Rosa, CA: Black Sparrow, 2001. Print.

————. *Three Diamonds.* Santa Rosa, CA: Black Sparrow, 1991. Print.

Maynard, John Arthur. *Venice West: The Beat Generation in Southern California.* New Brunswick, NJ: Rutgers University Press, 1991. Print.

McCabe, David, and David Dalton. *A Year in the Life of Andy Warhol.* London: Phaidon, 2003. Print.

McCarthy, David. "Andy Warhol's Silver Elvises: Meaning through Context at the Ferus Gallery in 1963." *Art Bulletin* 88.2 (2006): n.p. Web.

McDarrah, Fred W. *New York, N.Y.; A Photographic Tour of Manhattan Island from Battery Park to Spuyten Duyvil.* New York: Corinth, 1964. Print.

McKenna, Kristine. *The Ferus Gallery: A Place to Begin.* Göttingen, Germany: Steidl, 2009. Print.

McNichol, Dan. *The Roads That Built America: The Incredible Story of the U.S. Interstate System.* New York: Sterling Publishing, 2006. Print.

Mekas, Jonas. *Movie Journal: The Rise of the New American Cinema, 1959–1971.* New York: Macmillan, 1972. Print.

Mills, Katie. *The Road Story and the Rebel: Moving through Film, Fiction, and Television.* Carbondale: Southern Illinois University Press, 2006. Print.

Mojtabai, A. G. *Blessed Assurance: At Home with the Bomb in Amarillo, Texas.* Boston: Houghton Mifflin, 1986. Print.

"Monday Night on La Cienega." *Time,* July 26, 1963: n.p. Print.

Moruzzi, Peter. *Palm Springs Holiday: A Vintage Tour from Palm Springs to the Salton Sea.* Salt Lake City, UT: Gibbs Smith, 2009. Print.

Bibliography

Murphy, J. J. *The Black Hole of the Camera: The Films of Andy Warhol.* Berkeley: University of California Press, 2012. Print.

Name, Billy, and Dagon James. *Billy Name—the Silver Age*: n.p., n.d. Print.

Nicosia, Gerald. *Memory Babe: A Critical Biography of Jack Kerouac.* New York: Grove, 1983. Print.

O'Connor, John T., and Benjamin Liu. *Unseen Warhol.* New York: Rizzoli, 1996. Print.

Oldenburg, Claes, Achim Hochdörfer, Maartje Oldenburg, and Barbara Schröder. *Claes Oldenburg: Writing on the Side, 1956–1969*: n.p., n.d. Print.

Peabody, Rebecca. *Pacific Standard Time: Los Angeles Art, 1945–, 1980.* Los Angeles: Getty Research Institute and the J. Paul Getty Museum, 2011. Print.

Pearlstein, Philip, and Patterson Sims. *Philip Pearlstein: Objectifications.* Montclair, NJ: Montclair Art Museum, 2008. Print.

"Pop Art." *Time*, May 3, 1963: n. p. Web.

Priore, Domenic. *Riot on Sunset Strip: Rock'n'roll's Last Stand in Hollywood.* London: Jawbone, 2007. Print.

Rasmussen, Frederick. "Baltimore Artist Recalls Andy Warhol." *The Baltimore Sun*, October 9, 2010: n.p. Print.

Ratcliff, Carter. *Andy Warhol.* New York: Abbeville, 1983. Print.

Regarding Warhol Sixty Artists, Fifty Years. New York: Metropolitan Museum of Art, Communications Department, n.d. Print.

Richardson, John. *Sacred Monsters, Sacred Masters: Beaton, Capote, Dalí, Picasso, Freud, Warhol, and More.* New York: Random House, 2001. Print.

Rosenthal, Mark, Marla Prather, Ian Alteveer, Rebecca Lowery, Polly Apfelbaum, John Baldessari, Vija Celmins, Chuck Close, Robert Gober, Hans Haacke, Alfredo Jaar, Deborah Kass, Alex Katz, Jeff Koons, Julian Schnabel, Ryan Trecartin, and Luc Tuymans. *Regarding Warhol: Sixty Artists, Fifty Years*: New York: Metropolitan Museum of Art, 2012. Print.

Ruskin, Yvonne Sewall. *High on Rebellion: Inside the Underground at Max's Kansas City*. New York: Thunder's Mouth, 1998. Print.

Saroyan, Aram. *Starting Out in the Sixties: Selected Essays*. Jersey City, NJ: Talisman House, 2001. Print.

Scherman, Tony, Andy Warhol, and David Dalton. *Pop: The Genius of Andy Warhol*. New York: HarperCollins, 2009. Print.

Schwartz, Alexandra. *Ed Ruscha's Los Angeles*. Cambridge, MA: MIT, 2010. Print.

Sitney, P. Adams. *Film Culture Reader*. New York: Praeger, 1970. Print.

Smith, Patrick S. *Andy Warhol's Art and Films*. Ann Arbor, MI: UMI Research Press, 1986. Print.

Smith, Patrick S. *Warhol: Conversations about the Artist*. Ann Arbor: UMI Research Press, 1988. Print.

Snyder, Tom. *Route 66: Traveler's Guide and Roadside Companion*. New York: St. Martin's Griffin, 2011. Print.

Sontag, Susan. *Against Interpretation and Other Essays*. New York: Picador, 2001. Print.

Southern, Terry. "The Loved House of the Dennis Hoppers." *Vogue*, April 1. 1965: 138. Print.

Stavitsky, Gail, and Andy Warhol. *Warhol and Cars: American Icons*. Montclair, NJ: Montclair Art Museum, 2011. Print.

Stein, Jean, and George Plimpton. *Edie: An American Biography*. New York: Knopf, 1982. Print.

Steinbeck, John. *Travels with Charlie: In Search of America*. New York: Viking, 1961. Print.

Swenson, G. R. "What Is Pop Art?" *ARTnews*, November 1963: n.p. Print.

Tax, Sissi. "Interview with Taylor Mead." May 1, 2004: n.p. *Brooklyn Rail*. Web.

This Fabulous Century: 1950–1960. New York: Time-Life, 1970. Print.

Tomkins, Calvin. "All Pockets Open." *New Yorker*, January 6, 1973: n.p. Web.

Bibliography

————. *Off the Wall: Robert Rauschenberg and the Art World of Our Time*. Garden City, NY: Doubleday, 1980. Print.

Tyler, Parker. *Underground Film: A Critical History*. New York: Grove, 1970. Print.

Varnedoe, Kirk, Jasper Johns, and Roberta Bernstein. *Jasper Johns: A Retrospective*. New York: Museum of Modern Art, 1996. Print.

Violet, Ultra. *Famous for 15 Minutes: My Years with Andy Warhol*. San Diego: Harcourt Brace Jovanovich, 1988. Print.

Wakefield, Dan. *New York in the Fifties*. Boston: Houghton Mifflin/Seymour Lawrence, 1992. Print.

Wallis, Michael. *Route 66: The Mother Road*. New York: St. Martin's, 1990. Print.

Warhol, Andy. *America*. New York: Harper & Row, 1985. Print.

————. *Andy Warhol, 365 Takes: The Andy Warhol Museum Collection*. New York, NY: H. N. Abrams in Association with the Andy Warhol Museum, 2004. Print.

————. *Andy Warhol's Time Capsule 21*. Cologne: Dumont Literatur und Kunst Verlag, 2003. Print.

————. *The Philosophy of Andy Warhol (From A to B and Back Again)*. New York: Harcourt Brace Jovanovich, 1975. Print.

Warhol, Andy, and Daniel Blau. *From Silverpoint to Silver Screen: Andy Warhol, 1950s Drawings*. Munich: Hirmer, 2012. Print.

Warhol, Andy, and Bernhard Bürgi. *Andy Warhol, the Early Sixties: Paintings and Drawings 1961–1964*. Ostfildern: Hatje Cantz, 2010. Print.

Warhol, Andy, and Rainer Crone. *Andy Warhol: A Picture Show by the Artist*. New York: Rizzoli, 1987. Print.

Warhol, Andy, Georg Frei, and Neil Printz. *The Andy Warhol Catalogue Raisonné*. London: Phaidon, 2004. Print.

Warhol, Andy, and Pat Hackett. *The Andy Warhol Diaries*. New York: Warner, 1989. Print.

————. *Andy Warhol's Party Book*. New York: Crown, 1988. Print.

————. *POPism: The Warhol Sixties*. New York: Harcourt Brace Jovanovich, 1980. Print.

Warhol, Andy, Gerard Malanga, and Jeff Koons. *Andy Warhol: 5 Deaths*. New York: Stellan Holm Gallery, 2002. Print.

Warhol, Andy, and Kynaston McShine. *Andy Warhol: A Retrospective*. New York: Museum of Modern Art, 1989. Print.

Warhol, Andy, and Eva Meyer-Hermann. *Andy Warhol: A Guide to 706 Items in 2 Hours 56 Minutes*. Rotterdam: NAi, 2007. Print.

Warhol, Andy, Annette Michelson, and B. H. D. Buchloh. *Andy Warhol*. Cambridge, MA: MIT, 2001. Print.

Watson, Steven. *Factory Made: Warhol and the Sixties*. New York: Pantheon, 2003. Print.

Weinberg, Joanna. "Art: It Happened One Night." September 1, 2002: n.p. Print.

Whiting, Cécile. *Pop L.A.: Art and the City in the 1960s*. Berkeley: University of California, 2006. Print.

Wilcock, John, Christopher Trela, and Harry Shunk. *The Autobiography and Sex Life of Andy Warhol*. New York: TRELA, 2010. Print.

Wolf, Reva. *Andy Warhol, Poetry, and Gossip in the 1960s*. Chicago: University of Chicago, 1997. Print.

Wolfe, Tom. *The Kandy-Kolored Tangerine-Flake Streamline Baby*. New York: Bantam, 1999. Print.

Wolfe, Tom. *The Painted Word*. New York: Farrar, Straus and Giroux, 1975. Print.

————. *The Pump House Gang*. New York: Farrar, Straus & Giroux, 1968. Print.

————. *Radical Chic: And Mau-mauing the Flak Catchers*. London: Joseph, 1971. Print.

Woronov, Mary. *Swimming Underground: My Years in the Warhol Factory*. Boston: Journey Editions, 1995. Print.

Index

Index

Index

Index

Index

Index

Illustration Credits

CHAPTER 1

Personal collection of the author.

CHAPTER 2

Unknown photographer. *Andy Warhol (right) with classmates Philip Pearlstein and Joan Kramer, visiting Rockefeller Center*, ca. 1948. Gelatin silver print, 3⁹⁄₁₆ x 2½ in. (9 x 6.4 cm.), The Andy Warhol Museum, Pittsburgh; Founding Collection, Contribution The Andy Warhol Foundation for the Visual Arts, Inc. T595.

CHAPTER 3

Copyright © Ken Heyman.

CHAPTER 4

Alfred Statler. *Andy Warhol's art in his studio at 1342 Lexington Avenue, New York City*, 1962. Gelatin silver print, 8⅛ x 10 in. (20.6 x 25.4 cm.) The Andy Warhol Museum, Pittsburgh; Museum Purchase, © The Andy Warhol Museum, Pittsburgh, a museum of Carnegie Institute 2014.7.8e. © 2015 The Andy Warhol Foundation for the Visual Arts, Inc./Artists Rights Society (ARS), New York.

CHAPTER 5

Edward Wallowitch. *Contact Sheet (Andy Warhol and Gerard Malanga at Warhol's studio)* (detail), 1963. Gelatin silver print 8⅛ x 10 in. (20.6 x

Illustration Credits

25.4 cm.) The Andy Warhol Museum, Pittsburgh; Founding Collection, Contribution The Andy Warhol Foundation for the Visual Arts, Inc. 1998.3.10789. Permission from Paul Wallowitch. © 2015 Edward Wallowitch, all rights reserved.

CHAPTER 6

Andy Warhol, *Kiss*, 1963. 16mm film, black and white, silent, 54 minutes at 16 frames per second © 2015 The Andy Warhol Museum, Pittsburgh, PA, a museum of Carnegie Institute. All rights reserved. Film still courtesy The Andy Warhol Museum.

CHAPTER 7

Ephemera from Andy Warhol's 1963 Pasadena trip. Mixed media. The Andy Warhol Museum, Pittsburgh; Founding Collection, Contribution The Andy Warhol Foundation for the Visual Arts, Inc.

CHAPTER 8

Wallace Berman invitation courtesy of the Wallace Berman estate. © Wallace Berman Estate.

CHAPTER 10

Personal collection of the author.

CHAPTER 11

Route 66 road trip, 1963. *Andy Warhol/Taylor Mead/Wynn Chamberlain/ Gerard Malanga in photo booth, Albuquerque, NM.* Credit: Copyright © Gerard Malanga.

CHAPTER 12

1712 North Crescent Heights, 1965. © DENNIS HOPPER. Courtesy The Hopper Art Trust, www.dennishopper.com.

Illustration Credits

CHAPTER 13

Photographer unknown. *Taylor Mead, Andy Warhol, and Brooke Hopper at the opening of Warhol's Elvis and Liz exhibition at the Ferus Gallery,* 1963. The Andy Warhol Museum, Pittsburgh; Founding Collection, Contribution The Andy Warhol Foundation for the Visual Arts, Inc.

CHAPTER 14

Andy Warhol (with flower), 1963 © DENNIS HOPPER. Courtesy The Hopper Art Trust, www.dennishopper.com.

CHAPTER 15

Andy Warhol. *Tarzan and Jane Regained . . . Sort Of,* 1963, 16mm film, black and white and color, sound, 80 minutes. © 2015 The Andy Warhol Museum, Pittsburgh, a museum of Carnegie Institute. All rights reserved. Film still courtesy The Andy Warhol Museum.

CHAPTER 16

1963. Copyright © Julian Wasser. All rights reserved.

CHAPTER 17

Las Vegas News Bureau.

CHAPTER 19

Photo by Fred W. McDarrah/Getty Images.

CHAPTER 20

Air Lingus, Andy Warhol Studio: 1966-183-004-048, Manhattan, New York, USA, 1966. Copyright © Jerry Schatzberg.

Permissions Acknowledgments

Grateful acknowledgment is made to the following for permission to reprint previously published material.

Houghton Mifflin Harcourt: Excerpts from *The Philosophy of Andy Warhol (From A to B and Back Again)*. Copyright © 1975 by Andy Warhol. Reprinted by permission of Houghton Mifflin Harcourt Publishing Company. All rights reserved.

Houghton Mifflin Harcourt: Excerpts from *POPism: The Warhol Sixties* by Andy Warhol and Pat Hackett. Copyright © 1980 by Andy Warhol. Reprinted by permission of Houghton Mifflin Harcourt Publishing Company. All rights reserved.

Trela Media: Excerpts from *The Autobiography and Sex Life of Andy Warhol*. Copyright © 2010 by John Wilcock. Reprinted by permission of Trela Media, LLC. All rights reserved.

Martino Publishing: Excerpt from *The Holy Barbarians*. Copyright © 2009 by Lawrence Lipton. Reprinted by permission of Martino Publishing. All rights reserved.

Claes Oldenburg: Excerpts from *Claes Oldenburg: Writing on the Side, 1956–1969*. Copyright © Claes Oldenburg. Reprinted by permission of Claes Oldenburg. All rights reserved.

Perseus Books Group: *Warhol: The Biography*. Copyright © 2003 by Victor Bockris. Reprinted by permission of Perseus Books Group. All rights reserved.

Gerard Malanga: "Mirage." Copyright © Gerard Malanga. Previously published in *Art & Literature*, edited by John Ashbery. Reprinted by permission of Gerard Malanga.